Art Treasures from Japan

Art Treasures from Japan

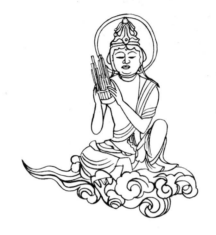

 KODANSHA INTERNATIONAL LTD.

講談社 Tokyo, Japan & Palo Alto, Calif., U.S.A.

The publishers wish to express their gratitude to the Los
Angeles County Museum of Art, the Detroit Art Institute,
the Philadelphia Museum of Art, the Royal Ontario
Museum, Toronto, and the Japanese National Commission
for Protection of Cultural Properties for making possible
this trade edition of the 1966 exhibition catalog, *Art
Treasures from Japan.*

Distributed in the British Commonwealth (excluding
Canada and the Far East) by Ward Lock & Company Ltd.,
London and Sydney; in Continental Europe by
Boxerbooks, Inc., Zurich; and in the Far East by Japan
Publications Trading Co., C.P.O. Box 722, Tokyo.
Published by Kodansha International Ltd., 2–12–21,
Otowa, Bunkyo-ku, Tokyo 112, Japan and Kodansha
International/USA, Ltd., 599 College Avenue, Palo Alto,
California 94306. All rights reserved. Permission to
reproduce any portion of this work must be obtained from
the Los Angeles County Museum of Art.
 LCC 79–162652
 ISBN 0–87011–160–4
 JBC No. 1070–783161–2361
First edition, 1971

Contents

Preface

This book was originally the catalog for a remarkable exhibition, *Art Treasures from Japan*, which was held in the United States and Canada during 1965 and 1966. One hundred and sixty-two superb paintings, sculptures, and examples of the applied arts, most of which have been designated National Treasures or Important Cultural Properties of Japan, are included in the publication.

The exhibition and its catalog were received with such intense interest and enthusiasm that the ensuing demand for the catalog exhausted all available copies. This publication, which illustrates and discusses many important masterpieces in the history of Japanese art, is intended to enable a still greater number of people to achieve a deeper understanding and appreciation of the art and aesthetic traditions of Japan.

The difference between the arts of Japan and the West can provide the stimulation necessary to arouse curiosity and foster creativity. The collision of cultures strange to each other often produces fruitful results. In the nineteenth century the importation of Japanese prints into Europe had an enormous effect on European painting, particularly that of Whistler, Monet, Degas, Toulouse-Lautrec, and Van Gogh. In this century the influence has been still more pervasive, and contemporary architecture and landscape gardening have been profoundly affected by traditional Japanese concepts. It is to be hoped that increased contact between the two cultures will continue to provide a creative impetus beneficial to both.

The text of this book is the joint effort of specialists from Japan and America who participated in the selection and organization of the original exhibition. Takaaki Matsushita and Bunsaku Kurata and their scholarly staff at the former Bunkazai must be credited for much of the research on the art objects in the catalog. Futher acknowledgement for their efforts goes to the American participants, Jean Gordon Lee, Curator of Far Eastern Art, Philadelphia Museum of Art; Harold Phillip Stern, Assistant Director, Freer Gallery of Art; Henry Trubner, then Curator of the Far Eastern Department, Royal Ontario Museum; as well as to the present writer.

Bunsaku Kurata has contributed a new introductory essay for this edition. The notes and illustrations in the present publication are otherwise identical to the original catalog except for corrections of typographical errors and deletions of the foreword material pertaining to the exhibition.

George Kuwayama
Senior Curator of Far Eastern Art
Los Angeles County Museum of Art

Foreword

The objects in this volume represent the quintessence of Japanese fine and applied arts. The publication of this excellent catalog again makes available in a convenient size a collection that, as a whole, provides a standard of appreciation for all Japanese art. Since the objects of the 1966 exhibit have now returned to their home collections throughout Japan, and since it now seems highly improbable that a collection of similar breadth and quality can be assembled in the forseeable future, if at all, a summary appreciation of each section of this book might prove of value to the reader.

Sculpture

The great age of Japanese sculpture occurred from the Asuka through the Kamakura periods. The works illustrated here are outstanding and typical examples from these periods.

The two Asuka period pieces of No. 1 are made of camphor wood, the material most commonly used for sculpture at that time. Asuka period style is characterized by an almost "abstract" rendering of form, evident in the oversized head and hands of the apsaras figure in No. 1. Also typical of this period is the static symmetry of the Kannon in No. 2, while No. 3 is an atypical example from late in this period, quite possibly having been made in Kyushu.

The Nara period saw a distinctly new style emerge. The soft, flowing quality, the gentle features, and the proportions of both Nos. 4 and 5 seem far removed from the stiff, austere symmetry and outsized head and hands of the Asuka Kannon. The development away from the earlier, abstract, static forms is clear in the Nara pieces, which have become more human, graceful, and amicable, and show a definate tendency toward the strong realism that developed later. Whereas the Asuka pieces were probably made by immigrant craftsman and their pupils, the Nara piece of No. 4 is an example of lost wax casting by native Japanese craftsmen, though the style is an emulation of that of T'ang China.

The Heian period saw a great flourishing of sculpture, and the development of a number of distinct styles. The Yakushi Nyorai of No. 6 is typical of the conservative style of the time. The great difference between this piece and the Miroku of No. 7 can be seen at a glance. In the latter the head and hands are immense and the legs grotesquely small in proportion. The massive and powerful folds of the robe also contrast strikingly with the robe of the figures in Nos. 6 and 8. No. 9 and 10 were both produced in provincial areas far from the center of culture in the capital, and are unusually fine examples of works showing the iconography of the Heian period. As provincial pieces they provide an important and interesting comparison with the work produced for temples in and near the capital.

The works of Jōchō in No. 12 are some of the most beautiful examples of a fully Japanese expression in Buddhist sculpture and represent the apogee of Heian period sculpture. These five pieces are also examples of Japanese relief sculpture, which is very

rare. The modeling of these figures shows a softness, grace, and strength of composition not present earlier and again lost in the mannerism of late Heian work.

The works of the masters Kaikei and Unkei typify the style of the Kamakura period. No. 14 is an early work of Kaikei, and clearly shows the influence of Sung China and the strong concern with realism present in this period. Nos. 14 to 18 clearly display the increasing inclusion of realistic detail in the sculpture of Kaikei and Unkei, and more so in that of Unkei's son Tankei.

The sculptural portrait of No. 19 typifies a peculiarly Japanese concept very much in vogue in the works of the Kamakura period, and a portrait technique also found in painting. The robes of all these sculpture portraits are stereotyped and almost identical in form; only the face is treated realistically, with the result that the detail and expression of the face alone is emphasized.

Animal sculpture in Japan is extremely rare. Though not typical of what could be called a mainstream of sculpture, the two deer figures of No. 20 are perhaps the best examples of Japanese animal sculpture.

Painting

The painting from the periods preceding the Heian are so rare and fragile that their inclusion in a traveling exhibit was not possible, with one noteworthy exception here. However, the first true Japanese expression in painting did not fully manifest itself until the Heian period. Included here are some of the best examples of this early expression.

The Amida Raigō (No. 24) is a subject very rare in China but common in Japan. This type of painting was also used in funerary ritual, and as such, may be thought of as a practical utensil, not just a formal icon. Since such pictures of Amida Raigō were to be seen and employed as a part of human activity, they were made to be appealing and, as such, are much more Japanese in expression than the more distant, sacred icons of a temple. The calm, gentle, almost leisurely grace of this well-composed Heian period trinity differs strikingly from the same theme painted in the Kamakura period. In the later paintings, Amida is shown as if dashing down from the Western Paradise; the Kamakura paintings have received the name "Rushing" Raigō accordingly.

The portrait of a priest of No. 25 is much more Chinese in concept than the preceding painting, and is one of the oldest extant examples of such portraiture in Japan. Though the pose and face have a distinct intensity, the entire work is aloof, distant, and formalized.

The portrait of an aristocrat of No. 26 is the same kind of uniquely Japanese concept as seen in the sculpture of No. 19. Again, the robes of such portraits are treated as flat areas and are almost identical, while the face is depicted with great attention to realistic detail. The lines of the face are soft and fine; the style is in the Japanese *Yamato-e* tradition. The robes of the priest portrait (No. 27) are also stereotyped, but here the face strikingly displays the artist's preoccupation with realistically capturing his subject.

No. 28 is the most famous portrait in the Zen painting tradition. Here, realism is fully pursued, but, in contrast to the previous portraits, the style is parsimonious, simple, and sketchlike. Nos. 28 and 29 are later works, but show a development of the portrait tradition into a simple, lively ink and wash style.

The primitive, essentially Chinese-style, illustrated sutra of No. 30 is the oldest painting in this collection. Although it is twelve hundred years old, its state of preservation is amazing. The twelfth century sutra of No. 31 was copied over simple, entirely Japanese-style line drawings of great elegance. The two illuminated sutras make an interesting contrast in style and concept.

Nos. 32 to 38 are some of the finest examples of the different types of emakimono (hand scrolls), the genre most typically Japanese in expression and style. These seven Kamakura period works can be classified by subject matter into religious, satirical, historical, fictional and biographical narrative, and humorous genre types. The styles of painting do not entirely follow these categories, however. The historical narratives are done with great attention to detail and are generally stiff and mannered. The fantastic scenes of hell (No. 32), the caricature scroll (No. 33), and the Eshi-no-Sōshi scroll (No. 38) share a similar style of flexible, lively, ink brushwork. The Ippen Shōnin Eden (No. 36), illustrating the life of Priest Ippen, is extremely important for its beautifully detailed depiction of Kamakura period provincial life and for its excellent landscapes. These emakimono represent the most typical examples of the *Yamato-e* tradition, and since they almost all depict Japanese themes, the painting style and composition are totally Japanese and quite different from the more distant, imported painting traditions. The detail of No. 38 shows the type of brushwork characterizing many makimono.

The Muromachi period saw the first Japanese developments of ink monochrome painting in the Zen tradition, characterized by economy and brevity of line and brushwork, the importance of unpainted space, and the inclusion of an inscription as an integral part of the composition. The three examples here (Nos. 39–41) were all painted by Zen priests, who used their art as a means of personal expression. The works of some of these talented amateurs often have as much appeal as the elegant paintings of the trained professionals.

The ink momochrome landscape reached one of its highest peaks in the Muromachi period in the works of Sesshū. The Sesshū paintings here illustrate two of his styles. No. 43 shows two sections of a small landscape scroll, while No. 44 is an on-the-spot sketch that clearly shows Sesshū's genius in using ink in a spontaneous composition.

The Momoyama period saw an entirely new development in the history of Japanese painting. With the building of large castles and palaces at this time, what might be called architectural painting developed. These often very large works decorated the walls, sliding panels and doors, and standing screens of castles, palaces, and temples, and often were enriched by embellishment or entire backgrounds of gold leaf. No. 48 is an excellent example of one of these opulent works, while the screens of Nos. 49 and 50 show the same large format used for ink monochrome compositions. The large

decorative screen format was also often used for the genre painting popular in the Momoyama-early Edo periods. Nos. 53 to 56 represent four types of genre screens: individual figures, scenes of Kyoto, depictions of Westerners, and narrative scenes.

The first half of the Edo period saw the emergence of three artists of great originality who have deeply influenced painting in Japan to this day. The scroll fragment (No. 58) by Kōetsu shows perhaps one of the most beautiful examples of the organic fusion of painting and calligraphy. Sotatsu's colourism and unfettered orginality are displayed at their best in No. 59, while No. 60 shows his mastery also of the subtleties of the ink monochrome medium. The third master of this decorative style, Kōrin, is represented in No. 62. Though this screen of autumn grasses does not have the immediate appeal to Western taste of Nos. 58–61, a brief study will reveal the excellence of composition and the profundity that underly this decorative painting.

The literati artists arising in the eighteenth century could not be said to share a single style other than their common adoption of one type of Chinese painting. They are noted most for their individuality and eccentricity, both in their art and in their personalities. As a whole, literati painting forms one of the more fascinating aspects of Japanese art, and the four literati works here (Nos. 63–66) are by four of the most skilled and most eccentric masters of the literati circle.

Applied Arts

A discussion of the various techniques, relation of decoration to form and usage, the limitations and freedoms of the various materials, etc. of the applied art objects would be too lengthy here. Though a photograph is not a good substitute for handling the actual object, each of the pieces included was chosen with the same criteria of quality and representation as the fine art objects, and each is an important study piece.

Among the metal work, the openwork pieces of Nos. 73 and 74 are exquisite examples of twelfth century metal craftsmanship. Also, the mirrors (Nos. 76–78) display a singularly Japanese handling of the decoration within the round shape.

In concept and execution the painted leather pendants of No. 85 should be considered among the best examples of Heian period Buddhist painting. Japanese ceramics need no introduction; included here is a brief but important display of the highlights of pottery and porcelain craftsmanship and design. The textiles displayed deserve special attention because they are an unprecedented collection of early costumes and pieces of apparel in a perfect state of preservation, and because they display uniquely Japanese concepts of colour, composition, and design.

Bunsaku Kurata
Curator in Chief
Tokyo National Museum

Source of Objects

His Majesty The Emperor of Japan

Imperial Household Collection, 38

Official Institutions

Kyoto Municipality, 53
Kyoto National Museum, 19, 29
Nara National Museum, 27, 32
National Commission for Protection of Cultural Properties, 30, 31, 47, 60, 104
Tokyo National Museum, 22, 23, 28, 34, 36, 40, 41, 42, 44, 50, 55, 56, 58, 61,
63, 68, 78, 81, 87, 90, 91, 94, 95, 96, 98, 100, 102, 105, 107, 112a, 112b,
112c, 112d, 113a, 113b, 113c, 113d, 114a, 114b, 114c, 115b, 116b, 116c.

Buddhist Temples and Shinto Shrines

Byōdō-in, Kyoto, 12
Chishaku-in, Kyoto, 48
Daihōon-ji, Kyoto, 15
Daisen-in, Kyoto, 46
Emman-in, Shiga, 67
Gangō-ji, Nara, 6
Hachimangū, Aomori, 83
Hōryū-ji, Nara, 1, 2
Ichijo-ji, Hyōgo, 25
Ishiyama-dera, Shiga, 37
Jigen-ji, Fukushima, 88
Jingo-ji, Kyoto, 26
Jinshō-ji, Shiga, 74
Jōshin-ji, Shiga, 77
Kairyūo-ji, Osaka, 75
Kanshin-ji, Osaka, 5
Kanzeon-ji, Fukuoka, 10
Kōdai-ji, Kyoto, 115a
Konjiki-in of Chūson-ji, Iwate, 73

Kōryū-ji, Kyoto, 11
Kōzan-ji, Kyoto, 20, 33
Kyō-ō-gokoku-ji, Kyoto, 85
Myōhō-in, Kyoto, 16
Niutsuhime, Jinja, Wakayama, 79
Nukisaki Jinja, Gumma, 76
Oka-dera, Nara, 4
Onjō-ji, Shiga, 13
Saikyō-ji, Shiga, 70
Sambō-in, Kyoto, 59
Sekkei-ji, Kōchi, 17
Shinren-sha, Ishikawa, 24
Shitennō-ji, Osaka, 8
Shōchi-in, Wakayama, 9
Shōkoku-ji, Kyoto, 49
Yusuhara Hachiman-gū, Ōita, 3
Tōdai-ji, Nara, 7
Yūshi Hachimankō, Wakayama, 21
Zuishin-in, Kyoto, 14

Private Museums and Individuals

Mr. Kazusue Akita, Tokyo, 84
Mr. Nagatake Asano, Tokyo, 43, 57
Atami Art Museum, Shizuoka, 52, 108
Eisei Bunko Foundation, Tokyo, 86
Daihiko Institute, Tokyo, 116a
Gotō Art Museum, Tokyo, 92
Mr. Moritatsu Hosokawa, Tokyo, 35, 103
Mr. Ryōichi Hosomi, Osaka, 45, 80, 111
Mr. Sazō Idemitsu, Tokyo, 101
Mr. Morio Ishijima, Tokyo, 110
Mr. Sōtarō Kubo, Osaka, 71
Mr. Renzo Maeda, Kanagawa, 72

Maeda Ikutokukai Foundation, Tokyo, 39, 82, 117
Mr. Hiroaki Manno, Osaka, 97
Mr. Yasuzaemon Matsunaga, Kanagawa, 51
Mr. Yōichirō Nakamura, Tokyo, 18
Nezu Art Museum, Tokyo, 109
Mr. Sōichirō Ōhara, Okayama, 65, 66
Mr. Tsūsai Sugawara, Kanagawa, 89
Suntory Gallery, Tokyo, 62
Seikadō Foundation, Tokyo, 54
Tokiwayama Bunko, Kanagawa, 69
Mr. Hikotarō Umezawa, Tokyo, 93, 99, 106
Mr. Kōzō Yabumoto, Hyōgo, 64

Table of Japanese Art Periods

Prior to the mid-sixth century a.d.	Pre-Buddhist Age
538-645	Asuka Period (Suiko)
645-794	Nara Period
645-710	EARLY NARA PERIOD (Hakuho)
710-794	LATE NARA PERIOD (Tempyo)
794-1185	Heian Period
794-897	EARLY HEIAN PERIOD (Jogan)
897-1185	LATE HEIAN PERIOD (Fujiwara)
1185-1334	Kamakura Period
1334-1392	Nambokucho Period
1334-1573	Muromachi Period (Ashikaga)
1573-1615	Momoyama Period
1615-1868	Edo Period (Tokugawa)
1615-1716	EARLY EDO PERIOD
1716-1868	LATE EDO PERIOD
1868-to date	Modern Japan

Introduction

Pre-Buddhist Age (Prior to a.d. 538)

The native arts of Japan, prior to the introduction of Buddhism in the middle of the sixth century, are represented by numerous accidental finds as well as controlled excavations of prehistoric and protohistoric sites, which include many burial mounds. The excavations have brought to light earthen vessels, large bronze bells of a type known as *dotaku*, and an important group of clay figures called *haniwa*. These last include representations of human beings, horses and other animals, as well as models of houses and various types of buildings. Relics such as armour, horse furniture, and personal ornaments of gilt bronze have also been found. Some of the objects, particularly the bronze mirrors recovered from burial mounds, are locally made but show the influence of Chinese as well as Korean art, while other objects were clearly imported. These finds provide valuable evidence which suggests that, even in ancient times, Japan was closely linked with the continent by way of Korea.

The greater part of the prehistoric period, as far back as the fifth millennium b.c. and extending approximately to the beginning of the Christian era, is termed Jōmon, a name derived from a style of pottery decoration which used impressions of twisted cords. The Jōmon period was succeeded by the Yayoi, called after a district by that name in Tokyo. The Yayoi culture lasted only a relatively short time. It was superceded in the Yamato plain, southeast of Osaka, by the appearance of great tumuli, raised over the graves of eminent personages, in a manner derived from Korean prototypes. Clay cylinders, or *haniwa*, were placed close together around their perimeters. The tops of these *haniwa* were decorated with figures of warriors, women, or animals, and it has been suggested that these clay models may have been substitutes for humans and animals who might have been immolated with a deceased noble.

Asuka Period (a.d. 538–645)

Following the founding of a new capital of Japan in Yamato near Nara, the government established diplomatic relations with the Three Kingdoms of Korea, which were vying for control of that peninsula. Japan came to the aid of Paekche (Kudara, the southwest kingdom), and with the resultant cultural exchange, the first Buddhist scriptures were brought to Japan in a.d. 538. This foreign religion soon found a foothold, for it brought with it a sense of security to the reigning house. Monks and craftsmen were invited to immigrate to provide the objects of worship necessary to the new religion. They came from both Korea and China.

Prince Shōtoku, the nephew and Regent of the Empress Suiko, embraced Buddhism at the end of the sixth century, and it was largely due to his fervor that the great temple of Hōryū-ji was founded. In this temple there still are many great treasures, including the Kudara Kannon, the Tachibana Shrine, the Tamamushi Shrine, and the great gilt bronze Shaka Triad. The Apsaras and Phoenix (No. 1) are from the Golden Hall of this temple.

One of the earliest schools of sculpture was that named after Tori Busshi, who was a descendant of a Chinese immigrant. The Kannon (No. 2) reflects the Tori style.

Early Japanese sculpture was very much influenced by that of Northern Wei China (a.d. 386–535). However, it was altered as it passed from China to Japan by way of Korea, and in the Asuka period elements that are distinctly Japanese are readily evident. Although the archaic smile, the accented head, hands and feet, and the symmetrical saw-tooth draperies appear as in the other cultures, the mark of the Asuka version manifests itself in a more personal manner. The images in wood and bronze communicate more directly to the worshipper and reveal a greater concern with plastic qualities and an understanding of the deity as a spiritual being rather than an abstract conception. The art of bronze casting, probably a *cire perdue* technique, was rapidly mastered, and a woodcarving technique of equal skill was developed.

Little painting of the period survives, but it is known that the continent strongly influenced its development. The Tamamushi Shrine in the Hōryū-ji is the outstanding example of this, for it is embellished with lacquer and an oil medium foreign to Japan, which was rarely used after this period.

Nara Period (a.d. 645–794)

T'ang dynasty China exerted a great influence on the culture of Japan, for it was the source to which they turned for guidance in the ways of the newly accepted religion. In addition to this, the level of cultural achievement of T'ang China was such that it gave inspiration, both lay and secular, to all its neighbors. The artists of Japan were overwhelmed by the beauty and richness of everything that they saw in that distant land and all that was brought back. Such an impact had many facets: city plans, government organization, dress, food, music, dance, skills and crafts, which all took on a T'ang cast.

Although the borrowings were many, the Japanese, with the passage of time, reinterpreted them, abandoning some and refining others.

The capital was moved to Nara in a.d. 710 and the city closely copied the grid plan of Ch'ang-an, the T'ang capital. Nara remained the political and cultural center until the close of the eighth century.

With the official acceptance of Buddhism, its power and influence grew. New sects came into being, and temples to accommodate the worshippers were constructed in large numbers. Much of this activity was due to the devout Emperor Shōmu, the great patron of Buddhism. He ordered temples, subordinate to Tōdai-ji, the Official Temple, to be raised in every province. Within the Tōdai-ji was the colossal *Daibutsu* of bronze.

Buddhist deities in bronze, wood and the new media of dry lacquer and clay were commissioned to fill the temples. Many sculptures survive and can be seen in the great temples of Nara. Their style, although showing T'ang influence, is more natural. The poses are less formal and the features more lifelike; however, they remain idealized and heroic. The Nara sculptor often imparted to his work a youthful spirit.

Few Nara statues are ever included in an exhibition because of their fragility and sanctity. Their style can, however, be seen in the gilt bronzes from the Oka-dera and Kanshin-ji (Nos. 4, 5).

In addition to sculpture, religious images were painted on walls and on other materials such as paper and silk. The murals in the Kondō of the Hōryū-ji lost in a fire of a.d. 1949 were the finest examples. Iconographically and stylistically these murals were inspired by Indian prototypes transmitted eastward through Central Asia, China and Korea. Chinese influences are evident in the Kichijō-Ten (Goddess of Good Fortune) of Yakushi-ji and the many paintings in the Shōsōin, the Imperial Repository, housing the personal collection of the Emperor Shōmu.

On the sutra called Inga-kyō, the earliest illustrated handscroll to survive (No. 30), scenes from the life of the Buddha are portrayed in an archaistic style which reflects the influence of Chinese religious paintings of the sixth century.

The technical accomplishments of the Nara period are also evident in the metal work and ceramics which were produced.

Heian Period (a.d. 794–1185)

The court moved in a.d. 794 from the Nara region to the area of present-day Kyoto called Heian-kyō, the City of Tranquil Peace. T'ang influence continued to be felt, and this great capital, like Nara, was constructed along Chinese lines.

Interest in the continent became more and more secularized. The court turned to that which was foreign not only for its religious content, but for its inherent beauty and novelty. Arts, letters and manners in the Chinese style became the fashion of the day. Not only did material things succumb to this persuasion but also thought. A period of grandeur flowered and life at court was one of gracious decorum and refined elegance. That which had been Chinese was made to suit the Japanese environment and temperament. This was a period when contests in poetry, painting, incense identification, and football flourished. The competition of nobles for positions of prominence went beyond mere physical prowess and extended to cultural competition. Thus it was in the Heian period that great contributions were made to the arts.

The renowned Buddhist priests Kōbō Daishi and Dengyō Daishi introduced the Shingon and Tendai sects of esoteric Buddhism respectively to Japan early in the ninth century. These new factions of the faith brought with them a huge pantheon of deities and complicated iconography which provided the painters and sculptors with fresh sources of inspiration.

Images made of wood carved from a single block, the *ichiboku* technique, were produced in numbers to supply the demand of the many newly built temples and to replace those of past periods which had been lost or damaged. The sculpture of the period often lacks the litheness of its predecessors. It has a tendency to be bulky and the figures are full faced and usually heavily draped (Nos. 6, 7). They appear to radiate a

great sense of outward calm and at the same time are austerely withdrawn as symbols of the power of Buddha. At times the influence of T'ang China is unmistakable (No. 10). Shinto, the native religion, which in the past had only relied on symbols to represent its deities, now turned on occasion to treating them in the Buddhist manner (No. 11).

As T'ang power receded in the tenth century, contacts with Japan were reduced until formal diplomatic exchange ceased. The period of voluntary isolation lasted three hundred years and served as a blessing in disguise, for the nobility of Japan began to assert their own native character, which was in contrast to the foreign. The Fujiwara clan, founded by Fujiwara-no-Kamatari, took over as Premiers ruling in the name of the Emperor. Not only were they active politically, but they also became active patrons and leaders of the arts. The period between the ninth and mid-twelfth century is often termed Fujiwara.

Not all Japanese preferred the esoteric sects. The rituals were so involved and the iconography so complex that many nobles turned to the Amida cult, whose path to salvation is simple, for the Western Paradise of Amida is open to all who invoke its name. Once again the Japanese inclination for personalizing a deity and making it a part of one's life is evident. The Byōdō-in Hōōdō (Phoenix Hall) designed and ordered built in a.d. 1053 by Fujiwara Yorimichi was one man's effort to bring the glory of Amida within reach. The heavenly musicians and the priest in prayer (No. 12) are from that structure which in plan resembles a phoenix and thus serves as an image of Paradise. Placed inside the Hōōdō is a large wood lacquered and gilded image of Amida by Jōchō. In making it the sculptor introduced a new method, for to create a figure of great scale, he had to use more than a single block, and the Amida is an assemblage of carved pieces fitted together, leaving the center hollow. From the mid-eleventh century this technique became the accepted practice. In line with the grandeur of the age it became the vogue to embellish sculpture with polychromy and *kirikane* (cut gold leaf). This treatment makes one less aware of the plastic qualities of the sculpture and leads one to concentrate on the graphic interpretation of the object.

The same techniques were applied to Buddhist paintings. Very thin and delicate lines (Nos. 21, 22, 25) and rich contrasts in colour and *kirikane* (No. 23) filled in the outlines and created small patterns of beauty. Even the calligraphy of sutras (No. 31) and poems (No. 69) bear evidence to the refined taste of the Heian period. After the break with China the artists turned to their own landscape, and favorite sites of great beauty began to appear in their paintings.

With the development of an affluent society centered about the court there was an increase in the demand for wall paintings, kakemonos and screens to decorate the homes of the nobles. Conventions borrowed from the Chinese were replaced by native ones. Literature became important and it took on a more purely Japanese character. Poetry and novels were circulated and texts which were very popular such as the *Genji Monogatari*, written by the eleventh century lady-in-waiting Murasaki Shikibu, were illustrated in the newly developed *Yamato-e* (Japanese picture) style of painting. The subject matter of this

style is normally Japanese; the figures wear native costume and appear in local settings. It is a form of genre painting.

Makimono (handscrolls) were produced in quantity to illustrate the increasing literature. The texts alternate with illustrations and the majority of them were done by artists of the *E-dokoro* (The Imperial Painting Academy). Painting catered to the tastes of the nobles and mirrored the world in which they lived. The priest artists at times sounded a note of warning against the evils of the prosperous society as in the Jigoku-zōshi (Scroll of Hells, No. 32). In contrast, the court painters provided unrelated popular background decoration for the scriptures (No. 70), which made the religious text more appealing. The story was all important to the *Yamato-e* artist, and to relate as much as possible he made use of panoramic perspective and removed the roofs of structures so that all that went on within was visible. The pigments such as malachite, azurite and vermillion were bright and carefully placed in the composition to make controlled decorative patterns.

Heian decorative arts, especially when commissioned for temples (Nos. 73, 74, 85) and the court, reflect the devotion to rich and flowery ornamentation in this period.

Kamakura Period (a.d. 1185–1334)

The aesthetic elegance and the aristocratic refinement of the cloistered Heian court was too romantic and detached from practical realities to last. By a.d. 1185, Minamoto-no-Yoritomo, after bloody campaigns, won victory over his rivals and established a military *bakufu* (government) at Kamakura. A new power elite ruled Japan. Efficient in administration, austere in taste and anxious to rebuild the land, the *bakufu* ordered the great temples of Nara reconstructed and Buddhist sculptures restored. The sculptors in Nara were busy with their new commissions. The school of Unkei and Kaikei revived the style of the Nara period, but their works were nonetheless modified by an earthy realism, an interest in surface detail and a certain dramatic intensity (Nos. 14, 15, 16, 17). They reacted against the prevailing style from the Heian period toward a new naturalism and drew inspiration from the ripples of influence felt from Sung dynasty China. The burst of creative activity ended by the fourteenth century, and sculpture degenerated into a repetitious exaggeration of muscle and drapery, or the uninspired re-creations of the tradition.

Kamakura Buddhist painting was dramatic with movement and asymmetry, but followed the style established by Heian painters. Portraiture reached new heights in this age of heroic figures and artistic realism (Nos. 26, 27). Isolated from a declining Sung China, and menaced by Mongol invasions, Japanese creative activity turned to native traditions for inspiration. Japanese themes and national heroes absorbed the interest of artists. In secular painting, under the strong influence of *Yamato-e*, narrative scrolls illustrate romances (No. 34), legendary histories of Buddhist temples or Shinto shrines (No. 37) and the biographies of famous monks (No. 36). Even satires on human foibles

were drawn. In the Kōzan-ji handscroll, Chōjū Giga (No. 33), the artist caricatures in a merry way the indiscretions of monks and men. Drawn with wit and vivacity, these handscrolls relate the action and excitement of battles, the daily life of common folk, the natural beauty of mist-shrouded hills or snow-laden pines. All this is composed with the dramatic sense of a narrative with its climax and denouement. Linear rhythms and rhythmic patterns serve to unite or pace the movement from scene to scene.

Many fine examples of decorative art remain from the Kamakura period. Boxes for a multitude of uses, and bronze mirrors for the toilet, kettles for the tea ceremony, armour, sword furniture and lacquer saddles of exquisite workmanship were created for the daily use of their fortunate owners. Stupas, bells and other objects of very fine quality were made for the service of the temple and the shrine. Though this was not an age noted for great ceramics, utilitarian pottery was made which at times is strikingly beautiful in its rugged simplicity.

Muromachi Period (a.d. 1334–1573)

During the fourteenth century, following the fall of the Kamakura military government, Japan was again torn by civil strife. This period is commonly known as Namboku-chō and terminated with the ultimate victory of the Ashikagas, whose leader hereafter took the title of Shogun and ostensibly ruled in the name of the Emperor. The Emperor continued to live in Kyoto, but all power was vested in the Ashikaga rulers, who were the undisputed leaders of the country. They lived in the Muromachi district, and despite incessant warfare among rival clans continued their predecessor's policy of patronage and encouragement of the arts. They built villas of great elegance for retirement, relaxation and the fashionable pastimes, such as the tea ceremony which had been introduced earlier from China. Typical examples are the Kinkaku-ji (Golden Pavilion) and Ginkaku-ji (Silver Pavilion), buildings which also served as places of retreat from the affairs of state. Zen Buddhism (Chinese: Ch'an), which had earlier been introduced from China, had been patronized by Japan's military leaders since early in the thirteenth century, but now assumed a prominent position in the culture of Japan. Zen taught that Buddhahood lay dormant within every individual and could be realized by contemplation and self-examination rather than by the complex meditative practices prescribed by other sects. The directness and simplicity of Zen appealed to the Shoguns, who found peace of mind in the purity of the ritual and the frugality of its way of life. The absence of religious ceremony and emphasis upon simplicity led to an increasing interest in *sumi-e* (black-and-white ink painting), a technique frequently practiced by Zen priests, who had learned it from their Chinese teachers. *Sumi-e* was regarded as a reflection of Zen, and the direct, even austere, qualities of this technique found great favor among the Ashikaga rulers. The paintings by the monk painters Mokuan, Kaō and Bompō (Nos. 39, 40, 41) are excellent examples of this technique. They reflect the spirit of Zen in their swiftly and economically drawn compositions, and contrast sharply with the decorative Heian art.

Many of the Zen monks occupied positions of great influence in the Ashikaga government and freely advised the Shoguns. Some of the priests and painters, notably the celebrated Sesshū, travelled to China, studying paintings in the Sung and Yüan style. They returned, bringing with them large numbers of Chinese paintings which were admired and eagerly collected by the Shoguns and their court. These paintings, drawn in fluid lines and graded washes of ink, ordinarily expressed a romantic, pensive mood, and served as an accompaniment for contemplation and the tea ceremony.

The style and technique of these paintings were re-interpreted in distinctly Japanese and highly individual terms, as illustrated by the works of Shūbun, Sesshū (Nos. 43, 44) and their contemporaries. While landscapes were the favorite themes, flowers, birds (No. 45), priests or sages, and monkeys (No. 47) were also popular subjects.

It was the great achievement of Kanō Motonobu (No. 46) to combine a simple ink style with bright, thick *Yamato-e* colours. He is thus regarded as the founder of the Kanō school, which subsequently became the "official style" of painting under the patronage of the Shogunate.

The tea ceremony, mentioned previously, came to be a major factor in the art and culture of Japan. It is a highly organized ritual, performed according to strict rules, including specifications for the utensils to be used. As a result, many of the artisans began to turn out bowls, lacquers and other objects for it (Nos. 89, 94). The tea ceremony has persisted into present-day Japan and still exerts a considerable influence upon aesthetics and taste.

Momoyama Period (a.d. 1573–1615)

Oda Nobunaga (a.d. 1534–1582), the great warrior, finally displaced the Shogun, Ashikaga Yoshiaki, in a.d. 1573 and brought an end to that family's control of the government. Following this, a power struggle occurred in which the feudal lords took sides until control was firmly grasped by Nobunaga and in turn by his successors, Toyotomi Hideyoshi (a.d. 1136–1598) and Tokugawa Ieyasu (a.d. 1542–1616). These three, in addition to being military men, were patrons of the arts. The period began with turbulence, but later relative peace came to Japan and the country was unified. The name for the era is taken from the palace which Hideyoshi built in a.d. 1593 at Momoyama, near Kyoto.

Although the battles were over, the feudal lords remained in competition. However, they now directed their energy towards rivalry in court favor, love and the arts. They built massive castles and villas with great halls, and each lord tried to surpass his neighbor in the scale of his establishment and the quality of its interior decor. Artists and artisans were pressed into service to decorate these structures. The common man's lot had improved, for the land was relatively prosperous. Now not only the nobility but also the townsmen and farmers became interested in the fine arts. A way of showing one's wealth was to utilize elaborate carving and as much gold and silver as possible in a

decorative scheme. Elegant opulence was the keywork for Momoyama period design. Artists of various schools produced paintings for the walls and screens. Many were done by followers of the Kanō tradition.

The tastes of Eitoku (a.d. 1543–1590) and his pupil Sanraku (a.d. 1559–1635) were catholic, and they painted everything from Chinese themes, birds and flowers, the seasons and festivals to genre subjects. The only controlling factors were the size of the area they were to decorate and the dim light in which the painting would be viewed once it was completed. This latter factor conditioned the Kanō artists to use both strong brushwork and colours.

Paintings in the Momoyama taste were not confined to the Kanō school, for independent artists were also active. The Hasegawa school was led by Tōhaku (a.d. 1539–1610) and produced panels of great richness in many colours (No. 48) as well as those of a subdued and peaceful nature which harken back to the *sumi-e* tradition of the previous era (No. 49). Kaihō Yūsho (a.d. 1533–1615) was another artist who developed his own style (No. 50).

Influence from the Western world grew in importance during the Momoyama period. The Portuguese first set foot on Japanese soil in a.d. 1542 with their landing at Tane-ga-shima, and soon after, they as well as the Dutch and other Westerners penetrated to Nagasaki and Sakai. The Japanese were fascinated by the strange looking foreigners and began to portray them in screens known as *Namban* (Southern Barbarian) type (No. 55). The decorative arts followed the general Momoyama trend toward sumptuousness. Metal fittings, fabrics and lacquers were usually richly ornamented in good taste. Robes woven for the Noh theatre costumes, or for ordinary wear (Nos. 112a, 112b, 113a, 115a) were of the finest quality. In contrast to the grandeur of the other arts, ceramics of the period were relatively simple. The tea masters made use of humble, everyday provincial wares such as Oribe, Seto and Shino, decorating them with handsome, restrained patterns (Nos. 96, 97, 98). Thus even in ceramics, the ingenuity of Momoyama decoration is evident.

Edo Period (a.d. 1615–1868)

In a.d. 1615 Tokugawa Ieyasu triumphed over his rivals and consolidated his power to make himself Shogun. To escape the effete influences of the Kyoto court, he established his government in the remote village of Edo, present-day Tokyo. In a.d. 1637 to make his hold more secure, the third Tokugawa Shogun, Iemitsu, closed Japan to foreign intercourse except for infrequent contacts at the port of Nagasaki. This began the long period of isolation from the outside world until the arrival of Admiral Perry two centuries later. Edo grew to become the political, economic and cultural center of Japan, but Kyoto still retained its status in the arts.

The Shogun and the Kyoto court supported the official Kanō and Tosa schools of painting, which continued in an academic manner (No. 57). At the commercial centers of

Edo and Osaka the art of *Ukiyo-e* flourished. During the long period of peace, merchants prospered, though held at the bottom of the social hierarchy. These townsmen enjoyed the urban pleasures of the *kabuki* and the gay quarter, and patronized the art which portrayed these themes in paintings and in wood-block prints (No. 68).

The official encouragement given the study of Confucian ethics and philosophy, together with the availability through Nagasaki of Chinese paintings and illustrated books in the *wên jên* (literati) style, led to the development of the *Nanga* (southern paintings) or *Bunjinga* (literati) school. Ike Taiga (a.d. 1723–1776), Yosa Buson (a.d. 1716–1783) and Uragami Gyokudō (a.d. 1745–1820) were leading masters of the school whose subjective ink plays were composed into abstract expressions (Nos. 63, 64, 65).

In Kyoto, the Maruyama-Shijō school arose in the late eighteenth century as a reaction to the Kanō school. Okyo (a.d. 1733–1795), its founder, painted in a brilliant style of mannered naturalism (No. 67).

The tradition of *Yamato-e* received fresh impetus with the rise of the *Rimpa* school. The exuberant spirit of Momoyama is carried forward in the brilliant, decorative achievements of the *Rimpa* artists Tawaraya Sōtatsu (active early seventeenth century) and Honami Kōetsu (a.d. 1558–1637), and later revived by Ogata Kōrin (a.d. 1658–1716) and his followers (Nos. 58, 59, 60, 62). The artistic versatility of members of this school was so broad that they also designed lacquers, ceramics and textiles.

During the Edo period the decorative arts flourished as never before. Exquisitely potted and subtly glazed cups and bowls for the tea ceremony and fine porcelains with brilliant enamel patterns were created. The catalyst for this ceramic revolution was an indirect result of Hideyoshi's aborted Korean campaign, through which Korean potters came to Japan. They established new kilns to produce Karatsu, Hagi, Satsuma and Raku wares which were much sought by tea masters.

Since the introduction of porcelain manufacture into Japan at Izumiyama, Arita, in the early seventeenth century, the manufacture of porcelain progressed rapidly. Overglaze enameling was soon perfected by Sakaida Kakiemon (Nos. 104, 105), and porcelains with bold designs and bright colours were made by potters at the Kutani kilns (Nos. 102, 103) and those of Nabeshima (No. 106). In Kyoto, Ninsei adapted the overglaze techniques of Arita to pottery and decorated his wares with native designs.

The Edo period saw the ultimate development of Japanese costume and textile design. Chinese and European techniques learned in the Momoyama period and the invention of new methods of dyeing like *yūzen* led to the production of brilliantly decorated gowns in gorgeous colour and patterns.

Sculpture

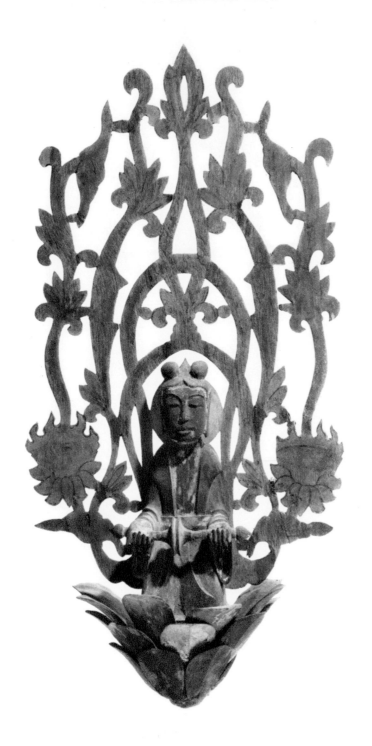

1) Apsaras and Phoenix

Asuka period, seventh century.
Wood, polychromed. Apsaras, Height 19",
Phoenix, Height 13".
Hōryū-ji, Nara.
Registered Important Cultural Property.

Over the three main groups of sculpture in
the Kondō (Golden Hall) of Hōryū-ji are
suspended polychromed wood canopies.
They are in all likelihood a translation
into wood of the silk and tapestry canopies
of India and Central Asia. These had been
copied in stone by Chinese of the Six

Dynasties period and were known by the
Japanese. The central and west canopies date
from the seventh century whereas the east
canopy is a replacement, for the original col-
lapsed in a.d. 1233. The Apsaras and
Phoenix described below are from the
west canopy.

The polychromed canopies are square and
roof shaped and are embellished with carved
wood apsarases, angel-like heavenly beings
playing musical instruments, and phoenixes.
In the lower area is a single row of
phoenixes; above are apsarases alternating
in a double row.

The apsarases, seated on lotus flowers,
serve on this canopy as a heavenly symphony
and play musical instruments such as flutes,
drums and harps. The one in the exhibition
plays cymbols.

The rectangular face is full and delicately
carved. The lips are accented and the eyes
barely open while the hair is parted in the
center and dressed in two knots on top of the
head. There is little modeling and only
the basic features are shown. The same
applies to the drapery. This style of carving
is typical of the Asuka period. Behind each
apsaras there is an openwork halo of lotus

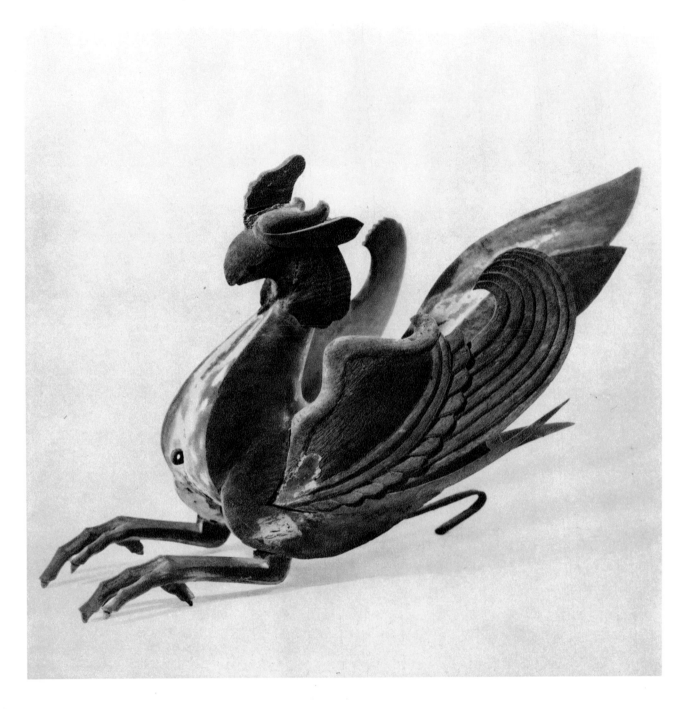

blossoms, leaves and scarves which appear to be caught in an updraft of the heavenly ether in which the figure floats.

The phoenix varies from the bird of similar name in Western mythology. In the Far East it is a divine creature and serves as an auspicious omen, heralding the advent of rulers who are destined to be great. The bird itself appears to be a combination of fowl including the pheasant and peacock. In Chinese Taoist legends the phoenix has the power to transport worthy mortals to the Western Paradise.

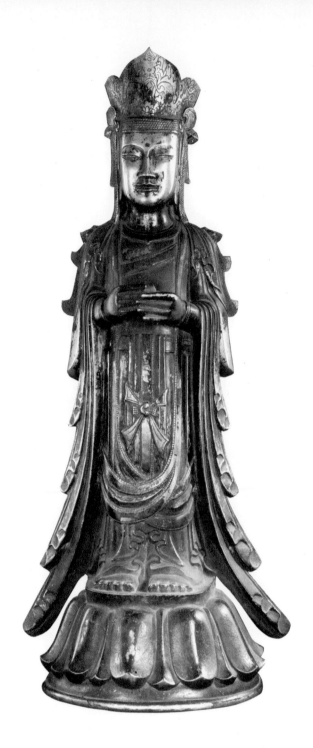

2) **Kannon Bosatsu**
Asuka period, seventh century.
Gilt bronze. Height 26¾".
Hōryū-ji, Nara.
Registered Important Cultural Property.

Kannon is but one of the many Bodhisattvas in the Buddhist pantheon and is most often associated in the Western mind with the attribute of mercy. In Sanskrit Kannon is called Avalokitesvara which means the Lord who is seen, and in Chinese, Kuan-yin. Closely associated with Amida Buddha, Lord of the Western Paradise, Kannon

reaches out to all beings and is thus one of the most popular deities. Some thirty-three manifestations of this deity are recorded in Buddhist scriptures.

This Kannon is shown standing on a lotus base and wearing a large crown with incised design, holding a sacred jewel with both hands. The drapery, with flowing scarves and cascading folds, is typical of the archaic style as seen in the famous gilt bronze central Triad in the Kondō of Hōryū-ji, completed in a.d. 623 by the sculptor Tori Busshi.

The symmetrical and stylized arrangement of the falling scarves (*tenne*) can be traced

to sixth century Chinese sculpture of the Northern Wei period. The disproportionate scale of the almond-shaped eyes, modeling of the lips, head, hands and feet, cusped necklace and flowing locks of hair falling over the shoulders, are all characteristic features of the Asuka style of the Tori school.

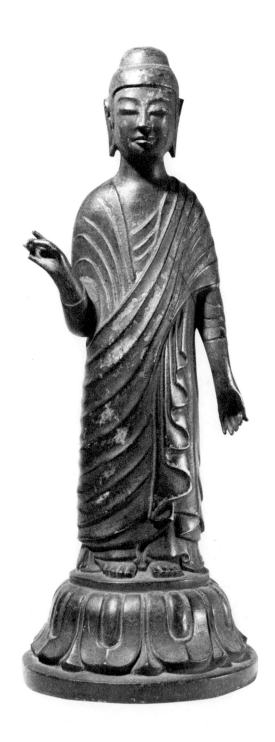

3) Nyorai
Asuka period, seventh century.
Gilt bronze. Height 14⅞".
Yusuhara Hachiman-gū, Ōita.
Registered Important Cultural Property.

This image was cast in bronze and heavily
gilded. It differs stylistically from the
Hōryū-ji Kannon (No. 2) in that the mod-
eling and stance are freer. The *mudra,*
or position of the hands, is unusual and the
identity of this Buddha thus difficult to
determine. Among the gilt bronze statues
of the seventh century this Buddha is unique
in style. It is also of great interest because it
comes from a temple in Kyushu, the
southern island, far removed from Nara,
the center of early Buddhist art.

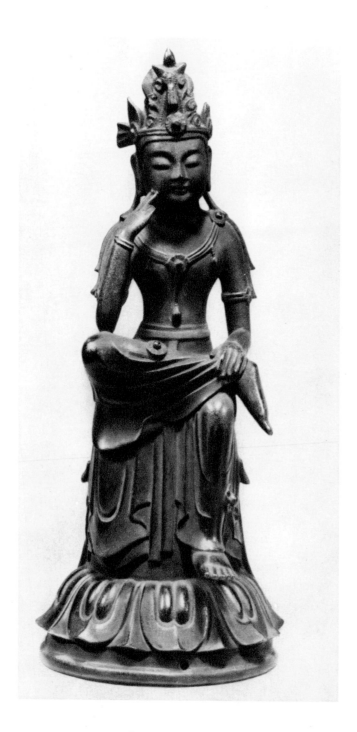

30

4) Bosatsu
Nara period, eighth century.
Gilt bronze. Height 12⅜″.
Oka-dera, Nara.
Registered Important Cultural Property.

The Bosatsu is seated in a position known as *hanka-shiyui,* with the left leg pendant, the right crossed resting on the left knee. The left hand rests on the ankle and the fingers of the right hand lightly touch the right cheek. This posture is believed to represent the position assumed by Prince Siddharta, later the Buddha Shaka, when he sat in contemplation prior to his enlightenment. In Japan, the pose was popular in the Asuka and Hakuhō periods. Miroku (Sanskrit: *Maitreya),* the Buddha of the future, was popularly represented in this position.

This figure is distinguished by smoother, fuller modeling and a more fluid, naturalistic treatment of the drapery folds than its predecessors. The facial expression, with half-closed eyes and gentle features, is at the same time more life-like, in contrast to the mysterious, brooding expressions of the Asuka style. A separate portion of the pedestal which originally supported the left foot is missing, as indicated by the hole in the front of the base.

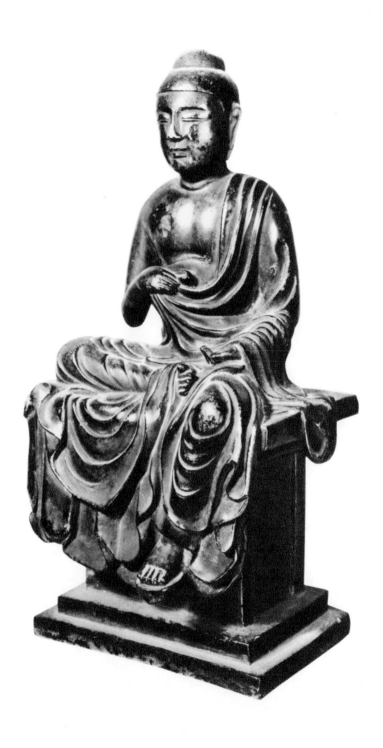

5) Nyorai

Nara period, eighth century.
Gilt bronze. Height 13⅛".
Kanshin-ji, Osaka.
Registered Important Cultural Property.

This Nyorai, including the square pedestal,
was cast as a single piece. The posture, with
the right hand holding the robe, one leg in
a horizontal position and the other leg
pendant and supported on an open lotus,
is unusual. However, the statue has been
identified as Shaka Nyorai. The treatment of
the drapery is strong and realistic, and the
image is a fine example of eighth century
bronze casting in the *cire perdue* technique.

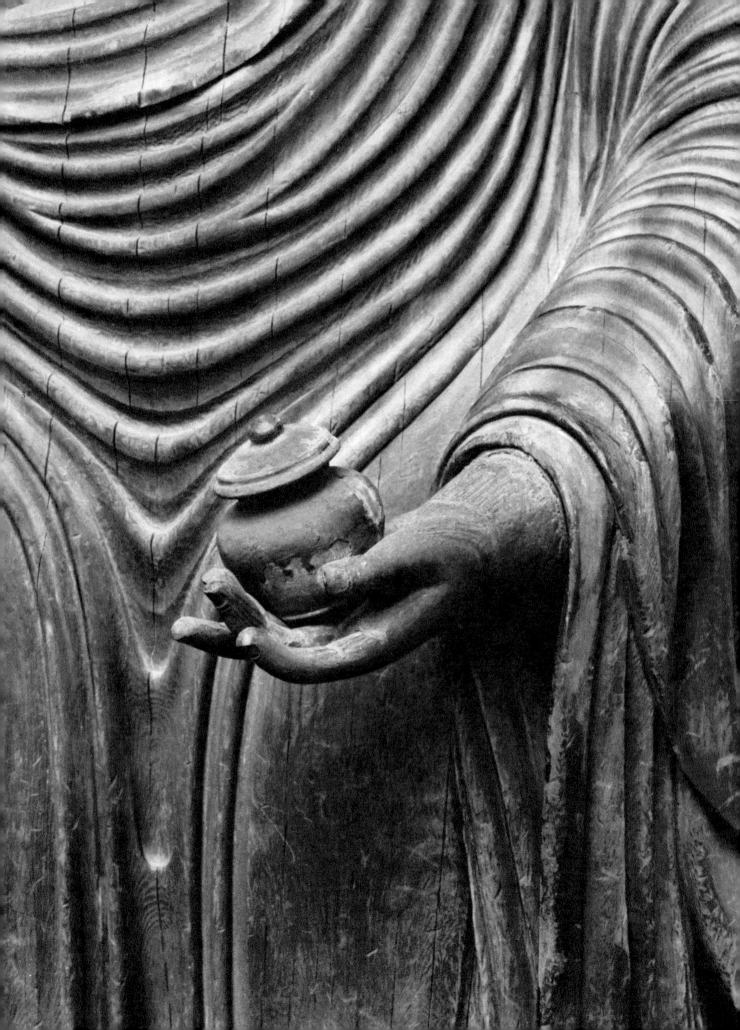

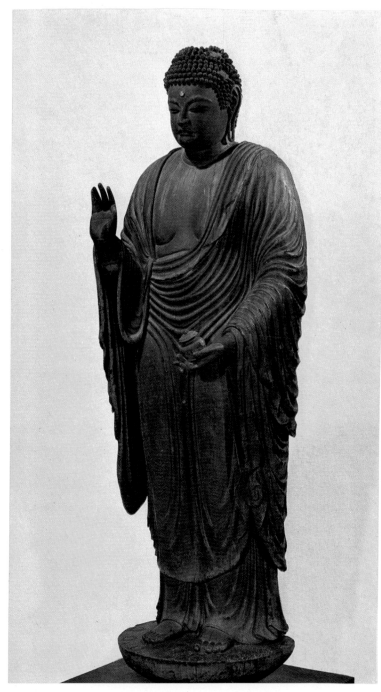

6) Yakushi Nyorai

Early Heian period, ninth century.
Wood. Height 62".
Gangō-ji, Nara.
Registered National Treasure.

The healing Buddha, Yakushi Nyorai
(Sanskrit: *Bhaiṣajyaguru*) made twelve
vows to heal the physical and mental ills of
all sentient beings. He generally holds a
medicine jar in his left hand and raises his
right arm, bent at the elbow, with the palm
of the hand outward. Worship of Yakushi
began in Japan a little later than that of
Shaka; in all likelihood during the later part
of the seventh century. An early example is
still worshipped at the Yakushi-ji. It was
dedicated in a.d. 680 by the Emperor Temmu
praying that his Consort would recover
from a grave illness.

The entire figure, including the lotus pod
under the feet, was carved from a single
block of cypress wood, the *ichiboku*
technique. Sculpture made in this manner
was hollowed out from the back to lessen the
danger of cracking and to provide a place
for dedicatory objects. The sculpture reflects
the characteristics of the Jōgan (Early

Heian) style, distinguished by heavy, broad
proportions and a solemn, austere
expression. Highly stylized drapery folds
produce a fluent linear pattern often referred
to as the "rolling wave" style. The figure has
the monumentality of the Late Nara style.
Both hands and much of the lotus pedestal
have been restored fairly recently.

Gangō-ji was one of the most important
temples of early Japan and only this im-
age and the foundation stones of a pagoda
remain as evidence of its lost glory.

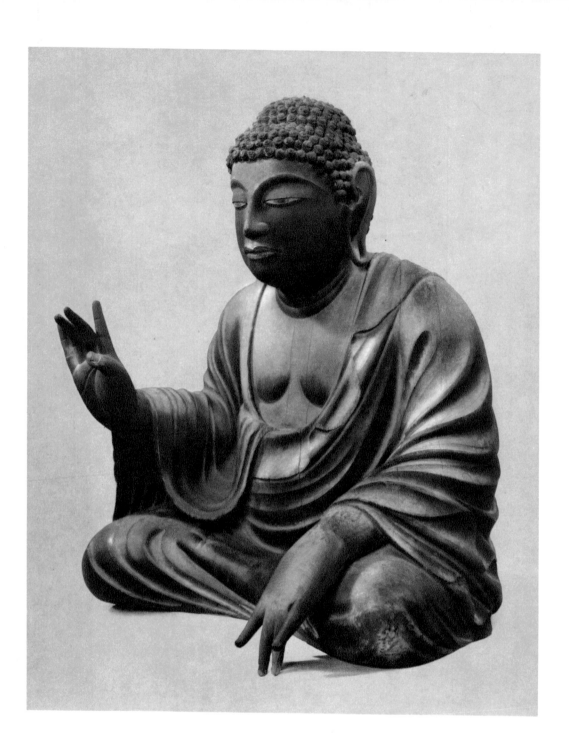

34

7) **Miroku Butsu**
Early Heian period, ninth century.
Wood. Height 15¼".
Tōdai-ji, Nara.
Registered Important Cultural Property.

Miroku, the Buddha of the Future who dwells in the Tusita heaven, will descend on earth to preach the gospel once more at the end of the present world cycle. He may be represented as a Buddha or Bodhisattva and is here shown as a Buddha, seated in *padmasana* (lotus posture). His right hand is raised in the *abhaya mudrā* ("Fear not"

gesture) and his left hand reaches down towards earth. A heavy mantle covers both shoulders, revealing only part of the strongly modeled chest, and falls in sharply defined folds of the "rolling wave" style. With the exception of the hands and spiral curls of hair resembling snail shells, the figure is carved out of a single block of Japanese cypress. Although the figure is considerably less than life-size, it conveys a feeling of great monumentality and spiritual intensity. The sweeping curve of the eyebrows, the heavy-lidded elongated eyes and the sensitively modeled lips are characteristic

features of Jōgan (Early Heian) sculpture.
There is a tradition at Tōdai-ji that this image was made as a trial model for the great bronze Buddha (Daibutsu) dedicated in a.d. 749. However, the style and craftsmanship of this small sculpture more closely resembles ninth century examples such as the Yakushi Nyorai of Shin Yakushi-ji.

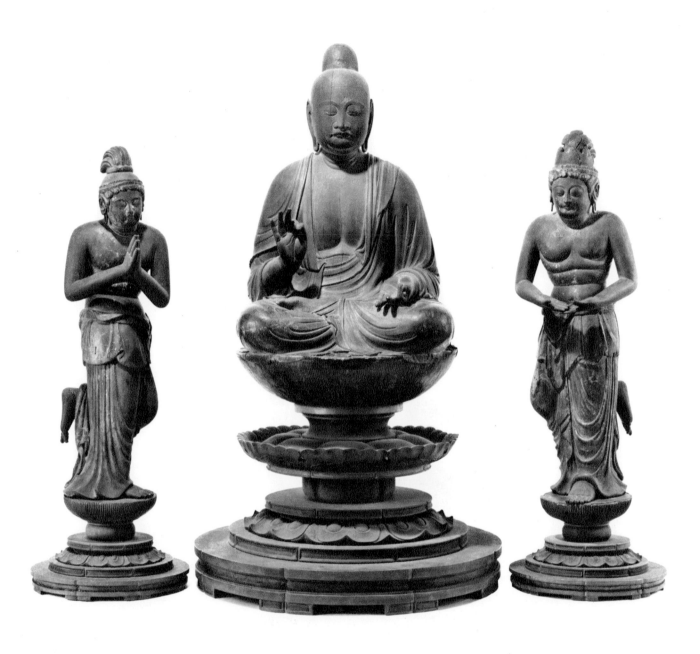

8) Amida Nyorai and Attendants
Heian period, tenth century.
Wood. Amida, Height 20″; attendants,
Height 23″ and 21½″.
Shitennō-ji, Osaka.
Registered Important Cultural Property.

Amida Nyorai (Sanskrit: *Amitābha*), the
Buddha of Infinite Light and Lord of the
Western Paradise where he receives all who
call upon his name, is represented here with
two attendants. Unlike the Yakushi from
Gango-ji, these are solid wood figures. The
softer modeling is characteristic of the

transition between early and late Heian
sculpture. The two attendants represent the
wisdom of Amida, Kannon on the viewer's
right and Seishi (Sanskrit: *Mahāsthāma-
prāpta*) on the left. The triad represents a
Raigō (Amida and his attendants descending
from heaven to welcome the dying devotee
into the Western Paradise). Kannon usually
holds a lotus and Seishi clasps his hands in
a traditional gesture of welcome. This is
apparently the oldest remaining *Raigō*
sculpture. The subject was more commonly
represented in pictorial form. The cult of
Amida Nyorai developed in Japan in the

ninth century and attained its greatest
popularity towards the end of the Heian and
during the Kamakura periods.

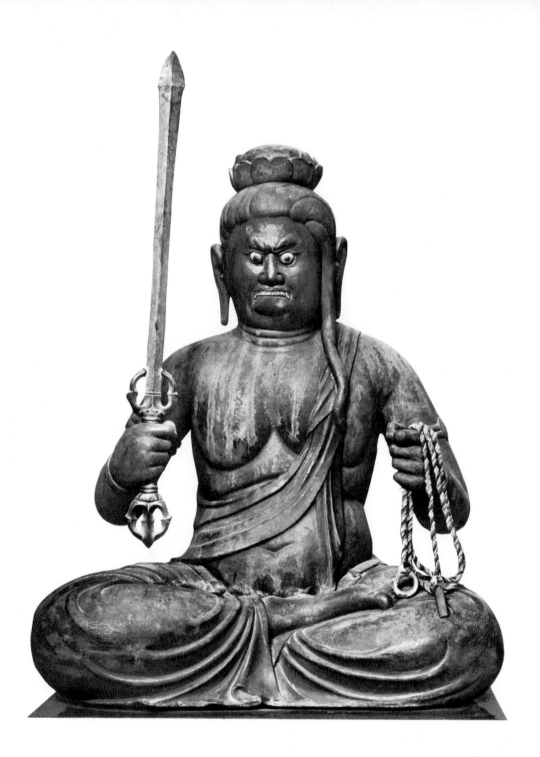

36

9) Fudō Myōō

Heian period, tenth century.
Wood, polychromed. Height 37⅜″.
Shōchi-in, Wakayama.
Registered Important Cultural Property.

Fudō (Sanskrit: *Acala*) is an immovable deity. He is said to be a manifestation of Dainichi Nyorai (Sanskrit: *Vairocana*), the supreme Buddha of the esoteric sects whose light is omnipresent. As protector of the faithful he conquers all the evils, and lives in flames which consume all that is impure. Usually represented with a flaming nimbus, here no longer extant, he holds a sword in his right hand and a rope in his left hand which he extends to those in need of help. A lock of hair hangs over his left shoulder and a lotus flower surmounts his head. His eyes are bulging and fangs protrude from the corners of his mouth. Fudō is one of the Five Great Myōō, incarnations of the conquering power of Buddha, whose popularity in the ninth and tenth centuries grew with the rise of the esoteric sects of Buddhism. Fudō was the patron of those who believed in the Shingon doctrine.

This image, made from a single block of wood, was originally created for the famous Buddhist monastery on Koya-san. Although the iconography was first introduced from China to Japan in the early ninth century, few representations in the round survive and this is one of the oldest.

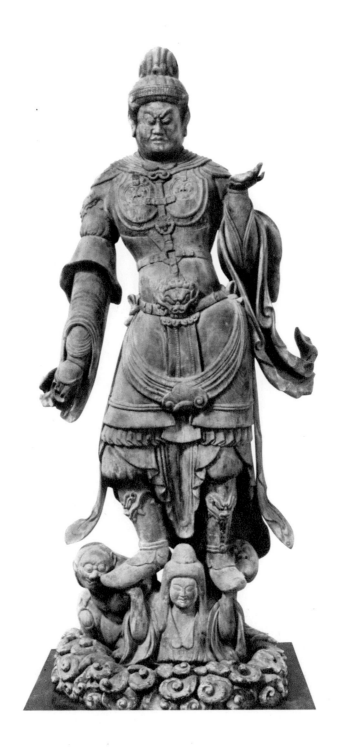

10) Tobatsu Bishamon Ten
Heian period, tenth century.
Wood. Height 63″.
Kanzeon-ji, Fukuoka.
Registered Important Cultural Property.

Bishamon Ten (Sanskrit: *Vaiśravana*), also
known as Tamon Ten, is Guardian of the
North quarter of the Buddhist heaven. He
is joined at times with other deities to form
groups known as the Four and Twelve
Guardians. These groups are often placed
on the dais upon which the principal image
in a temple rests.

Tobatsu Bishamon is represented standing
upon the palms of Jiten, God of Earth
(usually in the form of a goddess) accom-
panied by two goblins.

In China during the T'ang dynasty
(a.d. 618-907) it was the custom to install a
figure of a guardian spirit of the capital in
the main portal of the city wall. Later
in Japan the same custom was observed in
Kyoto, Heian-kyō, when it was the capital,
and a wooden guardian figure was installed
in the Rashomon gate. It is now preserved
in the collection of the Kyō-ō-gokoku-ji in
Kyoto.

The Kanzeon-ji, which has lent this
solid camphor wood image to the exhibition,
was the most important Buddhist temple
on the southern island of Kyushu. Colossal
statues of clay and wood are known to
have been made for the temple early in the
eighth century. Today only fragments of
some clay statuary remain and this is the
oldest wooden image preserved in the temple
collection.

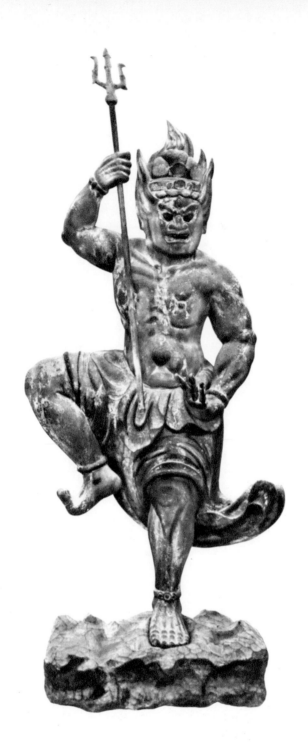

38

11) Zaō Gongen
Heian period, eleventh century.
Wood, polychromed. Height 38".
Kōryū-ji, Kyoto.
Registered Important Cultural Property.

Zaō Gongen is a divinity of purely Japanese
origin, believed to be a manifestation of
either Shaka or Miroku and has been
worshipped from early times as a mountain
god, combining elements of Buddhism,
as well as Shinto nature worship.

The original image of this deity is
traditionally said to have been carved by
En-no-gyōja, a seventh century holy man,
during a period of penance in the mountains.

The worship of Zaō Gongen became
very popular during the Heian period. Zaō
Gongen is shown as a Myōō, in dynamic
pose with his left foot firmly planted upon
a rock. His right leg is raised and he
brandishes in his right hand a three-pronged
spear. With his left hand he gesticulates
to ward off evil spirits. He has three eyes
and flame-like hair. This sculpture is carved
from a single block of wood and is
one of the oldest representations of Zaō
Gongen to survive.

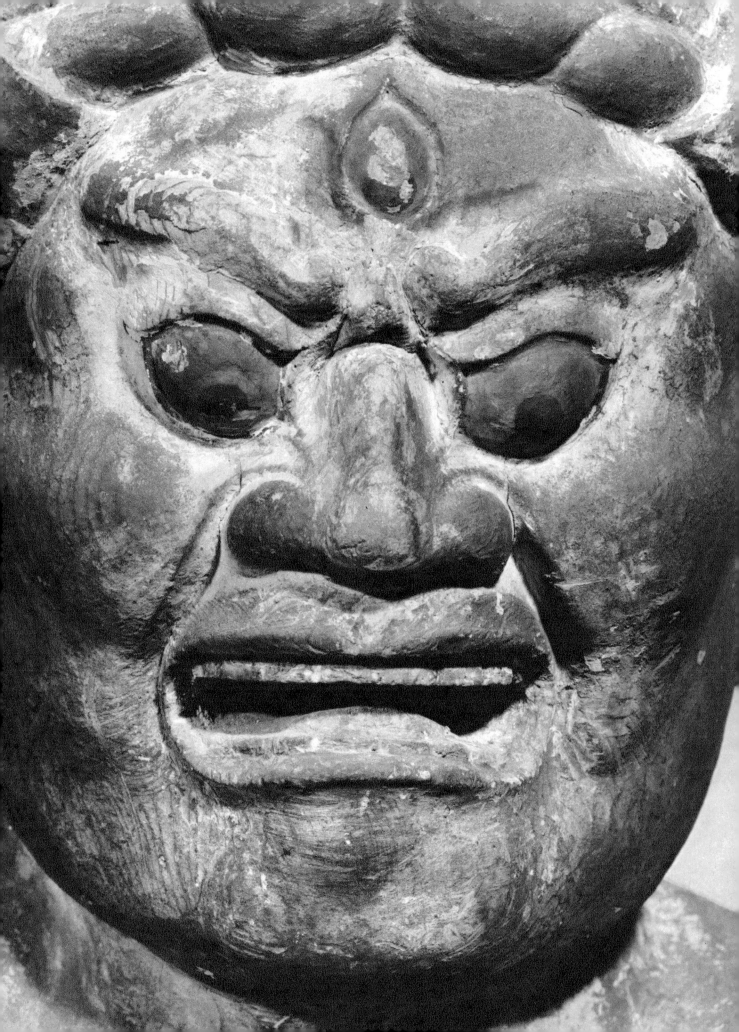

40

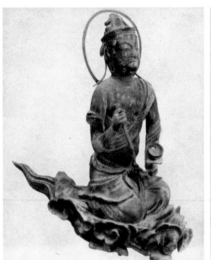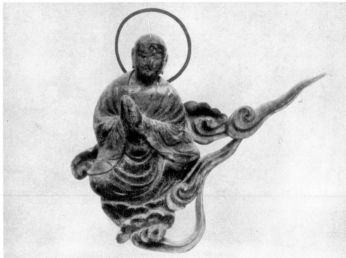

12) **Five Attendants of Amida Nyorai**
Jōchō and his studio.
Heian period, eleventh century.
Wood, polychromed. Height 20-27".
Byōdō-in, Kyoto.
Registered National Treasures.

The original building of the Byōdō-in was
the villa of Prime Minister Fujiwara-
no-Michinaga (a.d. 966-1024) and was
converted into a monastery in a.d. 1052 by
Fujiwara Yorimichi. The main hall, the
Hōōdo (Phoenix Hall) was built in 1053 to
house the now famous image of Amida

Nyorai by Jōchō. The Hōōdo is so called
because its plan resembles a descending
phoenix.

The four walls of the central hall which
enclose the Amida image were originally
richly painted with scenes of Amida's Pure
Land. A frieze of fifty-one wood carvings
of heavenly beings and monks on clouds was
placed around the upper part.

Five of the fifty-one carvings have been
lent by the temple to the exhibition.
Four are in the form of Bosatsu musicians.
They play the *shō* (a reed organ), a form of
koto (a zither-harp), a gong and a set

of chimes. The fifth appears to be a monk
who has his hands clasped in prayer as he
floats on his cloud in the paradise of Amida.

All the figures are finely carved in high
relief and it is believed that some were carved
by Jōchō who died in 1057, and others by
artists of his studio. This great sculptor
was traditionally said to be the originator
of the *yosegi* (joined block) technique of
carving. This fact cannot be substantiated.
Jōchō is especially noted for he was the first
sculptor to be honored with an official
ecclesiastical rank which raised the social
status of sculptors. He established a style of

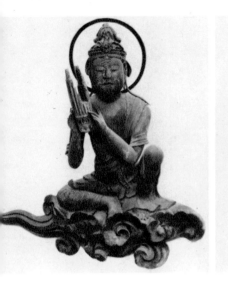 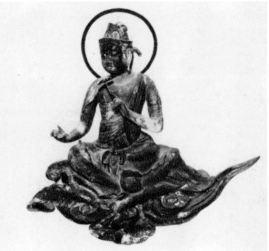 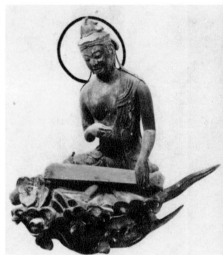

his own, expressive of native Japanese
ideals and taste. The skill of Jōchō was so
highly admired that in a.d. 1134, when
the Shokomyo-in was founded, similar
reliefs were made.

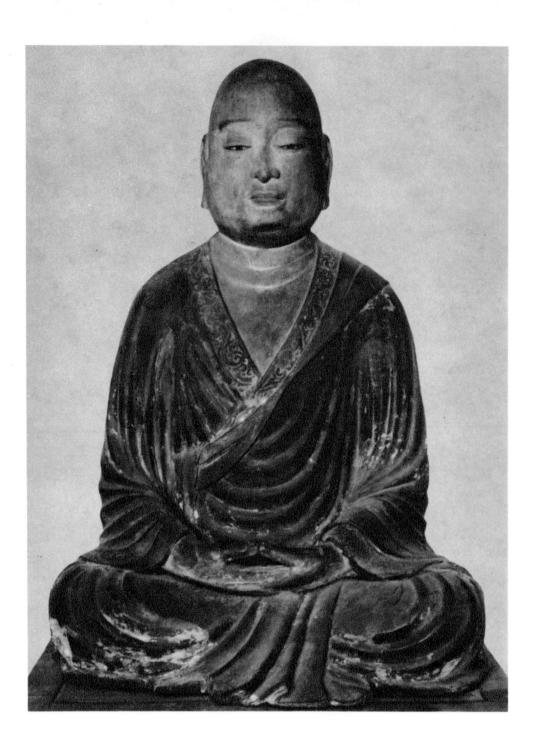

42

13) Priest Chishō Daishi
Heian period, twelfth century.
Wood, polychromed. Height 15½".
Onjō-ji, Shiga.
Registered Important Cultural Property.

Priest Enchin, who was given the
posthumous title Chishō Daishi, was born
in a.d. 816, the son of a niece of Kōbō
Daishi, founder of the Shingon sect of
Buddhism. After studying at Mt. Hiei,
headquarters of the Tendai sect, he went to
China in a.d. 853 and returned to Japan
five years later, bringing with him more than

one thousand scrolls of Buddhist scriptures
as well as numerous ritual objects. In
a.d. 868 he became Chief Abbot of
Enryaku-ji and by his writing and teaching
contributed greatly to the development of
the esoteric Tendai sect. He is also known as
the founder of the Jimon school of the
Tendai sect which had its headquarters at
Onjō-ji, which Chishō Daishi had founded
upon his return to China.

Since he was revered as one of the pa-
triarchs of the Tendai sect, portraits of him
were often carved, and the oldest
examples still survive in Onjō-ji. The

example in the exhibition, apparently a work
of the twelfth century, faithfully follows
the style of two older life-size statues. The
shape of the head and details of the drapery
folds, in particular, have been carefully
copied. The sculpture is made of a single
block of wood, and at the bottom there is a
circular hole, probably for the storage of
Buddhist scriptures.

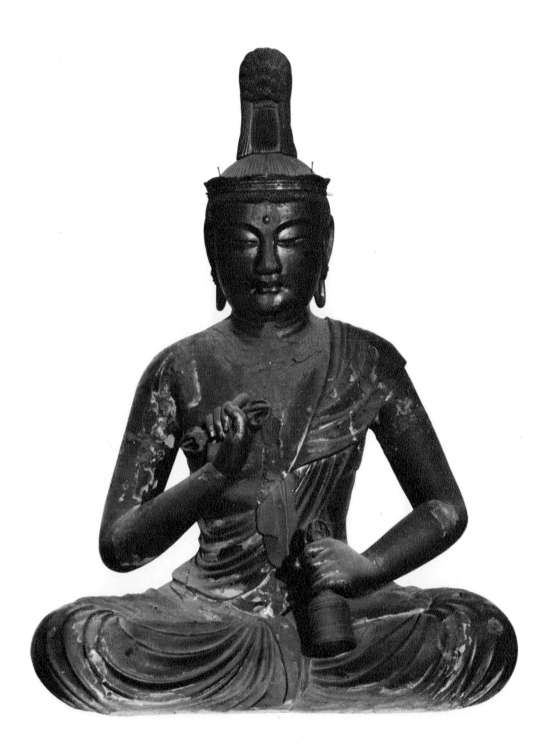

4) Kongō Satta

y Kaikei.

amakura period, early thirteenth century.

Vood, lacquered and gilded. Height 40⅛″.

uishin-in, Kyoto.

egistered Important Cultural Property.

.ongō Satta (Sanskrit: *Vajrasattva*) is
ommonly represented as a Bosatsu, holding
goko-sho (a baton with five-pronged ends)
 the right hand and a *goko-rei* (bell with
ve-pronged handle) in the left. This deity
 considered the Buddha Mother of Dainichi
yorai, the supreme Buddha of the esoteric

sects, and grew in importance with their rise
in the course of the century. He is more
often portrayed in *mandala* paintings.

The image is carved in the *yosegi* (joined
block) technique and is hollow. The
signature of Kaikei is written inside.

Kaikei was one of the foremost sculptors
of the Kamakura period, equal in fame to
his fellow artist, Unkei. He studied under
Kōkei, Unkei's father, and combined a
realistic style, deriving from the art of the
Nara period, with the more delicate, graceful
Fujiwara style, to create one of his own.
Over twenty pieces of his work survive. This

Kongō Satta probably dates from the
middle years of his active period. An early
example of his work, a Maitreya, dated
a.d. 1189, is preserved in the Museum of
Fine Arts, Boston.

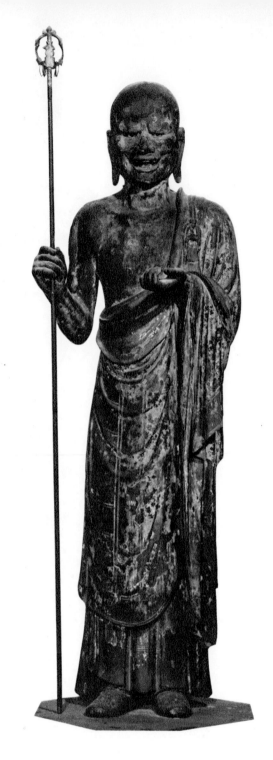

15) Daikashō and Subotai

Studio of Kaikei.
Kamakura period, early thirteenth century.
Wood, polychromed. Height 38¾".
Daihōon-ji, Kyoto.
Registered Important Cultural Properties.

These figures belong to a group of ten disciples surrounding a Shaka Nyorai, the principal image of the temple. Among the ten disciples, Daikashō (Sanskrit: *Mahākāśyapa* or *Pippalāyana*), who normally holds a *shakujō* (a staff with metal rings that jingle), is known for his self-discipline.

Subotai (Sanskrit: *Subhūti*), who holds a *nyoi* (a scepter), is known for his wisdom. The ten great disciples of Buddha were considered saints in India, and artists depicting them sought to distinguish them realistically as foreigners.

The group of Shaka Nyorai and his disciples in Daihōon-ji were made by Kaikei and artists of his studio. Two bear inscriptions by Kaikei, while the statue of Shaka Nyorai is the work of Gyokai, a pupil of Kaikei. The two statues shown here are virtually contemporary with the Kongō Satta (No. 14) from the Zuishin-in. The

realistic and dramatic expression and natural arrangement of the drapery are particularly striking and characteristic of the work of Kaikei and his pupils.

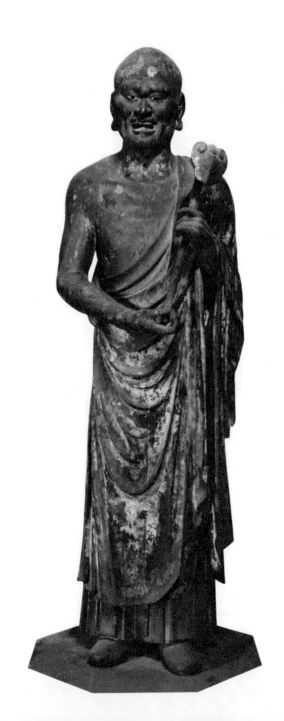

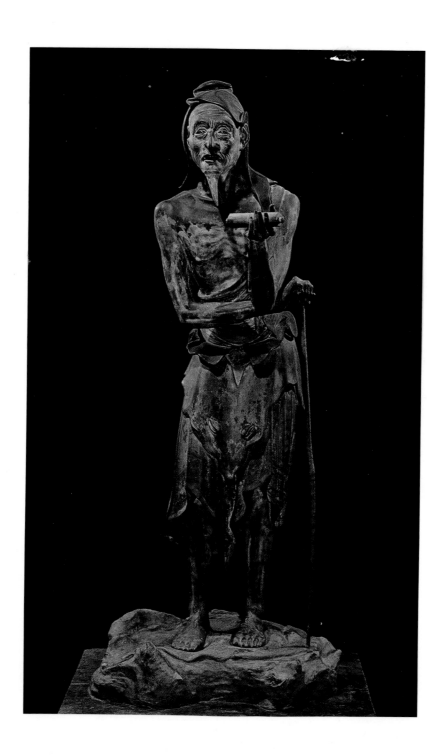

16) Mawara-nyo and Basu-sen
Kamakura period, thirteenth century.
Wood, polychromed.
Height 60½″ and 60⅞″.
Myōhō-in, Kyoto.
Registered National Treasures.

In a corridor behind the altar of the huge
Rengeō-in, popularly known as
Sanjūsangendō (Hall of the Thirty-three
Bays) of the Myōhō-in, are installed
twenty-eight statues of Buddhist divinities,
the Nijūhachi-bu-shū, or twenty-eight
followers who protect the worshippers of

Senju Kannon (Thousand-armed Kannon).
The principal deity of the temple, in the
center of the main hall, is accompanied
by one thousand smaller standing images of
Senju Kannon.

Mawara-nyo is shown as an old woman,
standing in contemplation and holding
her hands in prayer. Basu-sen is shown as a
pious old man with powerful features, long
beard and shrunken body, leaning on a staff
and carrying a scroll of Buddhist scriptures
in his left hand. These are examples of the
yosegi technique. The eyes are rock crystal.
Much of the original polychromy has flaked

off, thus exposing the surface of Japanese
cypress wood and revealing even more
clearly the marks of the sculptor's chisel.
Both figures are treated with great realism.

The group of twenty-eight statues, as
well as the gods of Wind and Thunder
placed with them, must have been made by
sculptors trained in the workshop of Tankei,
eldest son of Unkei. He was the artist
responsible for the temple's main image of
Senju Kannon, made in a.d. 1254.

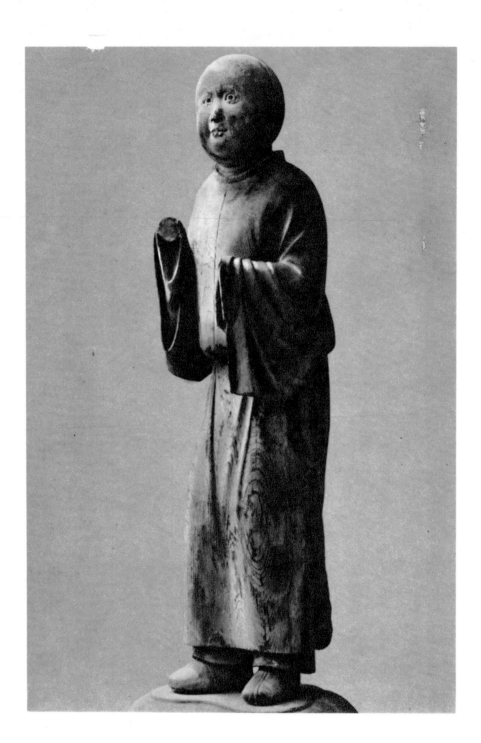

48

17) Zennishi Dōji

By Tankei (a.d. 1173-1256).
Kamakura period, thirteenth century.
Wood. Height 28″.
Sekkei-ji, Kōchi.
Registered Important Cultural Property.

Zennishi Dōji is one of the five attendants
of Bishamon Ten. The group in Sekkei-ji,
including this figure of Zennishi Dōji, is the
work of Tankei, sculptor of the Senjū
Kannon (Thousand-armed Kannon), the
principal image of the Sanjūsangendō.

Tankei, the eldest son of Unkei, was the
leader of the Shichi-jō sculptors' guild. An
inscription on the Bishamon Ten statue, the
central figure of the group, identifies
Tankei as the carver.

Zennishi Dōji is represented as the child
of Bishamon Ten and Kichijō Ten, one of
his attendants. He is shown in naturalistic
pose, with head slightly inclined. The eyes
are of rock crystal. It is evident that Tankei
enjoyed making this figure, for here we
find him at ease and in complete mastery of
his material. It is almost as though it was
a portrait of a well-loved child.

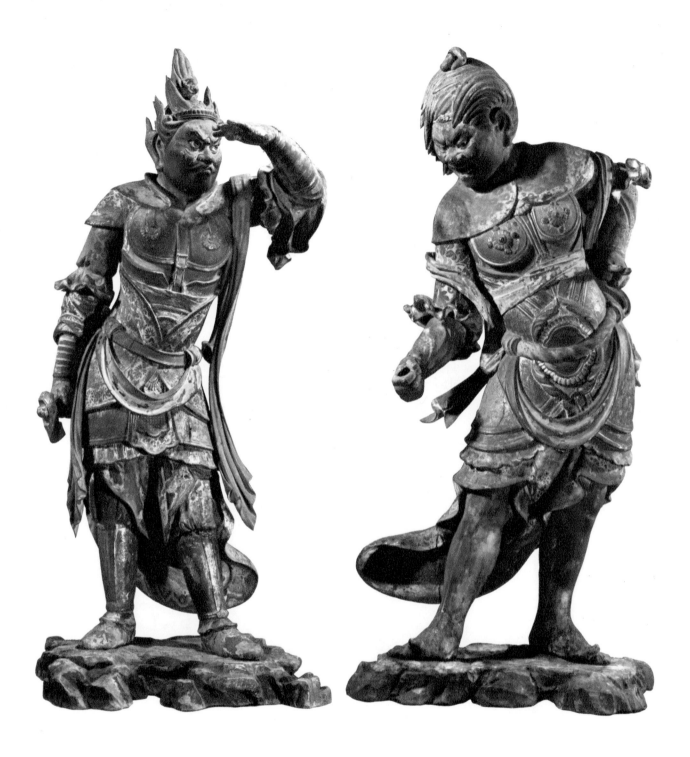

18) Santeira and Bikara
Kamakura period, thirteenth century.
Wood, polychromed. Height 27 ¼″ and 29 ½″.
Mr. Yōichirō Nakamura, Tokyo.
Registered Important Cultural Properties.

Santeira (Sanskrit: *Saṇḍila*) and Bikara
(Sanskrit: *Vikārala*) are two of the Jūni
Shinshō (Twelve Guardian Generals) who
often surround the principal image of
Yakushi Nyorai, the Buddha of medicine and
healing. These statues were made by the
yosegi technique. Admirable examples of
the Kamakura style, rendered with great
freedom, they are extremely virile in their
powerful poses and violent gestures. The
garments and armour are richly decorated
with painted designs in vivid colours and
kirikane, a cut gold leaf technique perfected
by the Japanese.

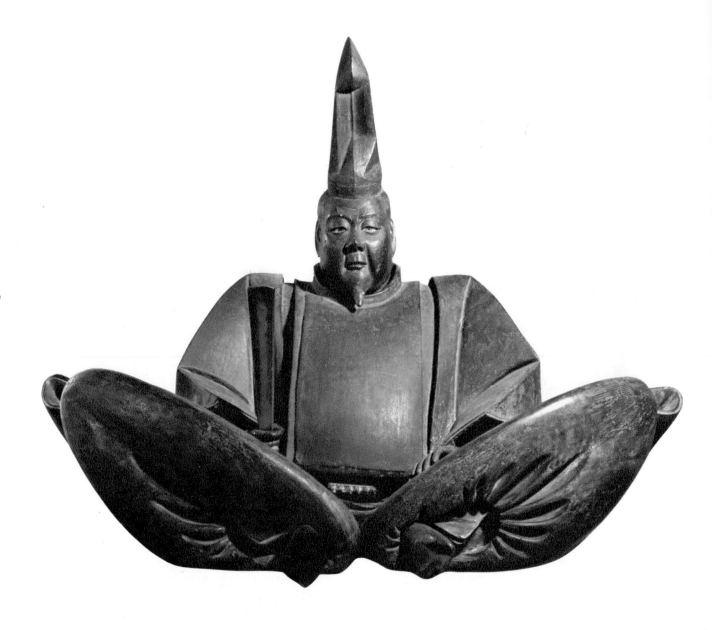

50

19.) **Portrait of Minamoto-no-Yoritomo**
Kamakura period, thirteenth century.
Wood, polychromed. Height 27⅛″.
National Museum, Tokyo.
Registered Important Cultural Property.

Minamoto-no-Yoritomo (a.d. 1147-1199)
was an important historical figure who
founded the Kamakura Shogunate and
distinguished himself as a noted warrior. He
directed the war against the hitherto
invincible Taira (Heike) clan, and ultimately
emerged victorious, bringing the entire
nation under his control. He established the

seat of his administration at Kamakura.
This made a political as well as cultural
break with Japan's past.

This sculpture and the painted portrait of
Minamoto-no-Yoritomo in the collection
of Jingo-ji, in Kyoto, are two outstanding
and famous examples of Kamakura portrai-
ture. The new interest in realism and life-
like representation which manifested itself
during this period found a natural outlet
in portraiture.

The statue was made by the *yosegi*
technique and about ten blocks of wood
were joined together. The eyes are crystal.

Yoritomo wears the formal court costume
of the period characterized by voluminous
trousers and a high hat and holds a sceptre
in his right hand. The emphasis upon the
realistic rendering of the features and
life-like expression is heightened by the
formal and stylized treatment of the body.
This sculpture is closely related in style and
character to the famous statue of Uesugi
Shigefusa, another military man, in the
collection of the Meigetsu-in, Kanagawa
Prefecture.

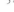

20) Deer

Kamakura period, thirteenth century.
Wood, polychromed. Height 20½″ and
18⅜″.
Kōzan-ji, Kyoto
Registered Important Cultural Properties.

Deer are commonly associated with both
Shinto and Buddhist worship. They are often
seen in paintings related to the Kasuga
Shrine, the famous Shinto Shrine at Nara,
particularly on the *Shika Mandara* (Deer
Mandara) depicting the gods of the shrine
with deer. The pair of wooden deer shown

here were made late in the Kamakura period
to be placed at Kōzan-ji, as its servants and
messengers.

The priest Kōben (a.d. 1173-1232), who
was given the honorary title of Myō-e
Shōnin, ordered a replica of the Kasuga
Shrine to be erected at Kōzan-ji, which he
restored.

The deer are examples of the *yosegi*
technique and have crystal eyes. They are
remarkably animated and the legs are
articulated. These deer are ranked among the
finest examples of animal sculpture in Japan.

Painting

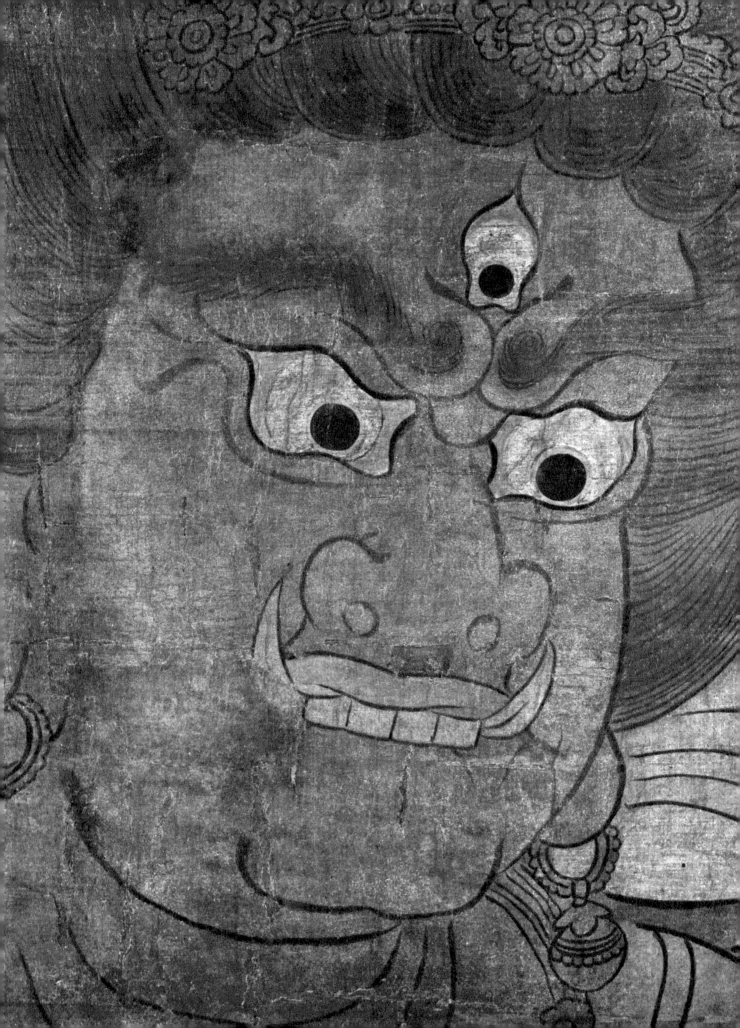

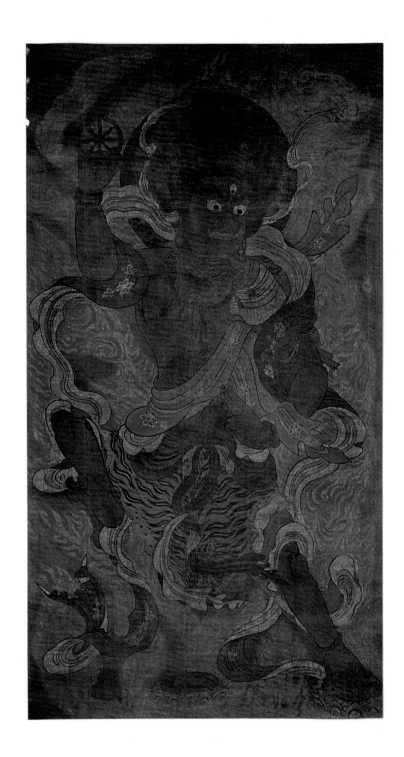

55

**21) Ryū-ō-ku, from set of five kakemono
 of Go Dairiki Bosatsu**

Heian period, early tenth century.
Kakemono, ink and colours on silk.
Height 126″, Width 70¾″.
Yūshi Hachimankō Temples of Kōya-san,
Wakayama / Registered National Treasure.

The Go Dairiki Bosatsu are the five powerful
Bodhisattvas, Guardians of the Four Cardinal
Quarters of the Compass and the Center, as
expounded in the Kyūyaku Ninnō-gyō Sutra,
which was translated into Chinese from San-
skrit at the beginning of the fifth century.

Paintings of these Bodhisattvas were used as
central images in the Ninnō-e services, when
prayers were offered for the protection of the
nation. Such services were held from time to
time during the Nara and Heian periods
(eighth to twelfth centuries). Paintings of the
five deities were hung side by side and used
during the ceremony. The figure of the central
deity was represented in its frontal view, and
the four other deities were depicted facing the
central image. This painting of Ryū-ō-ku
was hung to the left of the central deity.

The kakemono is one of the three remain-
ing works of the set of five, and dates from the

middle of the Heian period. Two other paint-
ings of this set, unfortunately, were recently
destroyed by fire. The five paintings were
formerly owned by Kyō-ō-gokoku-ji monas-
tery in Kyoto, which was the center of esoteric
Buddhism, and were kept there until the six-
teenth century when Toyotomi Hideyoshi
dedicated them to the temples of Mount Kōya.

The linear quality and the all-encompass-
ing flames reflect the artist's inheritance of
the great tradition of Nara period painting.
The simplicity of the textile designs on
the robes worn by the deity is an additional
indication of the style of this period.

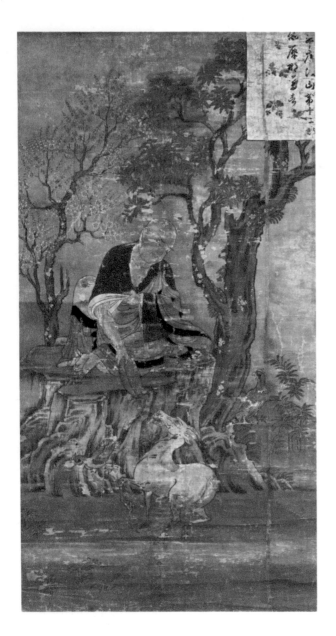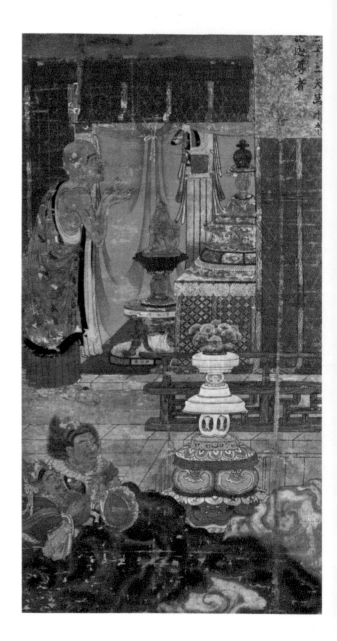

56

22) Jūroku Rakan (four of Sixteen Arhats)

Heian period, early twelfth century.
Four kakemono, ink and colours on silk.
Height 38″, Width 9⁵⁄₁₆″.
National Museum, Tokyo.
Registered National Treasures.

Rakan (Chinese: *Lo-han* or Sanskrit: *Arhat*) are Buddhist sages who have achieved enlightenment and are endowed with supernatural power which they obtained through their severe religious austerities. They are said to have been allowed to prolong their lives to serve the Buddhas.

These paintings of *Rakan* express both the supernatural power and the mercy of the sages. The representation of *Rakan* in a style close to human appearance, as is shown in these paintings, is less usual and older than their portrayal as grotesque supernatural beings.

The delicate style and use of soft, graceful colours are characteristic of Buddhist painting of the Heian period.

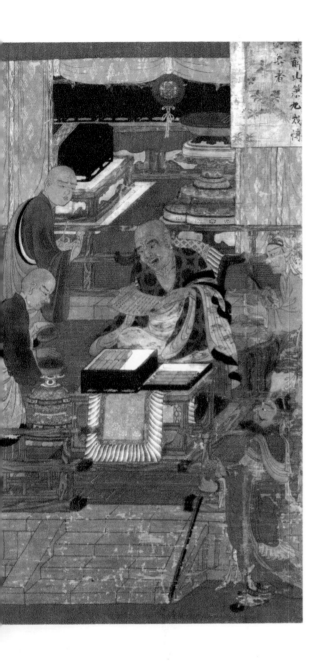

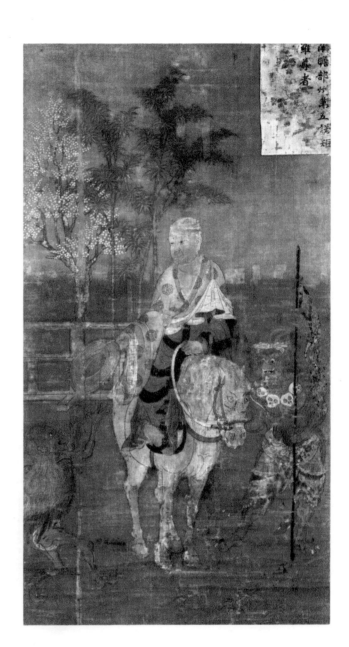

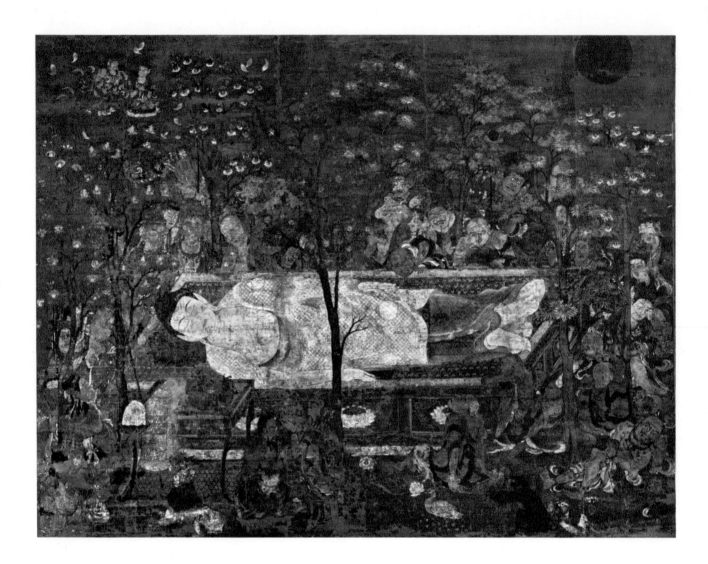

23) **Butsu Nehan** (Sanskrit: *Nirvana*)
Heian period, end of the twelfth century.
Kakemono, ink and colours on silk.
Height 49¼", Width 64".
National Museum, Tokyo.
Registered Important Cultural Property.

This is the scene of Shaka's death and his
rebirth as the Eternal Buddha. Shaka, who
has just ceased his life in this world, is the
center of the large composition. Surrounding
him are many Bodhisattvas, disciples,
ministers and even animals who mourn his
passing. Lady Maya, the mother of Shaka,

hurries down from the Tosotsu Heaven
where she resided after her death.

The contrast of movement and repose is
beautifully organized in this traditionally
composed and executed painting. The
refined brushwork and rich palette combined
with the use of delicate *kirikane* distinguish
this work as late Heian painting.

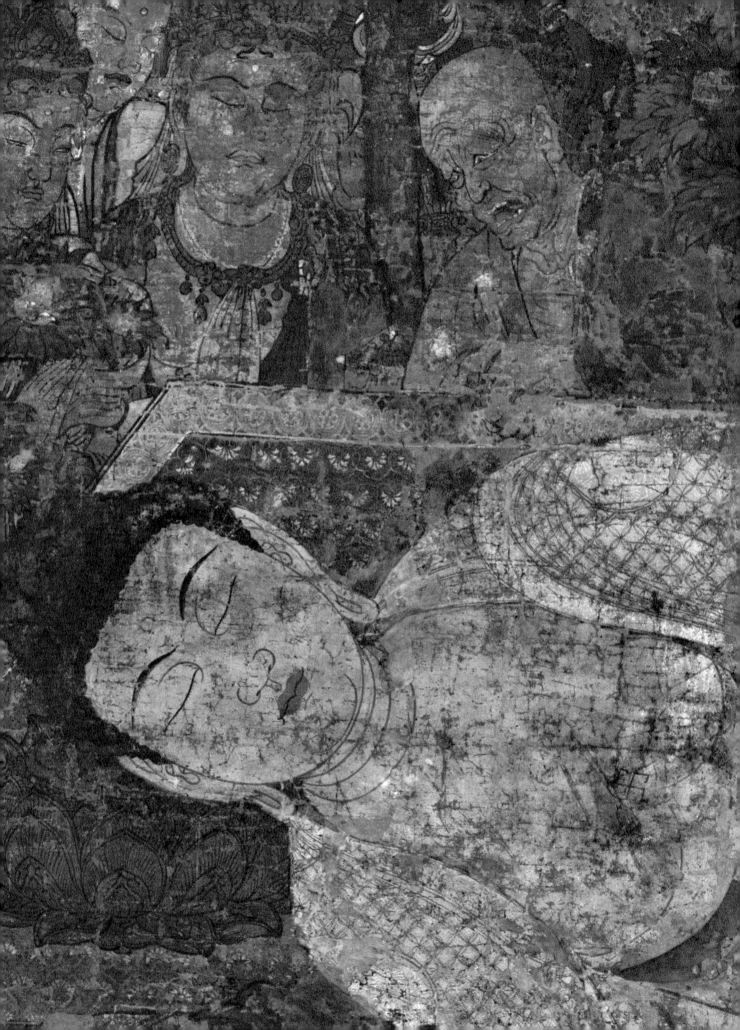

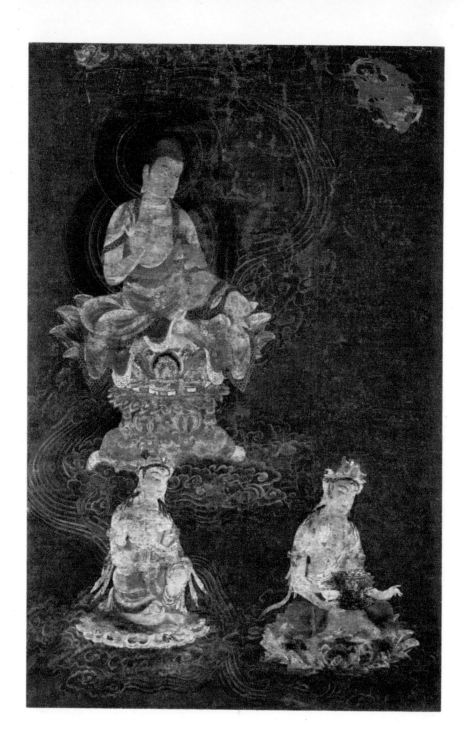

60

24) Raigō of Amida and His Host

Heian period, end of the twelfth century.
Kakemono, ink and colours on silk.
Height 43″, Width 28¼″.
Sinren-sha, Ishikawa.
Registered Important Cultural Property.

The subject of the Descent of Amida is based upon the description found in the Muryō-gyō Sutra, which promised those who follow Amida that, when they die, Amida would descend to receive their departing souls and take them back to the Western Paradise. Paintings of the Descent of Amida became popular with the increasing belief in the Paradise of Amida which developed in the late Heian and Kamakura periods (eleventh to thirteenth centuries). There are many varieties of paintings of the Descent of Amida, some of them are large and include twenty-five Bodhisattvas. This painting is rather small and depicts Amida and two attendant Bodhisattvas, Kannon and Seishi. This work might have been painted for a devout court noble. The fine colouring and splendid *kirikane*, make this painting one of the masterpieces of the late Heian period.

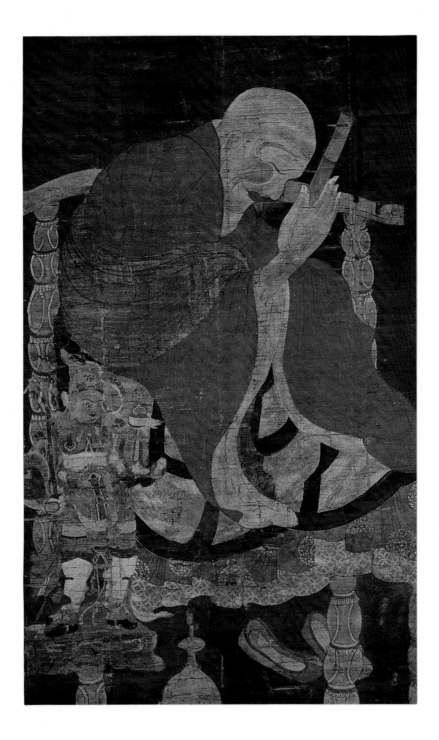

5) Zemmui, a Patriarch of the
 Tendai Sect

Heian period, second half of the eleventh
century.
Kakemono, ink and colours on silk.
Height 49¹³⁄₁₆″, Width 28⁹⁄₁₆″.
Shijō-ji, Hyōgo.
Registered National Treasure.

In the Tendai sect, the *miei-ku,* worshipping
of portraits of ancestral patriarchs, is a very
important religious rite which originated in
the beginning of the ninth century. As part
of the rite, portraits of the patriarchs of
India, China and Japan were displayed and
worshipped.

Zemmui (a.d. 637-735) was an Indian
monk who travelled to T'ang, China. He is
depicted here clasping a sutra scroll between
his hands, with one of the Guardian Kings,
Bishamon Ten, in attendance. This portrait
of Zemmui is possibly the earliest of its type
available. It was painted in the eleventh
century as one of a set of the Ten Patriarchs
of the Tendai sect. This painting, imaginary
and idealized though it be, is a warmly sen-
sitive expression of a truly humble and
religious spirit.

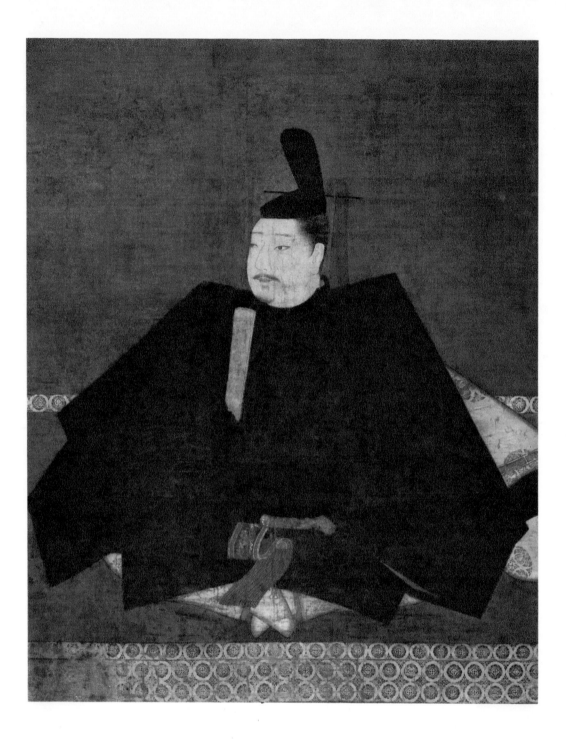

62

26) Portrait of Fujiwara Mitsuyoshi
Attributed to Fujiwara Takanobu
(a.d. 1142-1205).
Kamakura period, twelfth century.
Kakemono, ink and colours on silk.
Height 55", Width 44".
Jingo-ji, Kyoto.
Registered National Treasure.

Mitsuyoshi was one of the major advisors of
the retired Emperor Goshirakawa. This
painting was originally hung beside the
portraits of the retired Emperor, of Minamoto
Yoritomo, and of Taira no Shigemori in the

Sentō-in Hall of Jingo-ji built in a.d. 1188.

Fujiwara Takanobu, the artist to whom
this painting is attributed, was a master of
portraiture in the early Kamakura period.
He also distinguished himself as a poet.
For many generations he and his son and
successor, Nobuzane, were regarded as the
greatest portraitists of Japan. The excellent
brushwork and mastery of the technique
of *Yamato-e* painting, strongly support the
attribution to Takanobu.

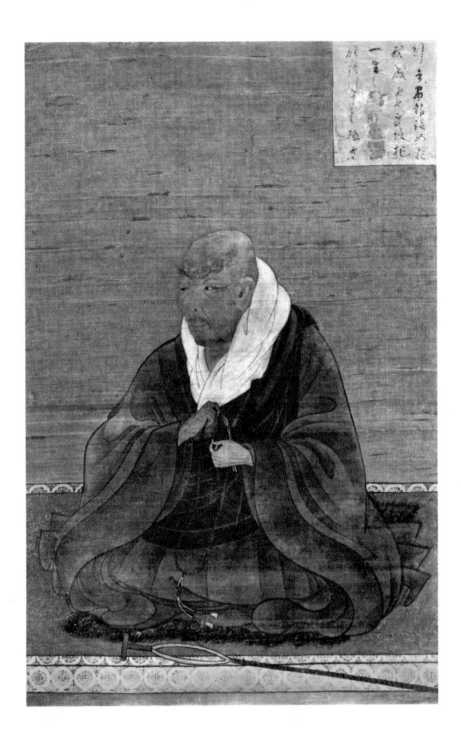

63

27) Portrait of the Priest Shinran
Attributed to Jōga.
Kamakura period, second half of the
fourteenth century.
Kakemono, ink and colours on silk.
Height 40½", Width 32".
National Museum, Nara.
Registered Important Cultural Property.

Shinran (a.d. 1173-1262) was one of the
most distinguished priests in the Kamakura
period. He founded the Jōdo-shinshū sect
of Buddhism which flourished among the
common people. His portrait has been kept
in the sect's main temple, the Hongan-ji,
since his time with several scrolls illus-
trating his life.

This painting closely resembles the
portrait *Anjo No Mie* also in the temple
collection, and is believed to have been
copied from it.

Jōga, who was also a Buddhist priest, is be-
lieved to have been the painter of this portrait.
He engaged in work connected with the Jōdo-
shinshū sect in the second half of the Kama-
kura period. He also painted the scrolls
relating the life of Shinran. The attribution
to Jōga has been considered dependable.

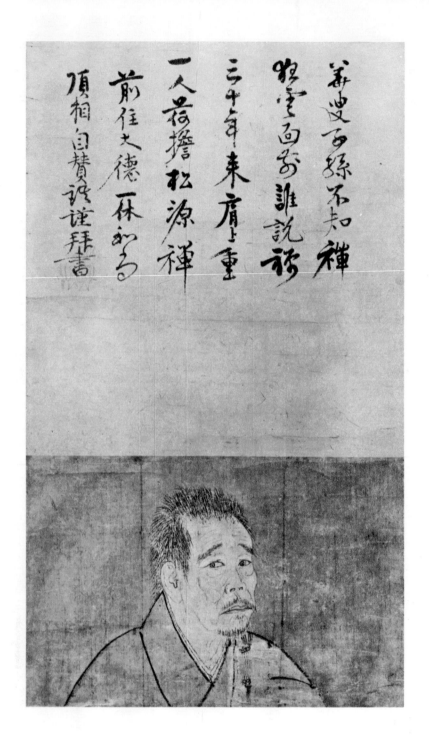

64

28) **Portrait of the Priest Ikkyū**
By Bokusai.
Muromachi period, fifteenth century.
Kakemono, ink and slight colours on paper.
Height 17⅛″, Width 10⅜″.
National Museum, Tokyo.
Registered Important Cultural Property.

Priest Ikkyū (a.d. 1394-1481) was one of
the eminent leaders of Zen Buddhism in the
first half of the Muromachi period. He
served as the Chief Priest of Daitoku-ji,
and was known for his extraordinary quali-
ties which were described in a text entitled

Kyōreishu. Portraits of him are owned by
such temples as Shinju-an of Daitoku-ji
and the Shuon-an where he died. The
portrait is unique in that it is executed in a
sketchy style which is strong enough to sug-
gest the personality of this man. The artist,
Bokusai, was a pupil of Priest Ikkyū and knew
him well. An inscription by Ikkyū himself
in the upper part of the portrait suggests that
it may have been painted from life.

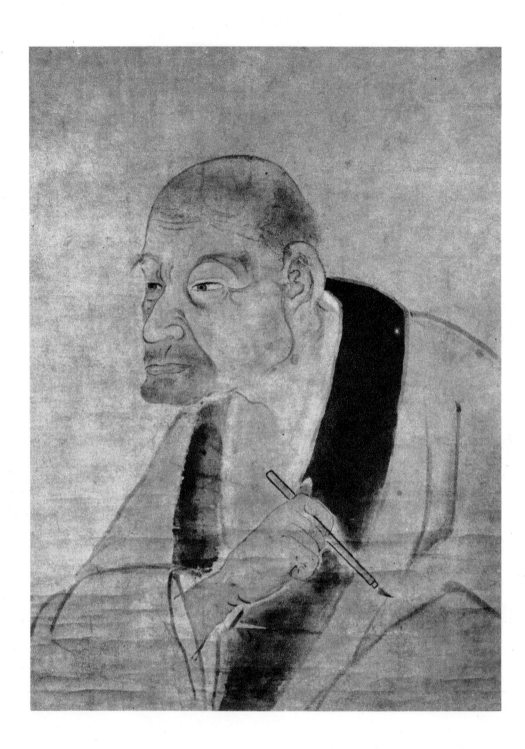

29) Portrait of Kanō Tanyu
Attributed to Momota Ryūei
(a.d. 1647-1698).
Edo period, seventeenth century.
Kakemono, ink and colours on paper.
Height 26⅛″, Width 19″.
National Museum, Kyoto.
Registered Important Cultural Property.

The Kanō family was in charge of the
Shogun's official painters' guild from the
Muromachi through the Edo periods. Such
artists as Masanobu, Motonobu, Eitoku and
Sanraku were the forerunners of the school.

Tanyu, grandson of Eitoku, worked early in
the Edo period and is called the "Revitalizer
of the Kanō School." He lived in Kyoto dur-
ing his youth, but was invited to Edo (the
present Tokyo) by the Tokugawa Shogun, and
lived at Kajibashi. There he founded a school
called the Kajibashi Kanō School. His most
impressive works are sliding doors of
Nijō Castle and the Nanzen-ji in Kyoto.

This realistic portrait shows the artist in
the latter years of his life. Ryūei, to whom
the portrait is attributed, was one of his four
most famous pupils.

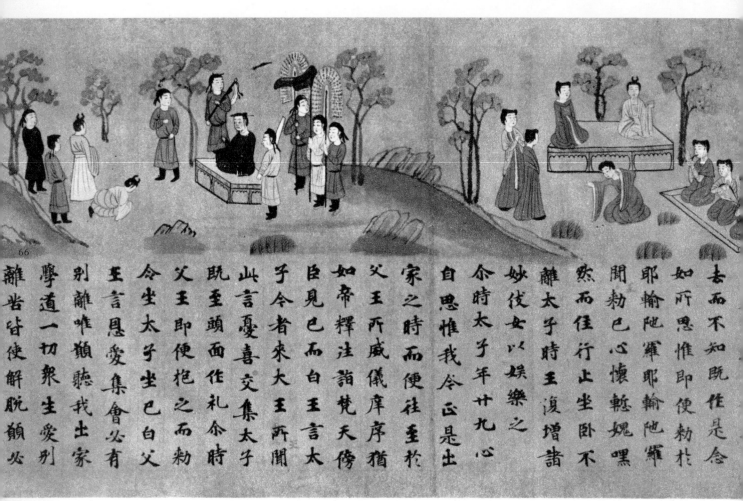

去而不知既作是念

如所思惟即便勅於

耶輸陀羅耶輸陀羅

聞勅已心懷軫媿嘿

然而住行止坐臥不

離太子時王渝増諸

妙伎女以娛樂之

尒時太子年廿九心

自思惟我今正是出

家之時而便往重於

父王所威儀庠序猶

如帝釋注詣梵天傍

臣見已而白王言太

子今者來大王所聞

山言憂喜交集太子

既至頭面作礼介時

父王即便抱之而勅

令坐太子坐已白父

至言恩愛集會必有

別離唯願聽我出家

學道一切衆生愛別

離岩皆使解脱顚必

30) Illustrated Sutra: The Inga-kyō (Vol. II)

Nara period, eighth century.
Makimono, ink and colours on paper.
Height 10¼″, Length 369⅛″.
National Commission for Protection of
Cultural Properties.
Registered Important Cultural Property.

The Inga-kyō is a scripture describing
stories of the life of Shaka in his previous
and present incarnations. The illustrated
Inga-kyō is usually divided into eight scrolls,
each of which has two registers, the lower
register for the text and the upper one for
the illustrations. Five scrolls and some
detached segments of the illustrated Nara
period Inga-kyō Sutra survive. The
most typical are these owned by the Hōo-in,
Jōbon Rendai-ji and the Tokyo University of
Arts. They are not all of the same series, but
were made separately during the eighth
century.

The exhibited scroll originally was part of
the Sutra in the Jōbon Rendai-ji collection
and is a section from the end of the first half
of the second chapter. The illustrations are
simple, archaic and beautifully coloured.

They depict the end of the story of *Prince
Siddharta's Four Excursions from the Four
Gates* and the beginning of the story of the
Prince's *Renunciation of the World*.

The illustrations are as follows:

1. The Prince listens to a monk who
 preaches the merits of renouncing
 the world.
2. The Prince returns to his palace having
 decided to renounce the world.
3. The King Suddhodana inquires about
 the outcome of the Prince's excursion.
4. By order of the King, the wife of the
 Prince, Yasodharā, entertains the Prince

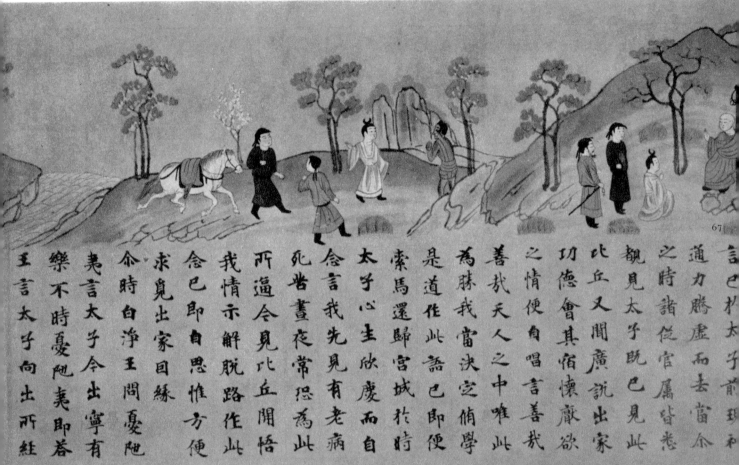

王言太子向出所�註
樂不時憂阨夷即荅
妻言太子今出寧有
企時太子令出寧有
求見出家回錄
念已即自思惟方便
我情示解脫路作此
所遍令見比丘開悟
死者晝夜常恐爲此
念言我先見有老病
太子心生欣慶而自
索馬還歸宮城於時
是道作此語已即便
爲朕我當決定俯學
善我天人之中唯此
之情便自唱言善我
功德會其宿懷廉欲
比丘又聞廣訊出家
覩見太子既已見此
之時諸侶官屬皆悲
通力騰虛而去當企
言已於太子前現神

with music and beautiful dancing girls
in order to dissuade him from
renouncing the world.

5. The Prince asks his father, the King,
for permission to depart.

亦令諸天　大得精氣　充益身力　歡喜快樂

是經力故　能令地味　志出地上　願百由旬

其中氣味　充令衆生　厚十六方八千由旬

如是大地　重金剛際　元不遍有　患令第生

地神大力　勢分甚深　是經力故　能裏其味

夜卧惡夢　悟則憂怖　如是衆事　消惡威盡

五星諸宿　變異災怪　能令皆　元有遺餘

於諸衆生　增令擁護　功德威銀　庄嚴悟常

心生歡喜　專来擁護　愛樂親近　是諸神

地神堅牢　種種園林　棄寶大神　如是諸神

大辯天寺　元量天女　功德天寺　各興眷屬

富勤擁護　十方世界　受持經者

鳴雞檀提　歡入精氣　如是寺神　郁有大力

菩隨寿悟　訶陀揩陀　利大鬼神　共等鳴雞

鬼子如是　及立百神　當來擁護　聽是經者

常來擁護　聽受經者　盡夜不雛　訶利帝南

及以健陀　是寺訶是　阿備羅王　有大神力

眺摩利子　倍羅驕陀阿利子

婆梨羅眼　阿備羅王　昆摩貫多　及以我脂

以大神力　常来擁護　聽是繕哥　畫夜不雛

難陀龍王　跋難陀王　有如是寺　百千龍王

阿辧蓬王　娑伽羅王　目真瞵王　伴羅逢王

聽受如是　後妙典者

如是寺神　皆有元量　神足威力　常勤擁護

31) Kon-kōmyō-kyō Sutra (Vol. III)
Kamakura period, dated a.d. 1192.
Makimono, *hakubyo* ink painting on paper.
Height 10¼″, Length 325⅝″.
National Commission for Protection of
Cultural Properties.
Registered National Treasure.

The scripture is the *Kon-kōmyō-kyō*, also
known as the *Menashi-gyō* (literally, "the
Sutra of No Eyes"), so titled because the
faces depicted lack features. It is supposed to
have the merit of protecting the nation.
The illustrations, however, have no connec-
tion with text. The four scrolls were
originally planned as a set of paintings of
the *Tale of Genji*, and were commissioned
by the Retired Emperor Goshirakawa. The
drawings were completed about the time of
Goshirakawa's death in a.d. 1192. In the
following year, the Buddhist sutra was
written upon the painting by order of inti-
mate friends of Goshirakawa, as a prayer
for his repose. Sei-hen was the calligrapher
of the main scripture while Jōken wrote the
Sanskrit characters.

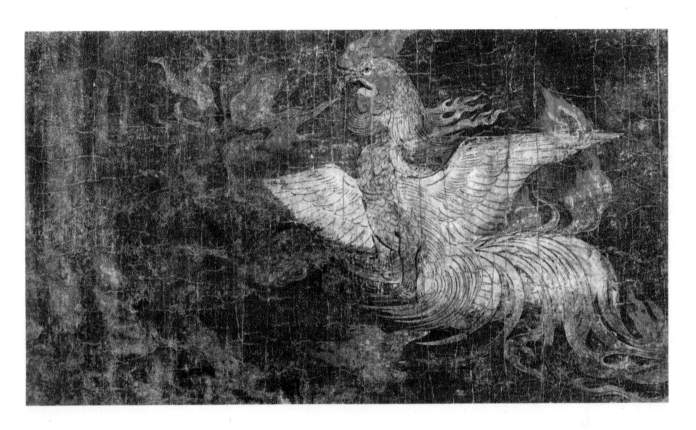

32) **Jigoku-zōshi (Scroll of Hells)**
Kamakura period, end of the twelfth
century.
Makimono, ink and colours on paper.
Height 10½″, Length 170⅞″.
National Museum, Nara.
Registered National Treasure.

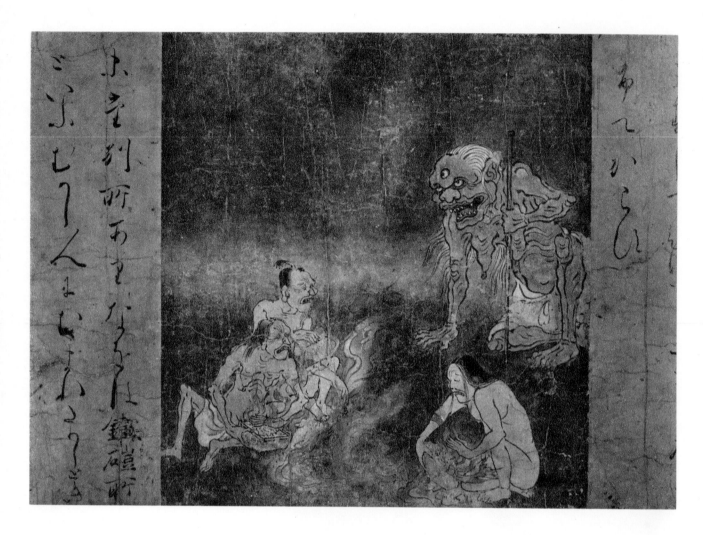

32) Jigoku-zōshi (Scroll of Hells)
Kamakura period, end of the twelfth
century.
Makimono, ink and colours on paper.
Height 10½", Length 170⅞".
National Museum, Nara.
Registered National Treasure.

The "Scroll of Hells" is generally considered
to be part of a series presenting the Six
Realms of Incarnation, which include such
other scrolls as the "Hungry Goblins" and
the "Diseases." This scroll illustrates seven of
the sixteen divisions in the Eight Great

Hells. They are classified in accordance
with the types of sins committed by wrong-
doers in the mortal world. Judging from the
content and the brushwork, the artist is
believed to have been a Buddhist monk
active at the end of the twelfth century.

The Hells illustrated are:
1. Hell of Excrement, where men suffer
 in a muddy pond of excrement. Those
 who sinned by calling clean things
 filthy and filthy things clean are
 relegated to this Hell.
2. Hell of Measures, where swindlers
 must measure charcoal fires with their

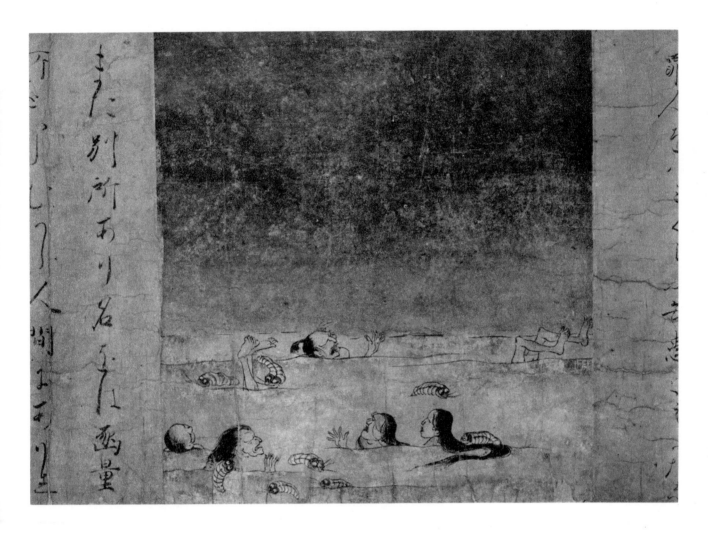

bare hands.

3. Hell of Mortars, where men are ground
 in an iron mortar by Hell-hounds. This
 is the Hell for thieves.

4. Hell of Cocks, where a flaming cock
 kicks men and tears them asunder.
 This is the Hell for those who liked
 violence and were cruel to animals.

5. Hell of Smoke, where arsonists try in
 vain to escape from a shower of heated
 sand falling from a cloud.

6. Hell of Pus and Blood, where those
 who served unclean food sink into a pond
 of pus and are eaten by worms.

7. A Hell where fire-breathing monsters
 blow flames at naked men and women.

72

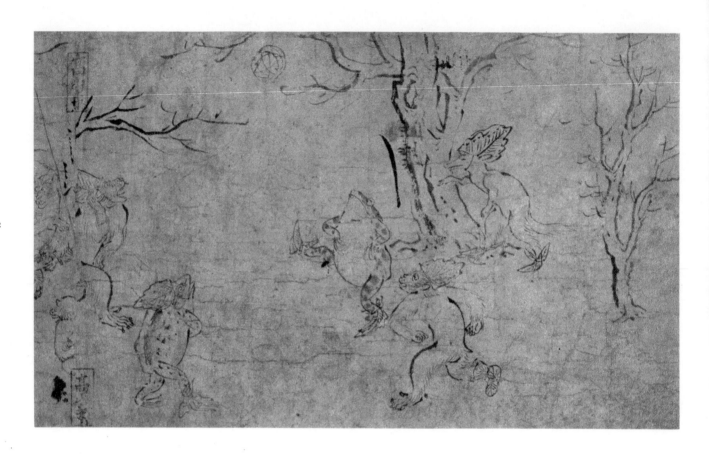

33) **Chōjū Giga (Cartoons of Animals and Humans, Vol. *Hei*)**

Kamakura period, early thirteenth century.
Makimono, ink on paper.
Height 12⅜″, Length 404″.
Kōzan-ji, Kyoto.
Registered National Treasure.

Four scrolls of "Cartoons of Animals and Humans" are owned by Kōzan-ji. The first two were painted in the Heian period and the other two date from the Kamakura period. This example is the third scroll. In the first section people are shown enjoying themselves playing games of *go*, backgammon, chess, or engaging in physical contests, or watching cockfights, dog fights and so forth. The second half of this scroll portrays monkeys, rabbits, frogs and other animals behaving as humans. The ink drawings exhibit a mastery of brushwork, which shares many common characteristics with the drawings of Buddhist icons of this period. Thus the painter of this scroll is believed to have belonged to the *ebusshi* (painters who resided at Buddhist monasteries).

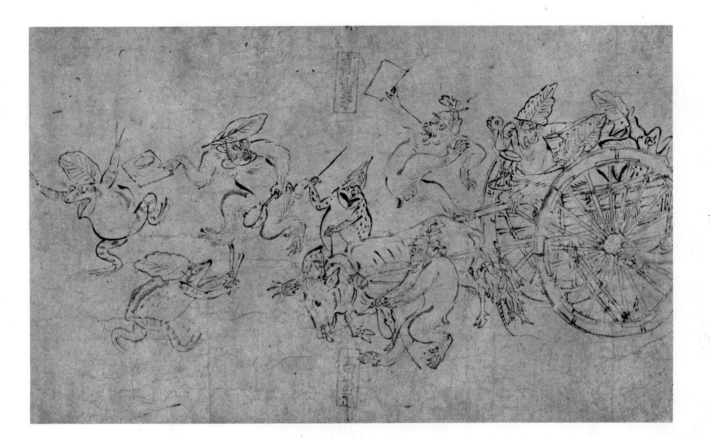

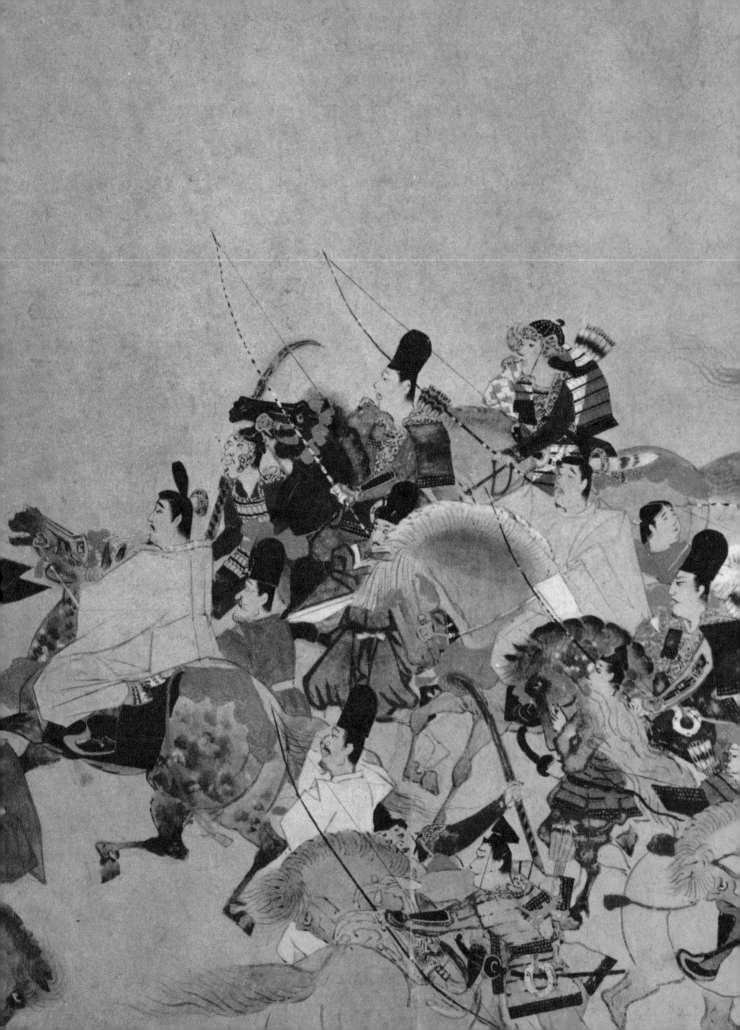

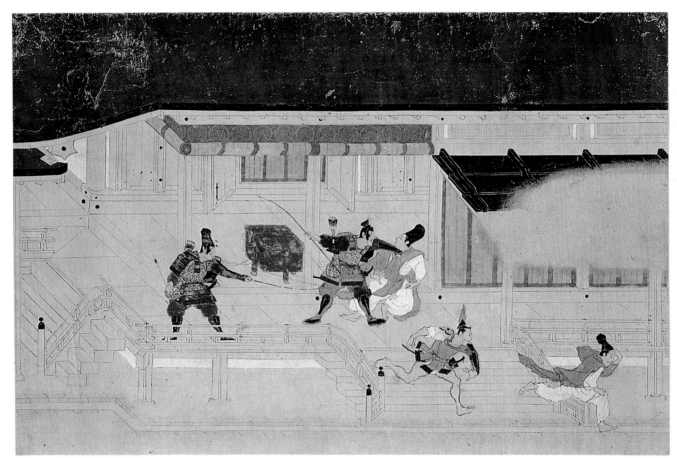

**34) Heiji Monogatari (The Tale of Heiji
—The Royal Visit to Rokuhara)**

Kamakura period, first half of the
thirteenth century.
Makimono, ink and colour on paper.
Height 16⅝", Length 333⅝".
National Museum, Tokyo.
Registered National Treasure.

This scroll painting is an adaptation of the
tale, *Heiji Monogatari,* a romance concerning
the Civil War which took place in the first
year of the Heiji era (a.d. 1159) between the
two most powerful clans of the time, the

Minamoto and the Taira. Three scrolls of the
original set have survived; one is "The Burn-
ing of the Sanjō Palace" in the collection of
the Museum of Fine Arts, Boston; the second
is "The Story of Shinzei" owned by the
Seika-dō Foundation; the third, in the exhibit,
depicts "The Royal Visit to Rokuhara
Mansion." This painting is often considered
the best of the three scrolls. The dynamic
treatment of the figures, the deft handling of
the composition and the architectural detail
are notable features of this great painting. It
is, in fact, one of the best examples of
Yamato-e of the Kamakura period.

The four sections of the scroll illustrate
the following incidents:

1. Fujiwara-no-Nobuyori, a general in
 Minamoto-no-Yoshitomo's force, searches
 the Imperial Palace and learns that the
 Emperor has fled to Kiyomori's house.
2. Disguised as a woman, Emperor Nijō
 escapes from the Palace and flees to Taira-
 no-Kiyomori's residence at Rokuhara.
3. Informed that the Emperor is at Roku-
 hara, court nobles hasten to attend him.
4. Bifukumon-in, the Imperial Consort,
 flees from her residence, Hachijō-den, to
 join the Emperor at Kiyomori's house.

35) **Haseo Kyō Sōshi**
 (**The Story of Lord Haseo**)
Kamakura period, early fourteenth century.
Makimono, ink and colours on paper.
Height 11¾", Length 384".
Mr. Moritatsu Hosokawa, Tokyo.
Registered Important Cultural Property.

This handscroll relates a story about
Ki-no-Haseo, a famous scholar and poet of
the early Heian period. It tells how Haseo
played *sugoroku* (a kind of backgammon)
and won a beautiful girl from a demon who
lived on the Shūjaku Gate. Haseo, despite

his promise to the demon not to touch the
girl, embraced her, whereupon she turned
into water. On learning that the promise
had been broken, the demon was enraged
and attacked Haseo who escaped with the
help of a Shinto god, Kitano Tenjin.

 The "Story of Lord Haseo" is typical of
popular legends related in this manner
during the Kamakura period. The unknown
artist was an excellent early fourteenth
century *Yamato-e* painter.

 The incidents illustrated are:
 1. A stranger, who is in fact the demon
 of the Shūjaku Gate, appears in human

form and visits Haseo's house. He
praises Haseo as the best *sugoroku*
player of the time and challenges him
to a game.
2. Accompanied by the demon, Haseo
 goes to the Shūjaku Gate.
3. The demon points to the place at the
 gate where they will play the game.
4. During the game, the demon, who is
 losing, grimaces.
5. The demon, as a human, brings to
 Haseo the beautiful girl the latter
 had won.
6. Haseo embraces the girl despite his

promise not to touch her, and she turns
into water.

7. One evening, on his return from the
Imperial Palace, Haseo meets the
enraged demon. He prays to the Shinto
deity, Kitano Tenjin, and barely escapes
destruction at the hands of the demon.

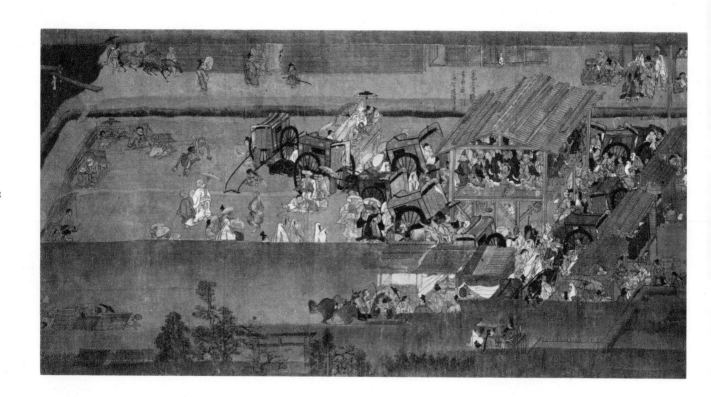

**36) Ippen Shōnin Eden (Illustrated Life
of Priest Ippen, Vol. VII)**
By En-i.
Kamakura period, a.d. 1299.
Makimono, ink and colours on silk.
Height 14⅞″, Length 306¼″.
National Museum, Tokyo.
Registered National Treasure.

Ippen (a.d. 1239-1289), founder of the
Ji-shū sect of Buddhism, spent the greater
part of his life on missionary trips through-
out the country. He visited many Shinto
shrines and Buddhist temples, preached the

Nembutsu faith to the nobles and com-
moners, and contributed to the populariza-
tion of the Belief of the Pure Land. His life was
portrayed in twelve illustrated scrolls by
Priest En-i, to commemorate the tenth
anniversary of Ippen's death.

Throughout this illustrated biography,
the painter depicted in detail many places
along the route of Ippen's travels. The scroll
is noted for its superb landscapes.

This scroll is the seventh of the set and
illustrates the following events:

1. Ippen, in a.d. 1283, visits the Sekidera
 in Omi Province and people gather for
 a devotional service.
2. In a.d. 1284, Ippen preaches to the
 people at Shakadō and Inabadō
 temples in Kyoto.
3. Ippen builds in the same year a hall at
 Ichiya, a site sacred to the memory
 of Priest Kuya, one of the patriarchs of
 the Nembutsu faith.

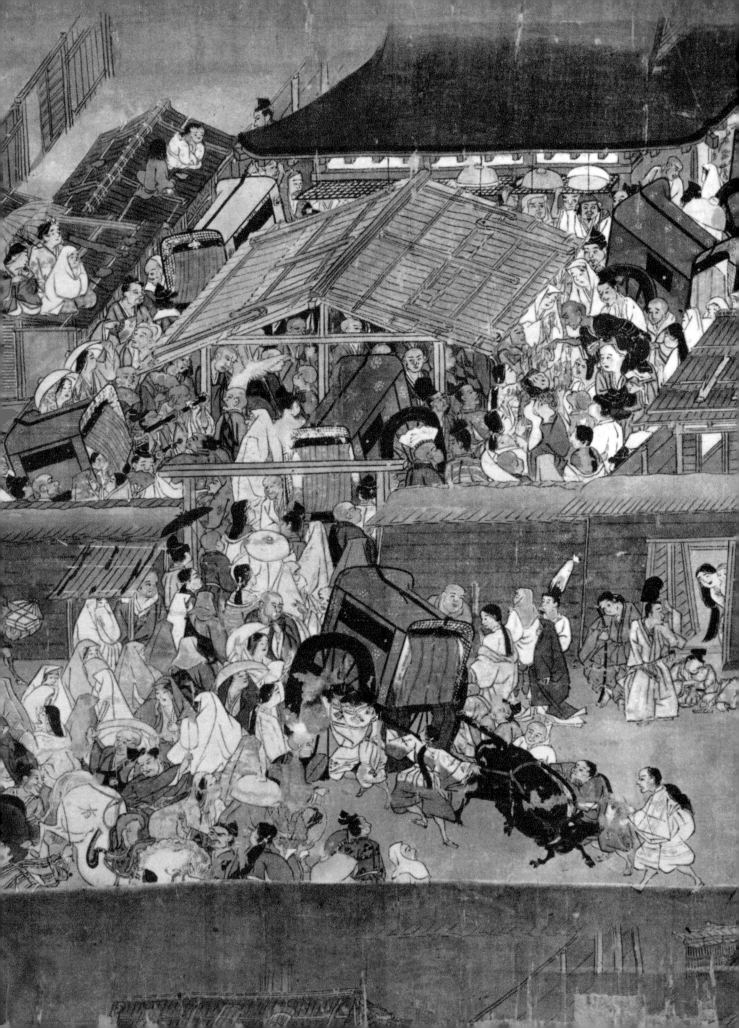

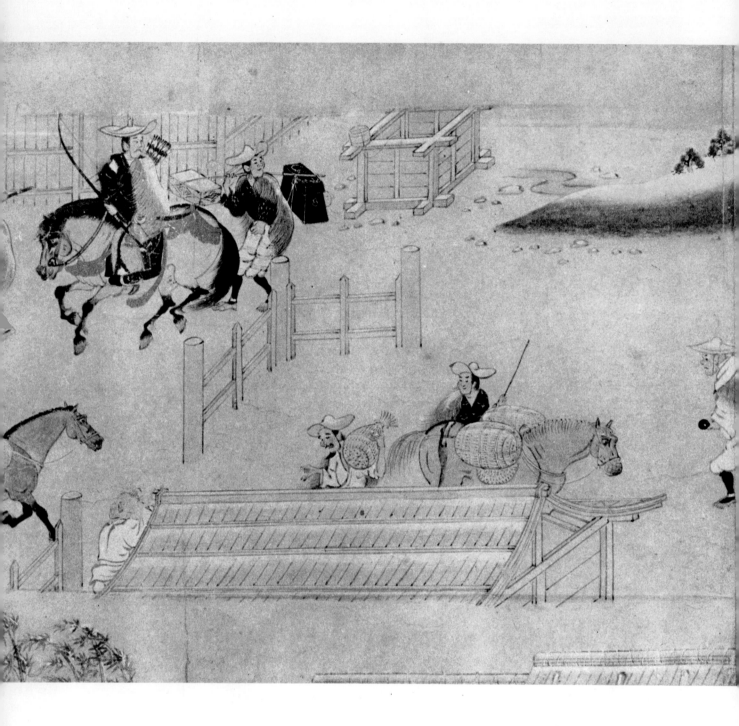

37) **Ishiyama-dera Engi (Illustrated
 History of Ishiyama Temple, Vol. III)**
Kamakura period, fourteenth century.
Makimono, ink and colours on paper.
Height 13¼", Length 669⅜".
Ishiyama-dera, Shiga.
Registered Important Cultural Property.

Many temples and shrines had scrolls made
to illustrate their traditions and miracles in
order to impress the people. "The History of
Ishiyama Temple" is related in seven scrolls,
completed late in the Kamakura period.
Among the seven scrolls the first three are

generally accepted as being from the
original set. This is the third scroll.

It shows a refinement reflecting the highly
developed decorative style of *Yamato-e*. The
painting resembles another well known
work of the same period, the *Kasuga
Gongen Reigenki,* painted by Takashina
Takakane. He is sometimes assumed to have
painted the *Engi.*

The illustrations are as follows:
1. The procession of the Princess Higashi-
 Sanjō-in proceeds to Ishiyama-dera
 through a snowy landscape.
2. The Princess visits the temple again

and attends a mass.
3. The daughter of Sugawara Takasue, the
 court lady who wrote the *Sarashina-
 nikki* in the eleventh century, visits
 Ishiyama-dera and attends an over-
 night service. She dreams she is given
 musk by the deity.

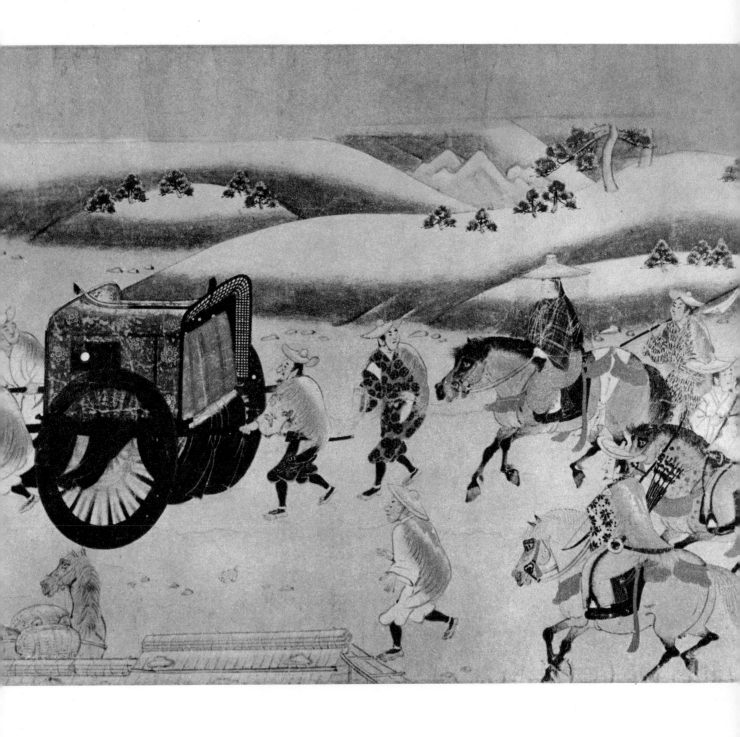

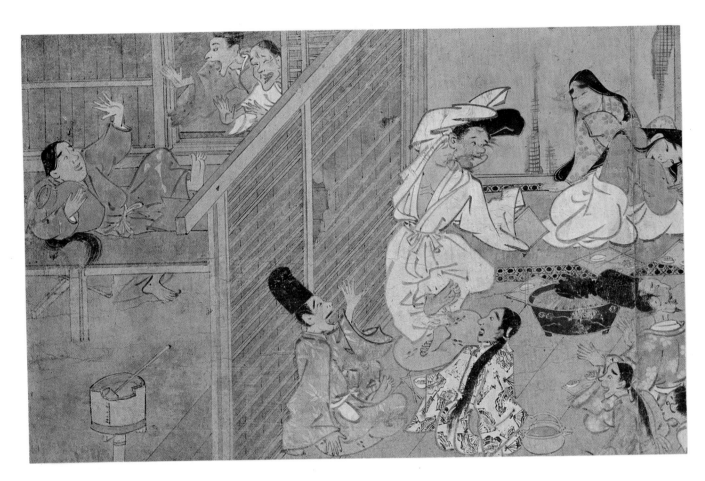

83

38) Eshi-no-Sōshi
 (Story of the Poor Painter)
Kamakura period, first half of the
fourteenth century.
Makimono, ink and colours on paper.
Height 1 1⅞″, Length 3 1 1″.
His Majesty the Emperor of Japan.

The scroll tells the story of a poor painter,
who held a big family party celebrating his
appointment as Governor of Iyo Province.
Later he found that his domain was already
occupied and that none of the land tax
would revert to him. He attempted a number
of times to resolve the issue, but failed.
In his last effort to secure aid he turned to
a nobleman in Hōshō-ji who was an official
magistrate of painting. Failing once again,
in his despair he became a Buddhist monk
and painted a record of his life.

 This scroll is noted among the paintings
of the first half of the fourteenth century for
its vivid, unrestrained brushwork and sense
of humour.

 The incidents illustrated are as follows:
 1. The painter reads to his family the
 Imperial Order appointing him
 Governor of Iyo, and they drink and
 dance at the happy news.
 2. A messenger, who was sent to Iyo,
 brings a report to the painter in his
 dilapidated house telling him of the
 difficult situation in the province.
 3. The painter entreats the nobleman in
 Hōshō-ji for help, fails, and returns
 in despair.

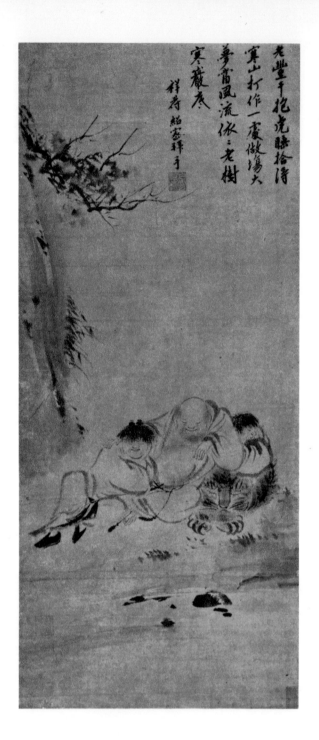

39) The Four Sleepers

By Mokuan.
Namboku-chō period, fourteenth century.
Kakemono, ink on paper.
Height 27½", Width 14¼".
Maeda Ikutokukai Foundation, Tokyo.
Registered Important Cultural Property.

The priest-painter Mokuan Reien travelled
to Yüan dynasty China during the Kareki
era (a.d. 1326-1328) and visited many
famous Buddhist monasteries. He studied
the style of the Sung dynasty master,
Mu-ch'i and was called "a rebirth of

Mu-ch'i." He died in China sometime in the
early 1340's. Mokuan occupies an important
position as a pioneer in the history of
Japanese *suiboku* (ink) painting.

The painting shows Bukan (Fêng-kan), a
Chinese priest of the T'ang Dynasty accompa-
nied by his pet tiger and Kanzan (Han-shan)
and Jittoku (Shih-tê) who are said to have
been his friends or disciples, all sound asleep.
The theme symbolizes the world of absolute
tranquility, which is the ideal of Zen Budd-
hism. This work was painted in China and
the inscription written above the painting is
by a Chinese Zen priest, Hsiang-fu Shao-mi.

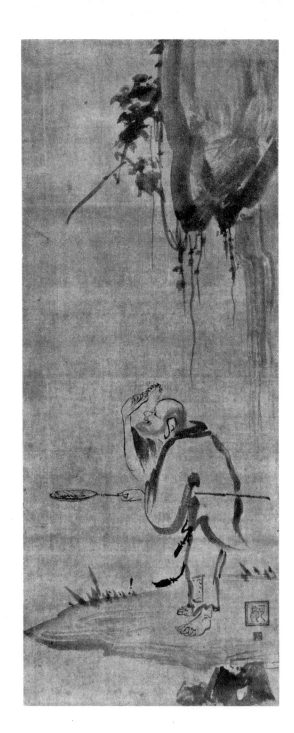

40) Kensu (Chien-tzū)
By Kaō.
Namboku-chō period, middle of the
fourteenth century.
Kakemono, ink on paper.
Height 34″, Width 13⅝″.
National Museum, Tokyo.
Registered Important Cultural Property.

The subject of this painting, Kensu, was a
prominent Zen priest in Sung dynasty China
who attained enlightenment while catching
and eating shrimp and shell fish. Kensu,
shown scooping shrimp with a net, was a
favorite theme of *suiboku* painters.

Kaō was a monk-painter who was active
in the middle of the fourteenth century and
is regarded as one of the pioneers of Jap-
anese *suiboku* painting. Although a number
of paintings attributed to him have sur-
vived, details of his life are rather obscure.
His skill is, however, fully evident in
the precise representation of the subject
with simple but effective use of the brush
and gradation of ink.

41) Orchids and Bamboo in Moonlight
By Gyokuen Bompō (died about a.d. 1420).
Muromachi period, beginning of the
fifteenth century.
Kakemono, ink on paper.
Height 29⅛″, Width 13¼″.
National Museum, Tokyo.

The orchid and bamboo traditionally
symbolize the Oriental ideal of the
cultivated gentleman.

The Chinese orchid *(cymbidium)*, has
delicate foliage and small flowers of
remarkable fragrance. Because of these
characteristics it symbolizes modesty
and nobility. The bamboo is symbolic of
longevity, as it is eternally green, as well as
humility and fidelity. The stem is hollow
inside and straight outside and it bends to a
storm but never breaks.

Gyokuen Bompō was a Zen priest, and
gifted as a poet, calligrapher and painter.
He is renowned for his refined ink paintings
of orchids in the style of the great Chinese
painter and Zen priest P'u-ming (act. a.d.
1340-1350). The poem inscribed on this
painting was written by Bompō, praising the
nobility and purity of orchids and bamboo.

42) Landscape

Attributed to Sōkei.
Muromachi period, a.d. 1490.
Four fusuma, ink and slight colour on paper.
Height 66⅞″, Width 45¾″ (each).
National Museum, Kyoto.
Registered Important Cultural Properties.

Shown here are four of twenty-eight *fusuma*
(sliding doors) from the Yōtoku-in of
Daitoku-ji, Kyoto, said to have been painted
in a.d. 1490 by Oguri Sōkei.
 Sōkei was the son of Sōtan and follower
of Shūbun, and was in charge of the
painters' guild for the Ashikaga Shogun.
He usually worked in the soft Mu-ch'i
manner, but, on these sliding doors he
proved that he could also master the crisp
linear Hsia Kuei style.

43) **Landscape**
By Sesshū (a.d. 1420-1506).
Muromachi period, a.d. 1474.
Makimono, ink on paper.
Height 9", Length 61¾".
Mr. Nagatake Asano, Tokyo.
Registered Important Cultural Property.

Sesshū is generally considered the greatest
Japanese *suiboku* artist. He studied painting
with Shūbun at the beginning of his career,
but changed his style completely as a result
of his visit to China, from a.d. 1467 to 1469.
Strongly impressed by all that he saw

during his travels, he devoted his time to
studying Ming interpretations of such
masters of the Southern Sung dynasty as
Ma Yüan and Hsia Kuei. As a result, he
created a unique style of landscape painting
which emphasized broad vistas and
atmospheric effects.

This scroll was painted in a.d. 1474 in
the style of the Yüan master, Kao K'o-kung,
as a gift for his pupil, Tōetsu (act. a.d.
1489-1500). However, it was divided into
two parts about a.d. 1680 and later the
second section was lost. Fortunately, an
artist of the Hasegawa school copied the

lost part, and his version is attached to the
end of this scroll.

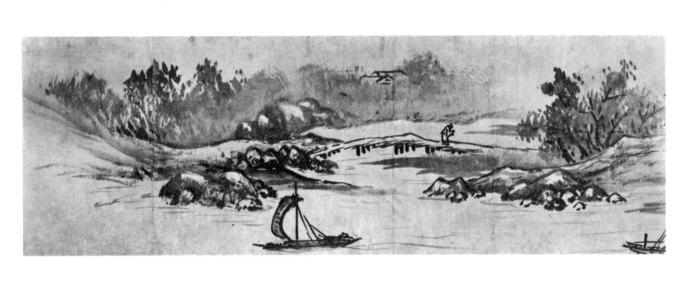

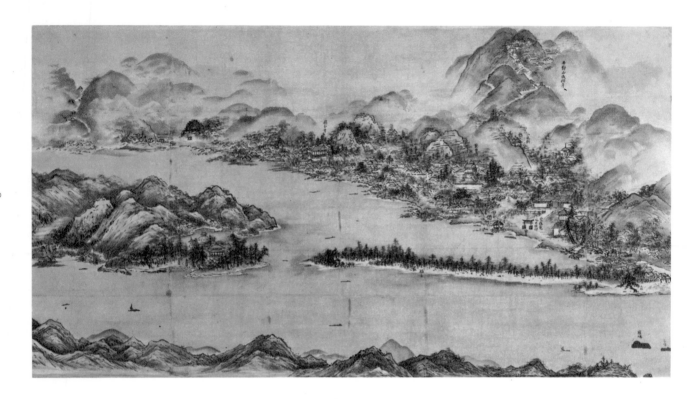

90

44) Ama no Hashidate
By Sesshū (a.d. 1420-1506).
Muromachi period, early sixteenth century.
Kakemono, ink on paper.
Height 35⅛", Width 66½".
National Museum, Kyoto.
Registered National Treasure.

Ama no Hashidate (Bridge of Heaven) is
one of the three most famous scenic spots in
Japan. Located on the coast of the Japan Sea,
northwest of Kyoto, it is a long sandy
peninsula jutting out into the sea, covered
with pine trees. Apparently Sesshū visited

this beautiful place in the latter years of his
life. When he was about 80 years old he
painted this landscape. The scenery is shown
in the traditional "bird's-eye view." Sesshū
is most successful here in suggesting the
misty atmosphere which envelops the
scenery and in unifying the various elements
of this vast panorama.

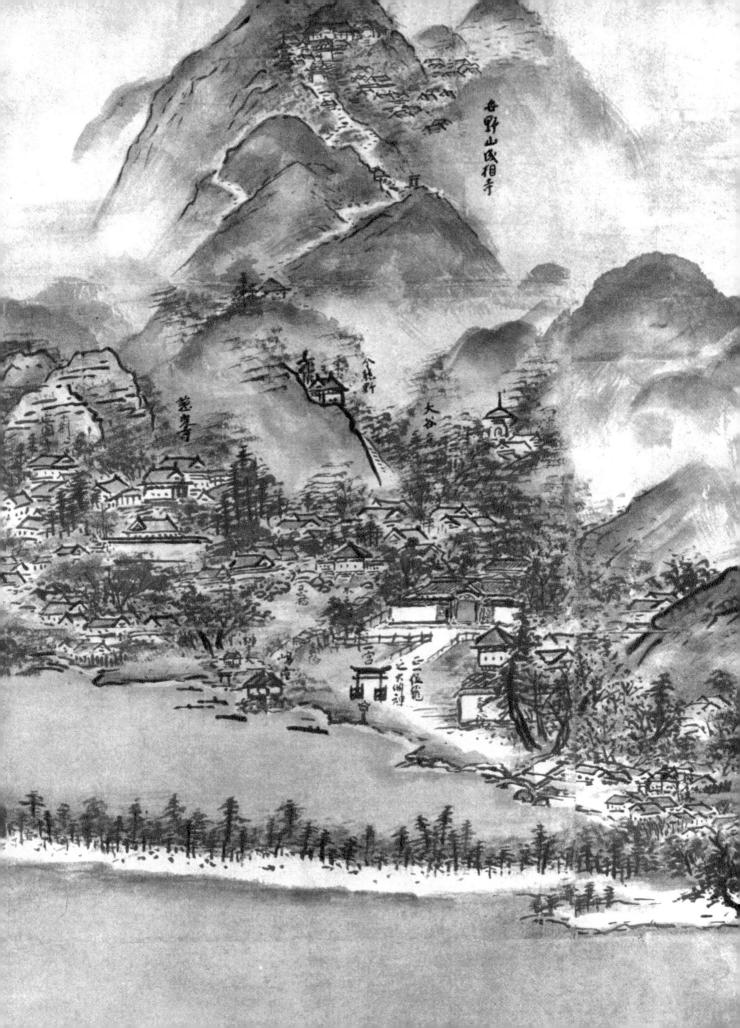

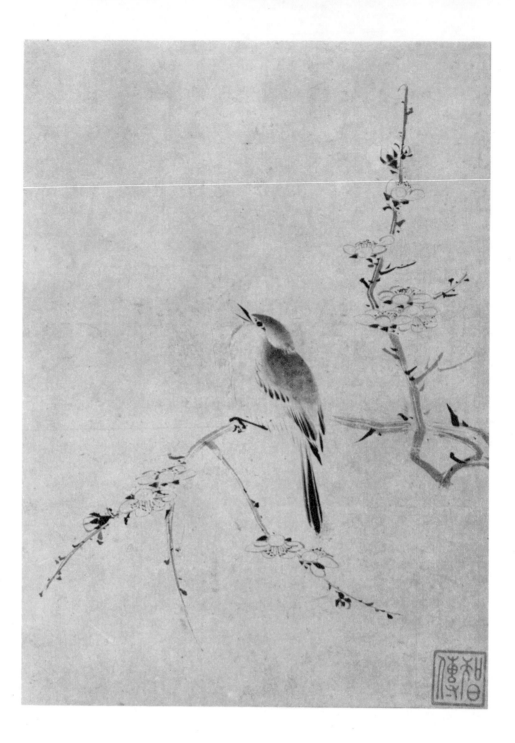

92

45) **Bird on a Flowering Plum Branch**
By Tan-an Chiden (Act. 1504-1520).
Muromachi period, sixteenth century.
Kakemono, ink on paper.
Height 11⅛″, Width 8″.
Mr. Ryōichi Hosomi, Osaka.
Registered Important Art Object.

Tan-an was asked by Sōami to become his
pupil. Sōami, with Nōami and Geiami,
enjoyed the special patronage of the
Shogunate. Their work is distinguished by
soft brushwork and rich ink effects. This
style was continued by succeeding genera-
tions of the family, and came to be known
as the Ami school.

Tan-an, though trained by Sōami,
developed a style of his own. He seems to
have been most proficient in the depiction
of flowers and birds, and this painting is one
of his most representative works. Unfor-
tunately few details of his life are known,
but it is believed that he died at an early age.

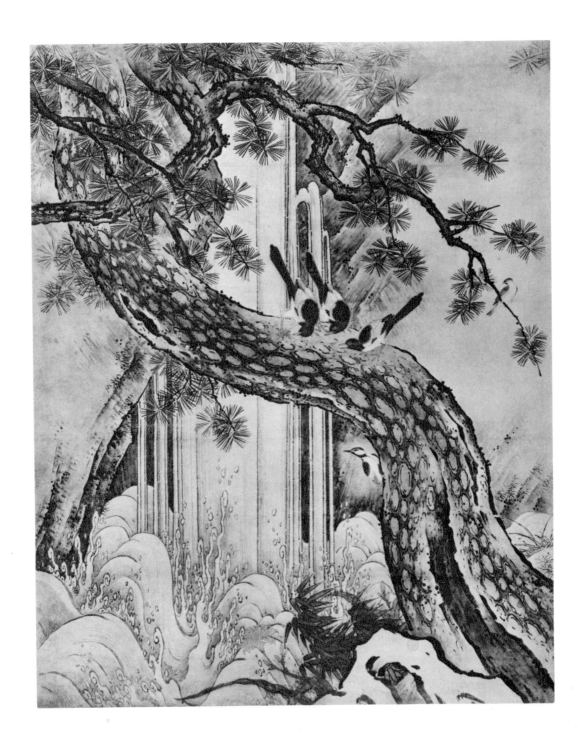

46) Birds and Flowers by a Waterfall
Attributed to Kanō Motonobu
(a.d. 1476-1559).
Muromachi period, a.d. 1509.
Pair of kakemono, ink and colours on paper.
Height 68¾", Width 54⅞" (each).
Daisen-in, Kyoto.
Registered Important Cultural Properties.

These paintings were originally mounted as
sliding doors in the Daisen-in of Daitoku-ji.
Motonobu, the son of Masanobu, to whom
the paintings are attributed, was in charge of
the painters' guild under the patronage of

the Ashikaga Shogunate. Both father and
son were founders of the Kanō school which
became the main and official current of
Japanese painting. The Kanō style fused
elements of traditional Japanese and Chinese
painting.

In this work, Motonobu uses the colour
and decorative sense of *Yamato-e*, and
combines it with the strong linear quality of
Chinese ink painting. Although the
kakemono are unsigned the attribution to
Motonobu is generally accepted.

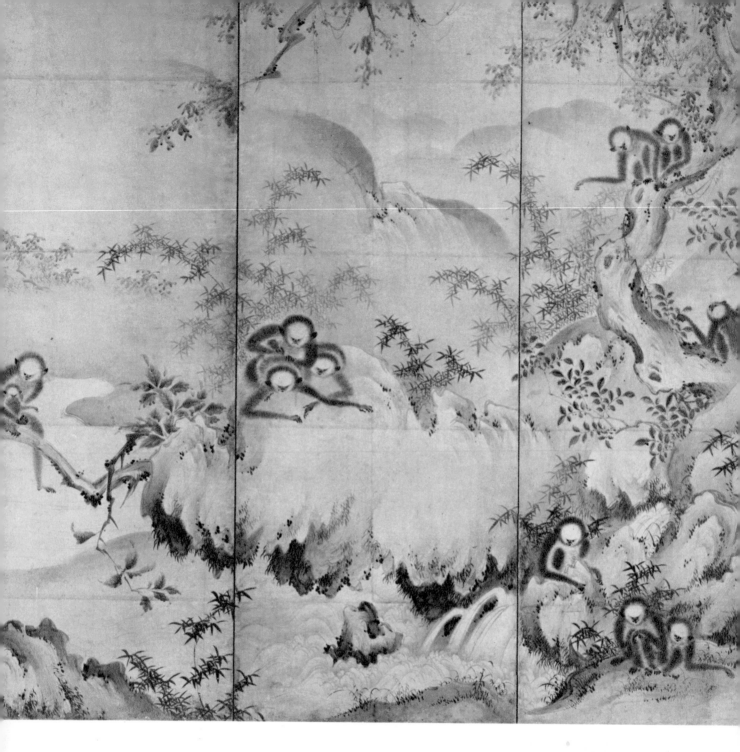

47) Monkeys

By Ryūkyō.
Muromachi period, sixteenth century.
Pair of six-fold screens, ink on paper.
Height 57″, Width 11⅛″ (each).
National Commission for Protection of
Cultural Properties.
Registered Important Cultural Property.

Very little is known about the artist Ryūkyō
save that he produced a number of paintings
and was active at the end of the Muromachi
period. It is believed that he, as were others,
was influenced by the work of Mu-ch'i.

Another name associated with Ryūkyō was
Shikibu and the seal on this painting can
be so read.

Monkeys were a favorite subject for ink
painters of this time.

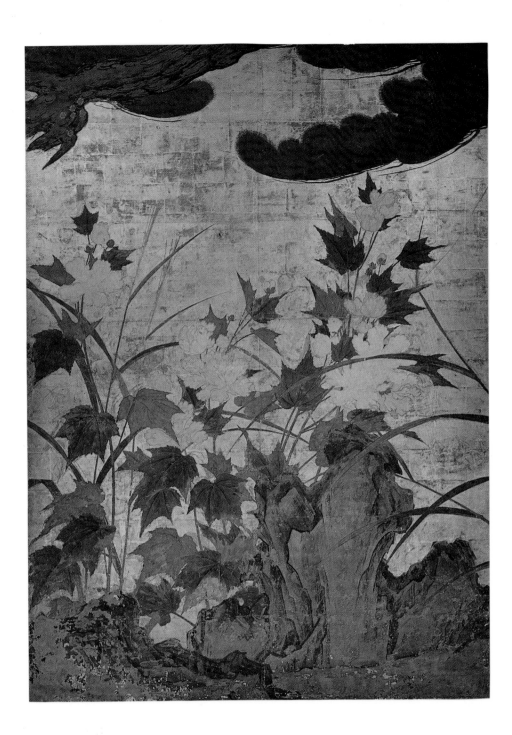

48) Pine Trees, Grasses and Flowers
Momoyama period, sixteenth century.
Two-fold screen, ink and colours on gold-leafed paper.
Height 90", Width 120".
Chishaku-in, Kyoto.
Registered National Treasure.

Many castles and residences were built in the Momoyama period. For these buildings numerous colourful and richly decorative paintings were produced for screens and sliding doors. Among these the sliding doors in the Chishaku-in collection are the finest masterpieces. The Chishaku-in was built at the beginning of the seventeenth century and was heir to the architectural remains of the Shōun-ji monastery, built in a.d. 1591 by Toyotomi Hideyoshi. It is believed that these two panels were originally *fusuma* from Shōun-ji.

Although the artist who produced these paintings is unknown, his style would identify him as a member of the Hasegawa school. In the past they have often been attributed to Tōhaku (a.d. 1539-1610).

49) Monkeys and Bamboo Grove
By Hasegawa Tōhaku (a.d. 1539-1610).
Momoyama period, sixteenth century.
Pair of six-fold screens, ink on paper.
Height 60", Width 132½" (each).
Shōkoku-ji, Kyoto.
Registered Important Cultural Property.

Hasegawa Tōhaku called himself a fifth
descendant of Sesshū. He founded the
Hasegawa school in opposition to the Kanō
school, which had already established its
position in the main stream of Japanese
painting. Tōhaku excelled in the use of both
ink and colours. When painting with the
former medium he followed the styles
of Sesshū and Mu-ch'i, the latter's influence
being evident in these screens.

The artist's personal style of ink paint-
ing is manifested in the lyrical and tender
treatment of the subject.

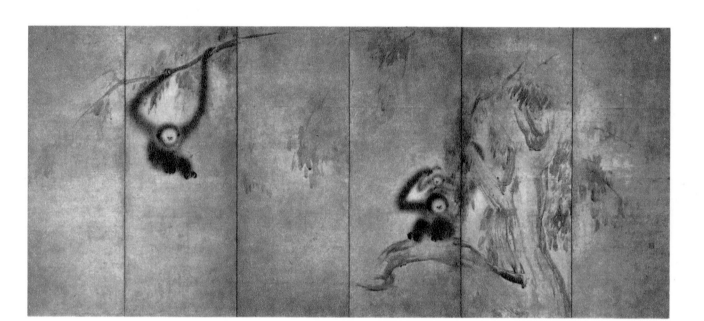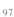

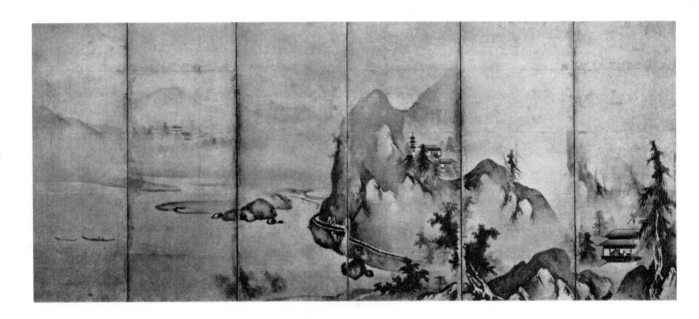

50) Landscape

By Kaihō Yushō (a.d. 1533-1615).
Momoyama period, a.d. 1602.
Six-fold screen, ink on paper.
Height 59¹⁄₁₆, Width 130⁵⁄₁₆".
National Museum, Tokyo.

Yushō, born in a samurai family, turned to painting after serving an apprenticeship at Tōfuku-ji in Kyoto. His colouring technique and ink painting are characterized by the economical use of brush strokes of strong intensity reflecting his samurai heritage.

He established the Kaihō school, per-petuated by his descendants to the end of the Edo period.

This screen, painted in ink, is regarded as one of his most important and characteristic works. The date of a.d. 1602 is written on it.

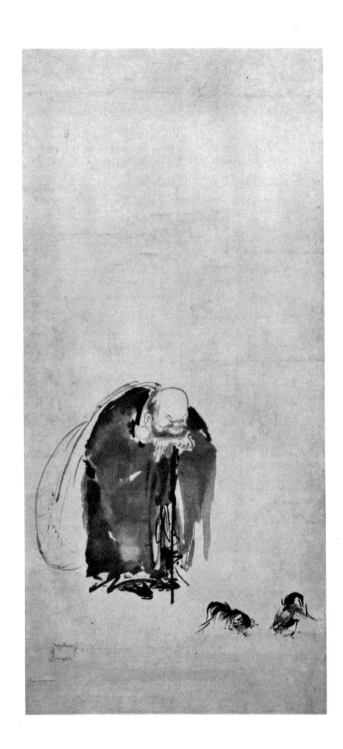

51) Hotei Watching a Cockfight
By Miyamoto Musashi (a.d. 1584?-1645).
Edo period, first half of the seventeeth century.
Kakemono, ink on paper.
Height 28⅛", Width 12½".
Mr. Yasuzaemon Matsunaga, Kanagawa.
Registered Important Art Object.

Miyamoto Musashi, also known as Niten,
was a samurai whose prowess as a swords-
man was legendary. He was also known for
his artistic talent. His ink paintings are
marked by a very personal style, noteworthy
for strong brush strokes. His manner is
somewhat akin to that of the Chinese artist,
Liang-k'ai in the dynamic use of few,
expressive lines.

Hotei, popularly considered one of the
Seven Gods of Good Fortune, is shown here
as a Zen priest, attaining enlightenment
while watching a cockfight.

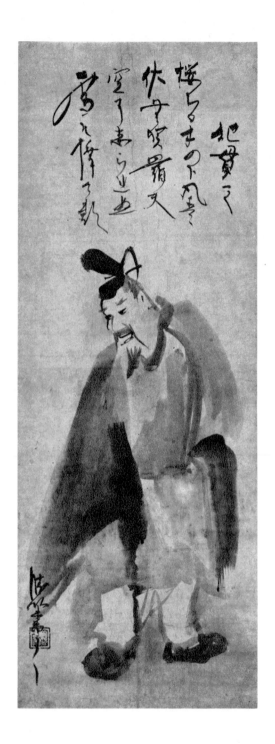
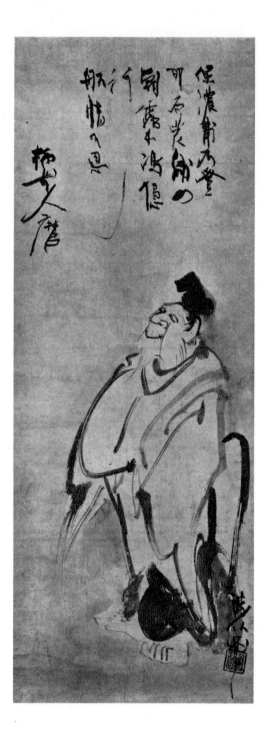

52) Hitomaro and Tsurayuki

By Iwasa Shōi.
Edo period, seventeenth century.
Pair of kakemono, ink on paper.
Height 37″, Width 14″ (each).
Atami Art Museum, Shizuoka.
Registered Important Cultural Property.

Both Hitomaro and Tsurayuki are included among "The Thirty-six Immortal Poets" of Japan. Hitomaro was one of the most noted poets of the Nara period and his works are also included in the *Mannyōshū*. Tsurayuki was active during the Heian period and his poems also appear in the *Kokinshū*.

Imaginary portraits of these famous poets were made as early as the Kamakura period. Shōi, who is popularly known as Iwasa Matabei, added a humorous and popular flavor in the Edo period to the traditional *Yamato-e* style. His unique brushwork, swift and bold, came to be known as the Matabei style. Traditionally the artist is considered a forerunner of the *Ukiyo-e* school.

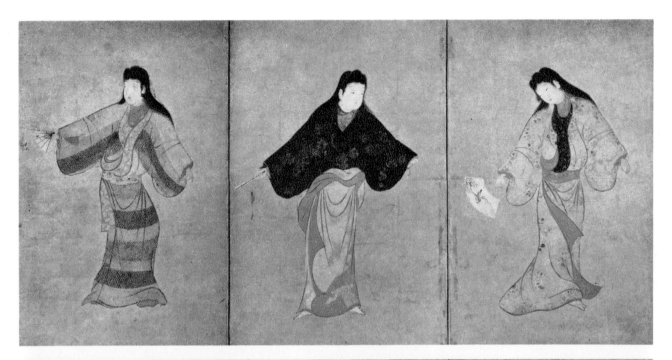

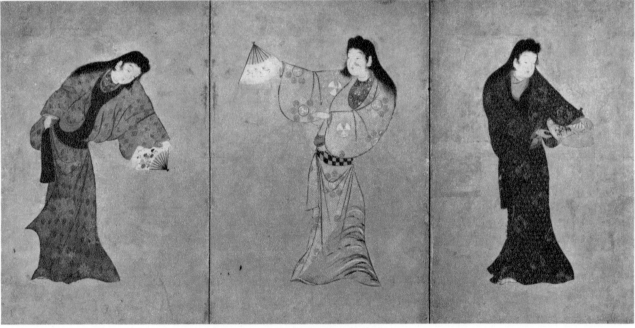

53) Dancers
Edo period, seventeenth century.
Six-fold screen, ink and colours on gold-
leafed paper.
Height 24½", Width 97¼".
The Municipality of Kyoto.
Registered Important Cultural Property.

This screen is a representative genre
painting of the early Edo period. One dancer
is painted on each of the six folds. From the
mode of the dancers' costumes it is believed
to date from the Kan-ei period (a.d. 1624-
1643) Although, apparently in the
Yamato-e style, the details of the flowers-
and-birds on the fans held by the dancers,
indicate an artist of the Kanō school. Genre
paintings were produced in quantity from
the Momoyama through the Edo period and
reflect the popular taste of the day. They
belong to a formative stage in the develop-
ment of *Ukiyo-e*.

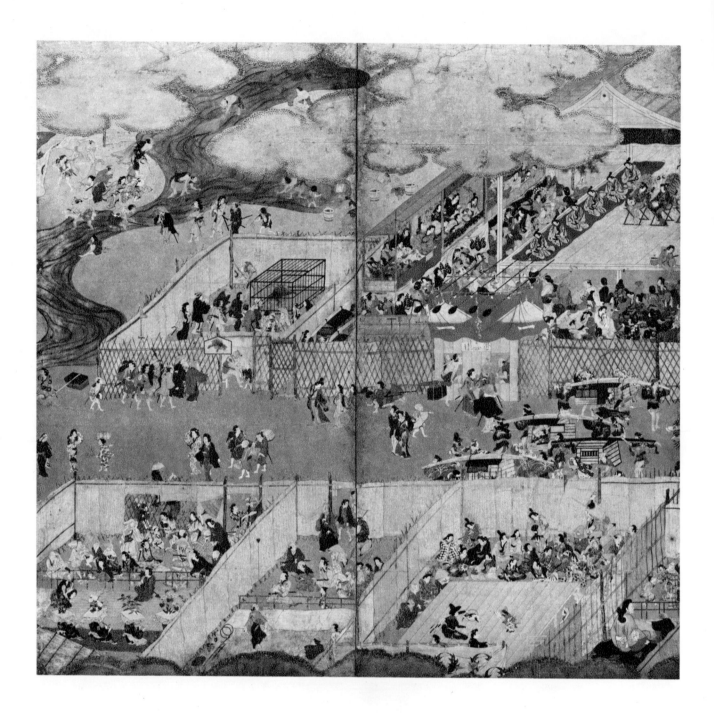

54) Amusements at the Shijō Riverside Resort

Edo period, seventeenth century.
Pair of two-fold screens, ink and colours on paper.
Height 64⅝″, Width 67⅞″ (each).
Seikadō Foundation, Tokyo.
Registered Important Cultural Property.

In the Edo period there was an amusement center on the bank of the Kamo River at Shijō in Kyoto. The many diversions available at the resort, *kanjin-noh* (noh plays performed to raise religious funds), *onna kabuki* (*kabuki* performed by women dancers) and many other interesting side shows are brought to life on the screens.

These paintings are the work of an artist owing allegiance neither to the academic Kanō nor Tōsa schools. Instead they are an expression of the artist's interest in the daily life and customs of the people. Painters such as this gradually established *Ukiyo-e*.

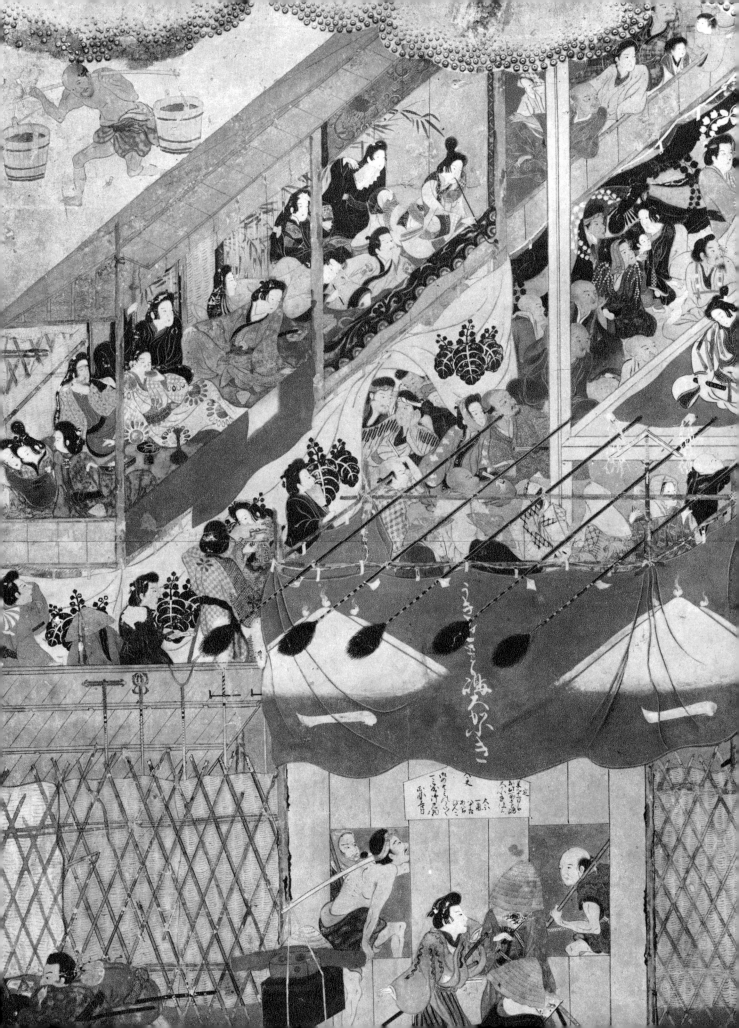

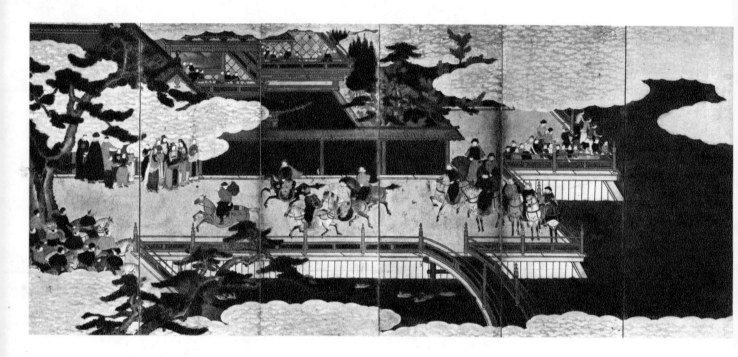

55) Namban Byōbu
 (Europeans in Japan)
Momoyama period, sixteenth century.
Pair of six-fold screens, ink and colours on
gold-leafed paper.
Height 61″, Width 146″.
National Museum, Tokyo.

From a.d. 1542 to the beginning of the
seventeenth century, the number of ships
carrying Westerners and cargo to Nagasaki
and Sakai increased greatly. The curiosity of
the Japanese was aroused by the strange
foreigners and their customs. As a result

they portrayed them on screens.
 On the right screen, a foreign ship has
dropped anchor and is unloading its cargo.
On the left screen, the Westerners are enjoy-
ing horseback riding. The artist was
presumably of the Kanō school. However,
he employed unusual techniques, which
apparently were imported from the West.
The screens are important documents
for the study of Japan's early contacts with
Europe.

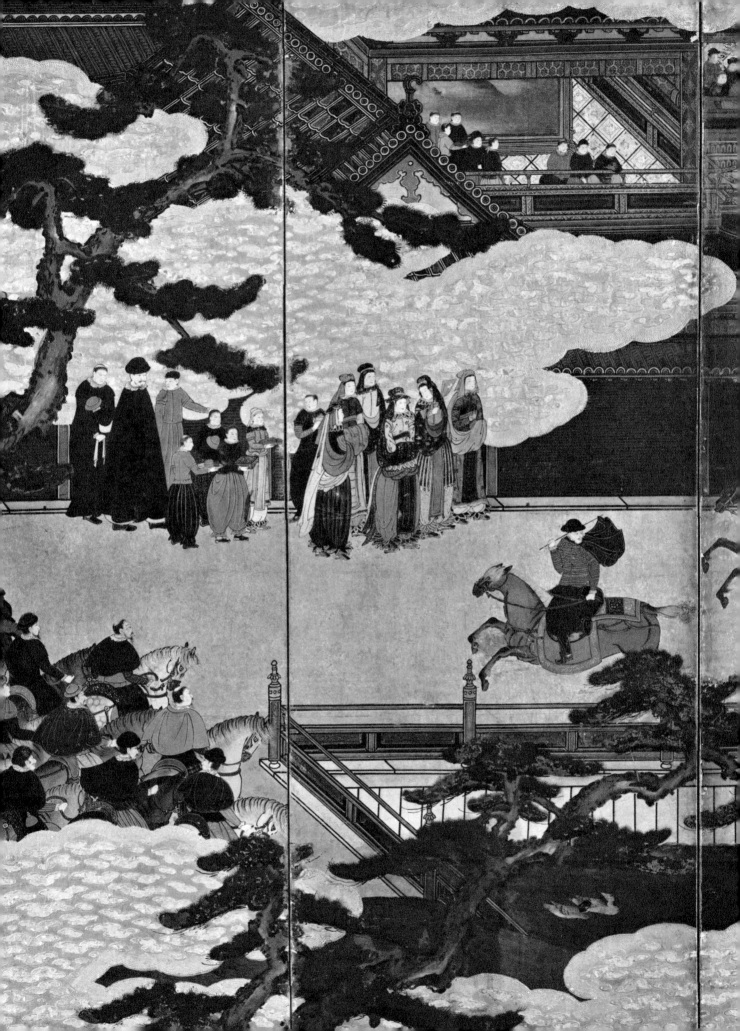

**56) Kuruma Arasoi
(Battle of the Carts—
the Tale of Genji)**
Attributed to Kanō Sanraku
(a.d. 1559-1635).
Momoyama period, seventeenth century.
Four-fold screen, ink and colours on
gold-leafed paper.
Height 69¼", Width 146".
National Museum, Tokyo.
Registered Important Cultural Property.

The subject is taken from the first book of
the *Tale of Genji*. It illustrates the incident

when Lady San-no-Miya was about to
depart for the Ise shrine to serve as an
attendant Virgin, escorted by Prince Genji.
The scene is the main street of Kyoto, which
was filled with a bustling crowd, gathered
to view the procession. In the midst of the
confusion, several bullock carts vied to
obtain a favorable position to see the
famous couple.

This screen was made from paintings
removed from *fusuma* originally in the
mansion of the Kujō family. Kanō Sanraku,
to whom it is attributed, was a great master
of the Momoyama period. As a member of

a collateral branch of the Kanō school, he
was free to deviate from the established
style. He also worked in a *Yamato-e* style,
but added a lighter touch to it.

57) Shuten Dōji Emaki
By Kanō Tanyu (a.d. 1602-1674).
Edo period, seventeenth century.
Three makimono, ink and colours on paper.
Height 13¼″.
Mr. Nagatake Asano, Tokyo.
Registered Important Art Object.

Tanyu was an artist who served the
Tokugawa Shogun in the early Edo period.
He painted many *fusuma* and folding screens
for castles, temples and shrines and also left
many scrolls. He was known as a versatile
artist and a very serious painter. Tanyu
studied an amazing number of old master-
works, copying them faithfully, and became
one of the great figures of the Kanō school.

These makimono illustrate the famous
story of the murder of a thief named Shuten
Dōji, who, with his men, robbed women and
properties in Kyoto. At the request of the
Emperor, Minamoto Raikō and his men, dis-
guised as priests, killed the thief while
he was drunk.

58) Poem Scroll (Fragment)
Calligraphy by Kōetsu (a.d. 1558-1637).
Painting attributed to Sōtatsu (act. early
seventeenth century).
Edo period, seventeenth century.
Kakemono, gold and silver and ink on
paper.
Height 13⅛", Length 27¼".
National Museum, Tokyo.

Poems chosen from the *Kokin Waka-shū,*
an ancient anthology, were inscribed by
Kōetsu on paper decorated with lotus flowers
in gold and silver ink. The painting is
generally attributed to Sōtatsu. This segment
was originally part of a long makimono.

Kōetsu was born in the Honami family,
which had long been authorities on swords.
He was known as a man of great artistic
talent, famed not only for his marvelous
calligraphy, but also for his creative work in
lacquer and ceramics. In the early seven-
teenth century, he founded a village of
artists at Takagamine in Kyoto. The scroll
was probably produced during his stay there.
The calligraphy and painting reflect the
sophisticated taste of the Momoyama period.

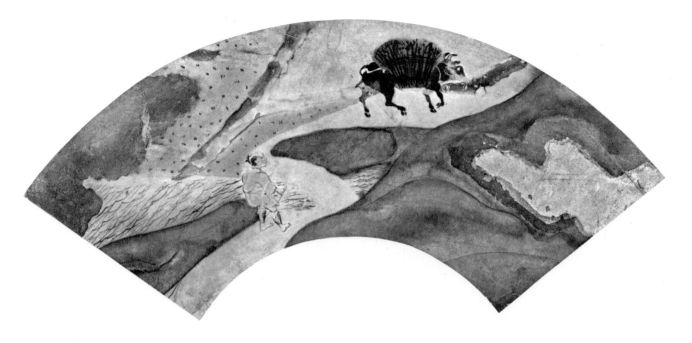

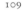

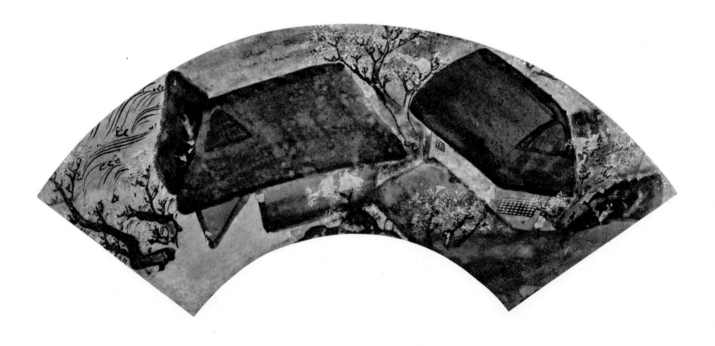

59) Screen of Fans
By Tawaraya Sōtatsu (act. early seventeenth century).
Edo period, seventeenth century.
Pair of two-fold screens, ink and colours on gold-leafed paper.
Height 66⅛", Width 61⅜".
Sambō-in, Kyoto.
Registered Important Cultural Property.

Sōtatsu, unlike the academic artists of the Kanō and Tōsa schools, lived among the common people in Kyoto. During the early seventeenth century he revived the *Yamato-e* tradition in response to the social demands for bolder and more colourful art. The characteristics of his style are a daring and free composition, enhanced by the use of bright colours.

Though small in size these fan paintings show the typical features of Sōtatsu's style and the great variety of his subjects.

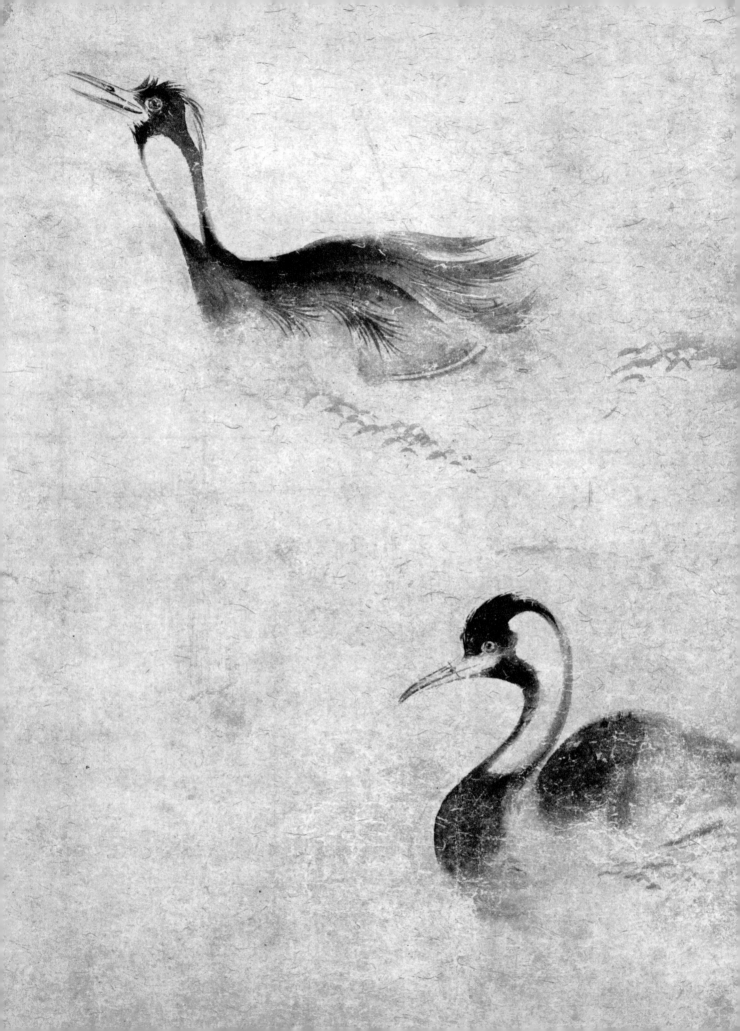

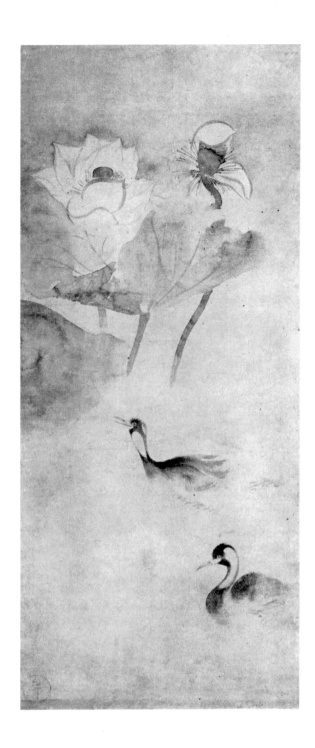

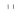

60) Waterfowl in a Lotus Pond
By Tawaraya Sōtatsu (act. early
seventeenth century).
Edo period, seventeenth century.
Kakemono, ink on paper.
Height 46", Width 19⅛".
National Commission for Protection
of Cultural Properties.
Registered National Treasure.

Sōtatsu, after having revived the classical
Yamato-e, turned to a unique style of
ink-wash painting not found in the tradi-
tional *kanga* (Chinese style painting).

His lines are smooth and broad. His style
is bold and he used the technique of
tarashikomi. It involves painting with a wet
brush in one shade of ink and then super-
imposing another shade to produce outlines
and a delicate merging of tonal values.

This kakemono is one of his finest works
using this technique, and depicts fowl
swimming in a lotus pond. It was originally
a panel of a folding screen.

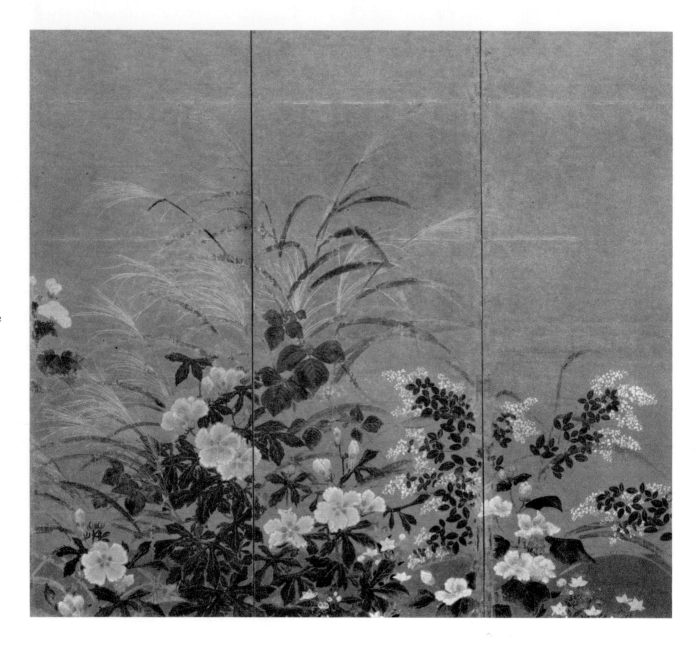

61) Autumn Flowers and Grasses
By Tawaraya Sōsetsu.
Edo period, seventeenth century.
Pair of six-fold screens, ink and colours
on gold-leafed paper.
Height 62¼″, Width 133¼″.
National Museum, Tokyo.
Registered Important Cultural Property.

Sōsetsu was a direct successor of Sōtatsu.
Plants and flowers were his favorite subjects.
Combining a moderate realism with decora-
tive qualities he developed his own unique
style of plant and flower painting. Kōrin,
the great master of decorative painting, was
much influenced by the work of this artist.

62) Autumn Flowers and Grasses

By Ogata Kōrin (a.d. 1658-1716).
Edo period, eighteenth century.
Pair of two-fold screens, ink and colours
on paper.
Height 61″, Width 70⅛″.
Suntory Gallery, Tokyo.
Registered Important Art Object.

Kōrin was related by marriage to Kōetsu and
Sōtatsu. From his youth, Kōrin admired
those masters and took them as his models.
Born the son of a rich draper in Kyoto, he
was able to devote his whole life to painting.

His beautifully elegant style suggests the
colourful atmosphere of the Genroku period
(a.d. 1688-1703).

These screens are said to have been
painted for a member of the Fuyuki family,
a wealthy merchant of Fukagawa in Edo,
who was one of Kōrin's patrons. Kōrin seems
to have favored this type of plant and flower
painting. He left quite a few examples of this
theme as designs for fans, textiles, ceramics
and other media.

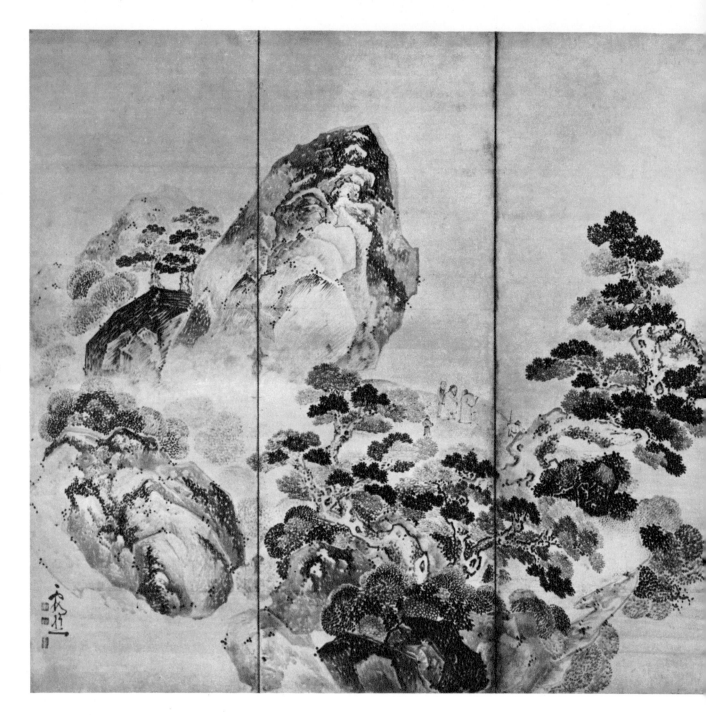

114

63) **Rising Tide at the River Ch'ien-t'ang**
By Ike Taiga (a.d. 1723-1776).
Edo period, eighteenth century.
Six-fold screen, ink and slight colours on pape
Height 65″, Width 145¼″.
National Museum, Tokyo.
Registered Important Cultural Property.

Taiga began his career as a calligrapher, but
later became interested in Chinese painting of
the literati school. The name for this school
in Japan was Nanga (Southern painting). In
preparation he studied with some of the Jap-
anese forerunners of this style such as Gion

115

Nankai, Yanagisawa Rikyō and Sakaki
Hyakusen, and brought this school to its cul-
mination. Taiga was known as an eccentric
for he wandered far and wide throughout
Japan, caring little for material things. He
drank, composed poetry and observed nature
with a perceptive eye. His fresh and vivid im-
pressions were translated into his paintings.

On the screen, he painted an autumnal
view of the rising tide in the estuary of the
river Ch'ien-t'ang. It is an idealized inter-
pretation of this famous sight in China and
is believed to have been painted during
the artist's middle years.

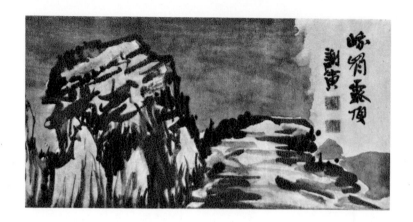

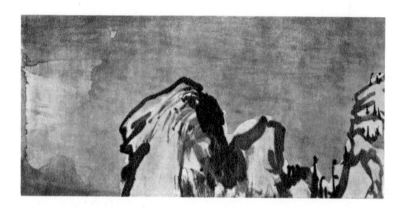

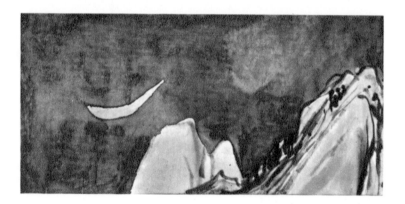

64) Gabisan (Mt. Gabi) above the Clouds

By Yosa Buson (a.d. 1716-1783).
Edo period, eighteenth century.
Makimono, ink and slight colour on paper.
Height 11½", Length 95¾".
Mr. Kōzō Yabumoto, Hyōgo.

Buson, like most Nanga artists, was an eccentric, and was distinguished as a painter and haiku poet. With Ike Taiga he was co-founder of the Nanga school. These two great masters often painted together, and their *Jūben Jūgi Chō* (Album of Ten

Advantages and Ten Attractions) is their most famous masterpiece.

The painting of Mt. Gabi shows the beautiful mountain, O-mei, in Szu-ch'uan province, China. A half-moon bathes the summit and its surrounding peaks in an ethereal white light. A quality of abstract modernity is achieved through the use of bold brushwork and broad washes.

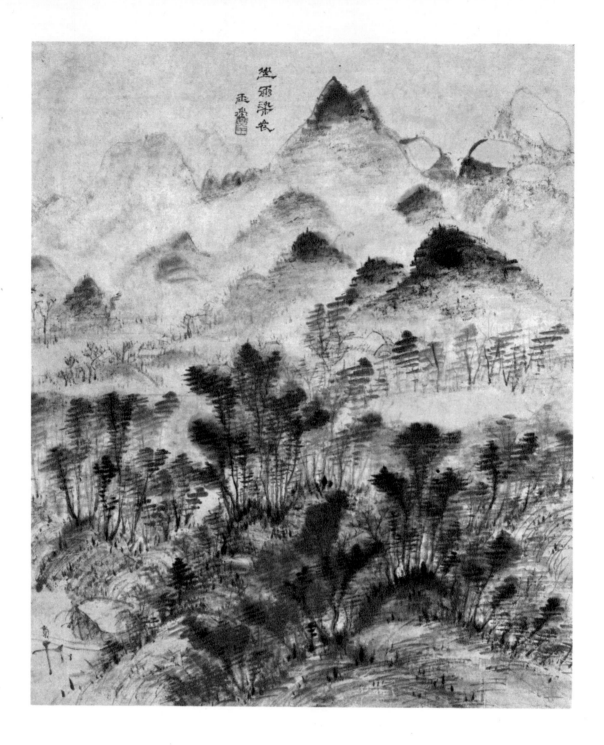

65) Mountain in Autumn Rain

By Uragami Gyokudō (a.d. 1745-1820).
Edo period, nineteenth century.
Kakemono, ink and slight colour on paper.
Height 14¾", Width 12½".
Mr. Sōichirō Ōhara, Okayama.
Registered Important Cultural Property.

Until he was forty years old, Uragami
Gyokudō was a retainer in the service of the
Ikeda family. He then joined the literati and
practiced their free way of life. Carrying a
koto and paint brushes, he roamed
throughout the country, playing and
painting as he went. His works are the most
individual of those produced by the
Nanga school.

In the foreground of this painting there is
a rain-drenched mountain and in the distance
peaks rise through the drizzle. The painting
is signed by Gyokudō who wrote the title and
affixed his seal, read "Kin-Gyoku." Although
not dated, it is stylistically a product of
his seventies.

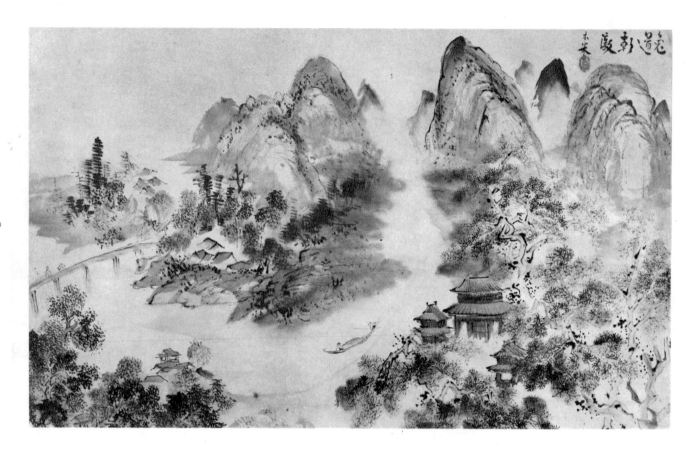

66) Sunny Morning at Uji

By Aoki Mokubei (a.d 1767-1833).
Edo period, early nineteenth century.
Makimono, ink and slight colour on paper.
Height 14¼", Width 23⅜".
Mr. Sōichiro Ohara, Okayama.
Registered Important Cultural Property.

Aoki Mokubei is best known as a potter.
Most of his ceramics were made for *sencha*
(a type of tea ceremony using tea leaves
instead of powdered tea), done in enameled
porcelain and celadon ware. Mokubei was an
intimate of Uragami Gyokudō, Rai San-yō

and Tanomura Chikuden, of the literati
circle.

This is a scene near Byōdō-in at Uji on a
sunny morning. The Phoenix Hall can be
seen through the pine trees on the lower
right, and on the left, the Uji bridge. The red
tint of the distant mountains and deep blue
are Mokubei's favorite colours.

Uji is famed for its fine tea, and as
Mokubei was a potter of tea utensils, he must
have visited Uji quite often. He painted this
theme several times.

There is no date inscribed on the paint-
ing; however, the title, the signature,

Mokubei, and his seal are there. The painting
is in its original mounting of plain dyed
cloth, bordered at top and bottom by a batik
printed cotton and reflects the taste of the
lovers of the tea ceremony of the time.

67) The Seven Misfortunes

By Maruyama Okyo (a.d. 1733-1795).
Edo period, a.d. 1768.
Pair of makimono, ink and colours on paper.
Height 12⅝", Length 473¾";
Height 12⅝", Length 657½".
Emman-in, Shiga.
Registered Important Cultural Property.

After studying the techniques of the Kanō
school, Ming and Ch'ing paintings and
Western perspective, Okyo established a new
realistic style of his own which was later
called the Maruyama-Shijō school.

These scrolls were painted when the artist
was thirty-six years old by order of his patron,
Prince Suketsune, of the Emman-in. The sub-
ject, "The Seven Fortunes and Seven Mis-
fortunes," is taken from the Ninnō Sutra
which expounds the means by which prac-
ticing Buddhists may obtain good fortune.
Okyo produced three scrolls: two for the
seven misfortunes and one for the seven
fortunes. The former enumerate fire
and storms and such menacing creatures
as wolves and snakes.

122

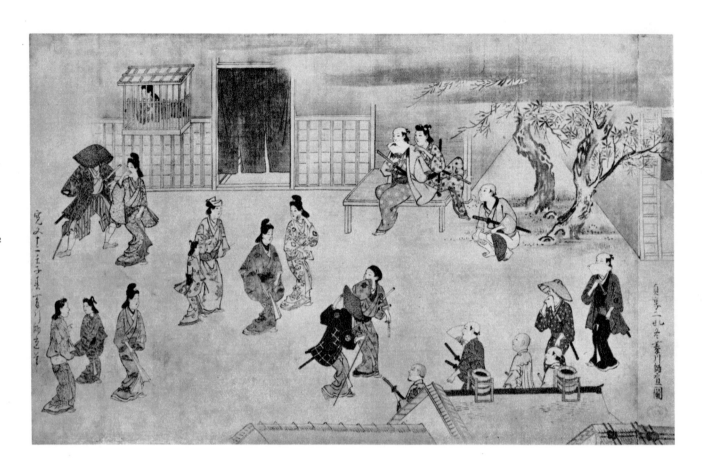

68) Genre Scenes
By Hishikawa Moronobu
(*Ca.* a.d. 1615-1694).
Edo period, seventeenth century.
Height 12⅝″, Length 274½″.
Makimono, ink and colours on silk.
National Museum, Tokyo.

Ukiyo-e painting, which concerned itself
with everyday life in the urban centers, rose
to prominence in the early Edo period. Life
in and about Kyoto is shown in this scroll.

Moronobu was one of the founders of the
Ukiyo-e school. During his youth, he was a

painter and designer of fabrics. He also
studied *Yamato-e* as interpreted by Iwasa
Matabei. Later, he combined Kanō elements
with *Yamato-e* to establish his own style.

Ukiyo-e flourished after its inception and
is known in the Western world through
wood-block prints. Moronobu was also noted
for his work in this medium.

Calligraphy

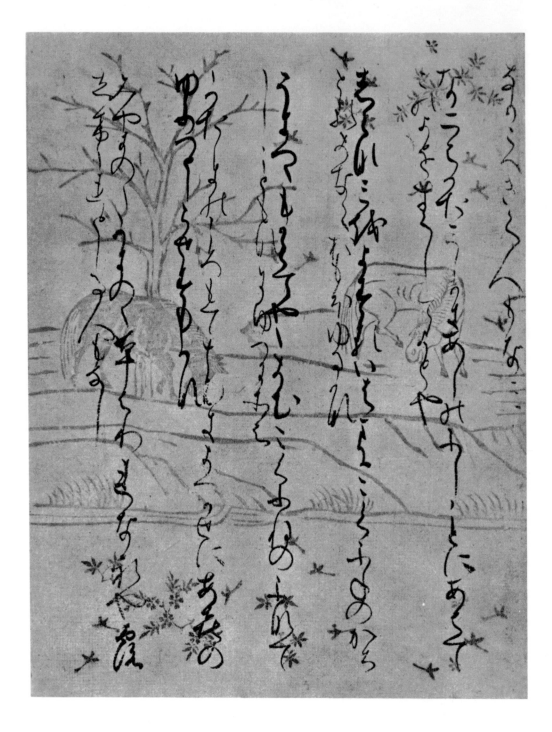

124

69) Page of Ise Shū
(Poems of the Poetess Ise)
Heian period, early twelfth century.
Kakemono, ink on coloured paper.
Height 7 15/16″, Width 6 5/16″.
Tokiwayama Bunko, Kanagawa.

The anthology of poems by the thirty-six master poets and poetesses of the early Heian period called *Sanjūrokunin Kashū* (Collection of the Poets of the Thirty-six Great Poets), or *Kasen Kashū* (Anthology of the Immortal Poets). The most famous version of this anthology is the one in the collection

of Nishi Hongan-ji, Kyoto. It was copied by a group of distinguished calligraphers at the beginning of the twelfth century and is a marvelous work of art with graceful characters written on decorated papers. Parts of the Nishi Hongan-ji version were separated from the original set and have been treasured by private collectors. The fragments are known as "Ishiyama-gire."

This page includes five poems. The paper was first dyed, using a wax technique, then decorated with two horses by a stream and embellished with birds and flowers painted in silver.

70) Fan-shaped Sutra
Heian period, second half of the
twelfth century.
Kakemono, ink and colours on paper.
Height 9⅞″, Upper Width 19¼″,
Lower Width 7⅜″.
Saikyō-ji, Shiga.
Registered Important Cultural Property.

Copying Buddhist sutras, as a form of
religious service, was very popular among
the aristocrats of the Heian period. Folding
fans of this type were therefore made in
abundance. They were even exported and
well known abroad. The basic designs on the
fan papers were done by wood-block
printing, and then coloured by hand. The
scriptures copied were usually from the
Hoke-kyō (Lotus Sutra); however, the subject
matter of the painting is not related to
the content of the religious texts written
upon them. They depict scenes from everyday
life or contemporary popular stories.

Fan-shaped sutras were originally folded
in half and bound together as books. This
is a leaf from such a book, later remounted
in the form of a kakemono.

Metal Work

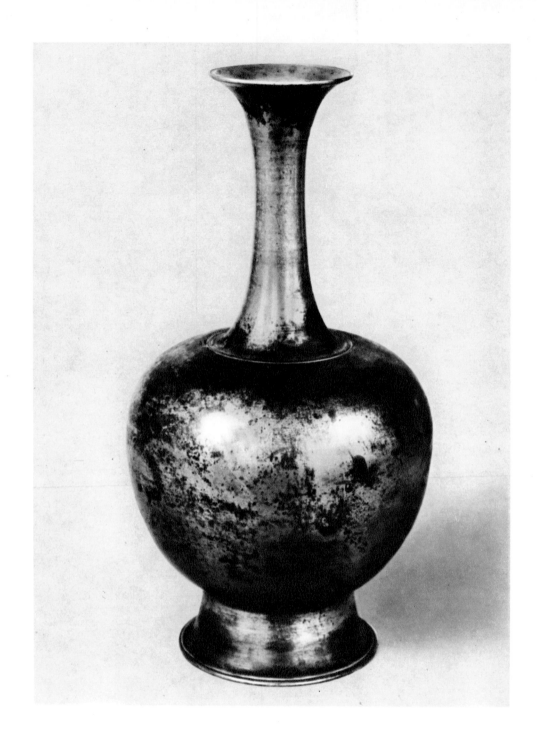

71) Suibyō (Ceremonial Vessel)
Nara period, eighth century.
Sawari (Copper alloy). Height 9″.
Mr. Sōtaro Kubo, Osaka.
Registered Important Cultural Property.

The term *suibyō* is given to a particular type
of water vessel carried by Buddhist priests
as one of the eighteen objects allotted to him
to serve his daily needs. Such vessels were
also made of clay, bronze or iron. This one
was cast of *sawari* (an alloy of copper, tin,
lead and possibly silver, popularly called
"resounding copper"). It has a long neck,
high shoulder and narrow waist. The foot
was cast separately and joined to the body
later. Several horizontal lines appear as
decorative elements on the base of the neck,
on the shoulder and on the lower edge of
the foot. The vessel probably had a lid and is
thought to have been in the collection
of Hōryū-ji.

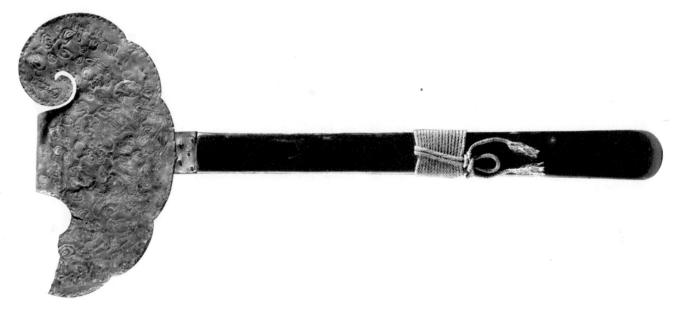

72) Nyoi (Buddhist Ceremonial Scepter)
Heian period, tenth-eleventh centuries.
Copper, gold and silver coated.
Total Length 24¾".
Mr. Renzō Maeda, Kanagawa.
Registered Important Cultural Property.

The *nyoi* was introduced into Japan by way
of China from India where it was used as a
back-scratcher. In China (where it was
called *ju-i*) and Japan it was used as an
emblem of dignity. It was held by Buddhist
prelates during lectures and masses.

The stylized cloud or fungus-shaped top
is made of copper, decorated with incised
designs of phoenixes and *hōsōge* (peony-
like) flowers and a mountain motif. The
metal plaque connecting the top and the
stem is also engraved with designs of
hōsōge and birds. The engraved surfaces are
gilded while the other metal surfaces
are silvered.

A similar mountain motif may be found
on art objects of the eighth century, but the
phoenixes and *hōsōge* flowers are typical
of the Heian period.

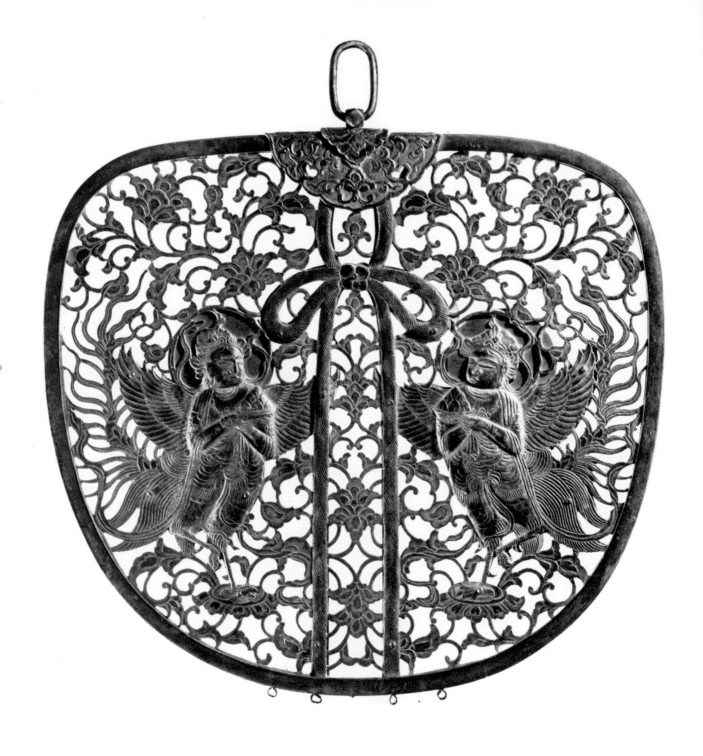

73) Keman (Altar Pendant)

Heian period, twelfth century.
Gilt bronze. Height 11½″, Width 12⅞″.
Konjiki-dō, Iwate.
Registered National Treasure.

A *keman* is an altar pendant hung from a beam inside a Buddhist sanctuary. Originally, natural flowers tied with a string were used in this manner, but later *keman* made of wood, cowhide or metal were substituted for the flowers.

This piece has an open-work pattern of *hōsōge* flowers. Two *kalavinka* birds are attached to the open-work with metal pegs. They are cast in low relief and engraved with delicate details. The shape and design are elegant, and it is a masterpiece of twelfth century metal work. This *keman* was made for the famous Konjiki-dō of Chūson-ji.

74) Keko (Ceremonial Flower Tray)
Kamakura period, end of the twelfth century.
Gilt bronze. Height 1⅝″, Diameter 11¼″.
Jinshō-ji, Shiga.
Registered National Treasure.

A *keko* is a tray, made of lacquered paper,
bamboo or metal, used in a Buddhist ritual.
Lotus petals are thrown from the tray by
priests during the ceremony.

This *keko* is in the shape of a shallow
bowl formed by a pattern of *hōsōge* flowers
and open-work. The outer surface is chased
in low relief and gilded save for portions
of the flowers which are silvered. The
contrast of the silver with the gilded surfaces
is subtly elegant.

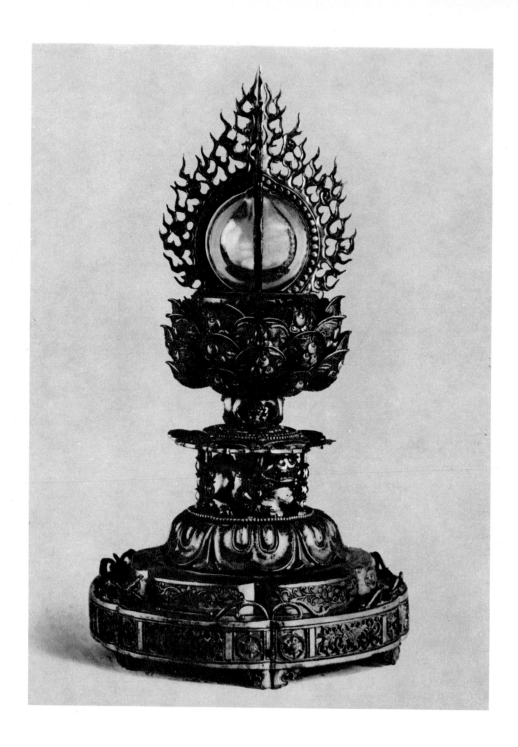

132

75) Miniature Stupa

Kamakura period, a.d. 1290.
Gilt bronze and crystal. Height 13⅜".
Kairyuō-ji, Nara.
Registered Important Cultural Property.

A stupa is a reliquary and this example
is an unusual form. On the top, a crystal ball
is held by four flame-like plates of open-
work. It was meant to contain a sacred relic
of the Buddha. The crystal rests on a lotus
flower which is, in turn, supported by a
crouching lion.

 In the Kamakura period, there was great
faith in the efficacy of relics of the Buddha,
and many elaborate reliquaries were made.
This example with its intricate design and
superb craftsmanship is certainly one of the
finest. The inscription incised on the base
states that the stupa was made in a.d. 1290
by Shirakawa Morisada and other craftsmen
for a priest of the Kairyuō-ji.

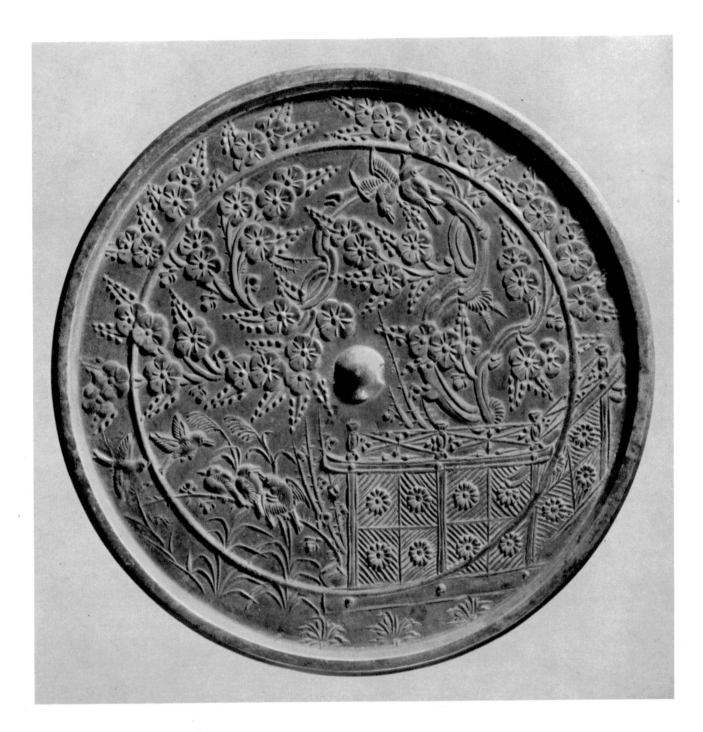

76) Mirror
Kamakura period, thirteenth century.
Bronze. Diameter 7 ½".
Nukisaki Jinja, Gumma.
Registered Important Cultural Property.

It was the general practice to decorate the
backs of mirrors with auspicious patterns.
The design on this example is a stylized
garden scene. A blossoming plum tree
extends its branches over a fence decorated
with a pattern of small chrysanthemums
while sparrows fly about. Designs of this
kind were very fashionable in the Kamakura

period. The skillful çasting of this mirror
is outstanding.

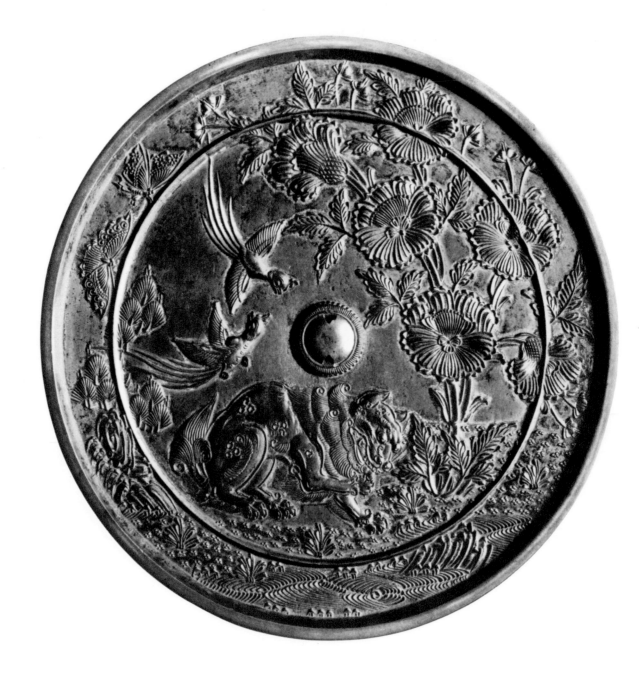

77) Mirror

Kamakura period, early fourteenth century.
Bronze. Diameter 8⅝".
Jōshin-ji, Shiga.
Registered Important Cultural Property.

On the back of the mirror a lion is shown
frolicking beside a stream where peonies
blossom and butterflies and birds fly. There
is an inscription dated a.d. 1442 engraved
on the mirror; however, on stylistic grounds
it is believed to be earlier.

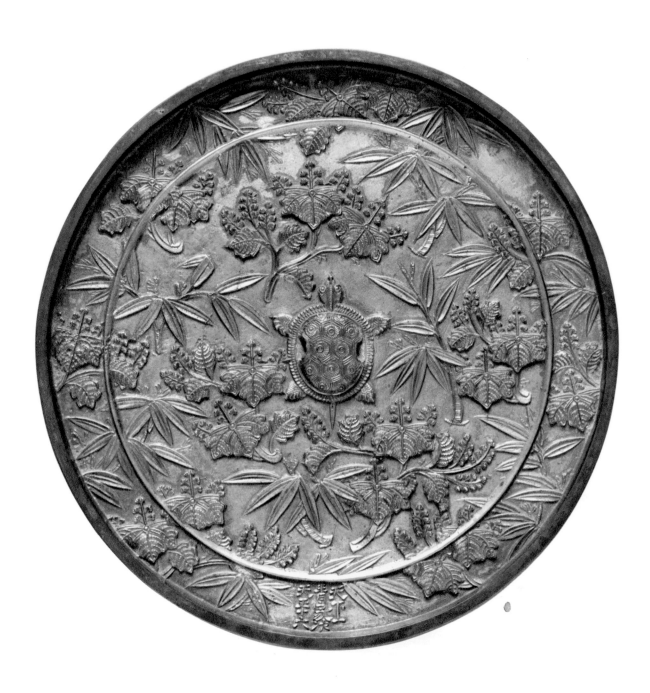

78) Mirror
By Ao Ietsugu.
Momoyama period, a.d. 1588.
Bronze. Diameter 8⅞″.
National Museum, Tokyo.

A tortoise, a symbol of longevity, serves as
the knob of this mirror. The surrounding
surface is decorated with an over-all pattern
of paulownia leaves, flowers and bamboo.
The finely finished surface is especially
worthy of note. An incised inscription states
that this mirror was made by "Ao Ietsugu,
the best under the sun, in the sixteenth year

of Tenshō" (a.d. 1588). Ao Ietsugu was a
master, descended from a long line of
mirror makers. The Emperor Goyōzei, a.d.
1587-1611, is said to have used this mirror.

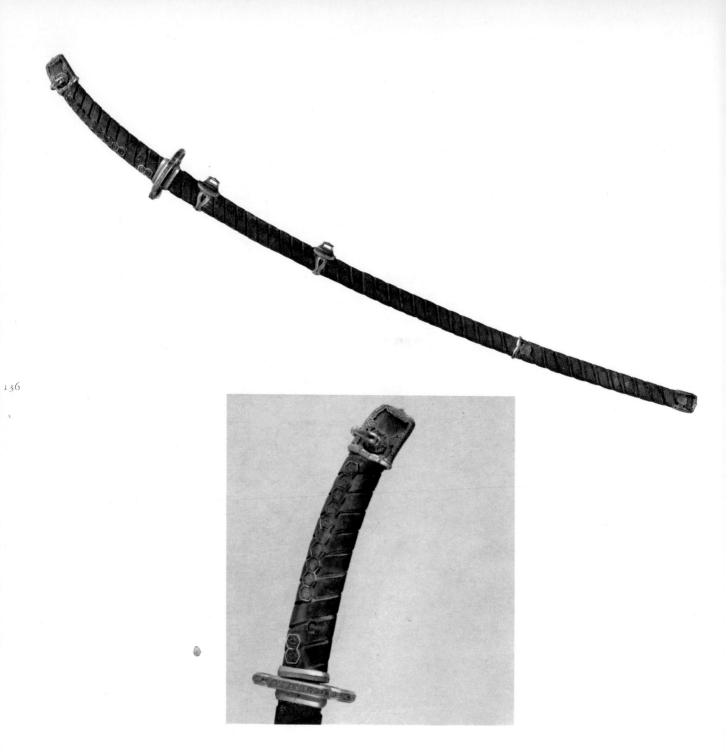

79) Sword Mounting (Tachi Type)
Heian period, twelfth century.
Wood, wrapped with lacquered leather,
copper lined. Length 41″.
Niutsuhime Shrine, Wakayama.
Registered Important Cultural Property.

Tachi is a type of sword worn with the edge
facing down. There is a distinction between
mountings for ceremonial use and those for
practical use. The earliest sword mountings
for ceremonial use date from the eighth
century and are kept in the Shōsō-in
Repository, Nara. Most of the other good
specimens are preserved in Shintō shrines,
for the sword is one of the Three Treasures
of Japan.

The mounting in the exhibition is slender
in shape and made of wood, wrapped
with leather and reinforced by coiling bands
of silver-coated copper. The surface of the
leather is finished in black lacquer and is
decorated with various gilt bronze plaques.

80) Kettle for Tea Ceremony
(Ashiya Type)

Kamakura period, *ca.* a.d. 1300.
Iron. Height 9¾₆″, Diameter 11⁹⁄₁₆″.
Mr. Ryōichi Hosomi, Osaka.

This kettle was made in Ashiya in the
Fukuoka area, which since the thirteenth
century has been renowned for its fine
kettles. The Ashiya type has a smooth surface
and often a beautiful natural pattern. The
present piece is a typical specimen of the
shinnari gama (kettle with basic form) type.
Its texture is smooth and has a characteristic
luster called "catfish skin." The design on
the side, a beach scene showing a sandy shore
with pine trees, waves and shells, was a
favorite *Yamato-e* theme.

The kettle is unusually large and was
probably meant for use at special tea
ceremonies.

138

81) Hanging Lantern

Muromachi period, a.d. 1550.
Bronze. Height 11¾", Diameter 13¼".
National Museum, Tokyo.
Registered Important Cultural Property.

Lanterns of this type are hung from the
eaves of Shinto shrines or Buddhist halls
and offer light to the deities.

This example is cast of bronze. On the
hexagonal roof there is an inscription which
tells that it was made for the Aizen-dō of
the Chiba-dera in Chiba, and that it was
donated in a.d. 1550.

Two doors open into the cylindrical
chamber which is enclosed by open-work
sides with designs of plum and bamboo.
The base is hexagonal, and has three legs of
"cat feet" design.

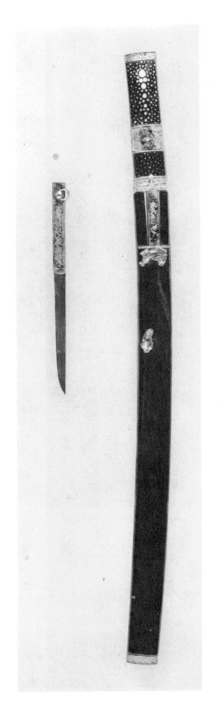

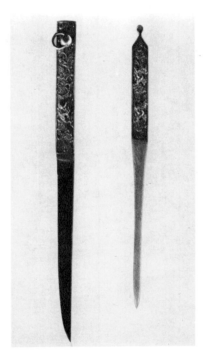

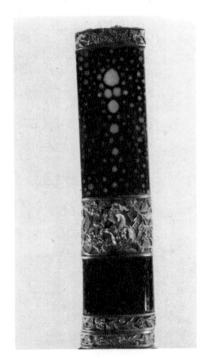

2) Short Sword Mounting

do period, seventeenth century.

ength 23⅜".

Maeda Ikutokukai Foundation, Tokyo.

Registered Important Cultural Property.

Honami Kōho (a.d. 1601-1682), the grand-
son of Kōetsu, made this sword mounting at
the order of Maeda Toshitsune, feudal lord
of Kaga Province. The metal fittings, how-
ever, are older, and are said to have been
made by Gotō Yūjō, a great master of metal-
work in the fifteenth century. He was the
founder of the Gotō school of metalsmiths

specializing in sword furniture. He served
the Shogun, Ashikaga Yoshimasa, and died
in a.d. 1512.

This mounting is a type called *chiisa
gatana* (short sword) which has no sword-
guard and was made for use in the palace.
The surface of the handle is covered with
shark skin, and the scabbard lacquered and
polished. The seven metal fittings are made
of gold, moulded and chased in high relief.
Each of these is decorated with a peony
and a lion.

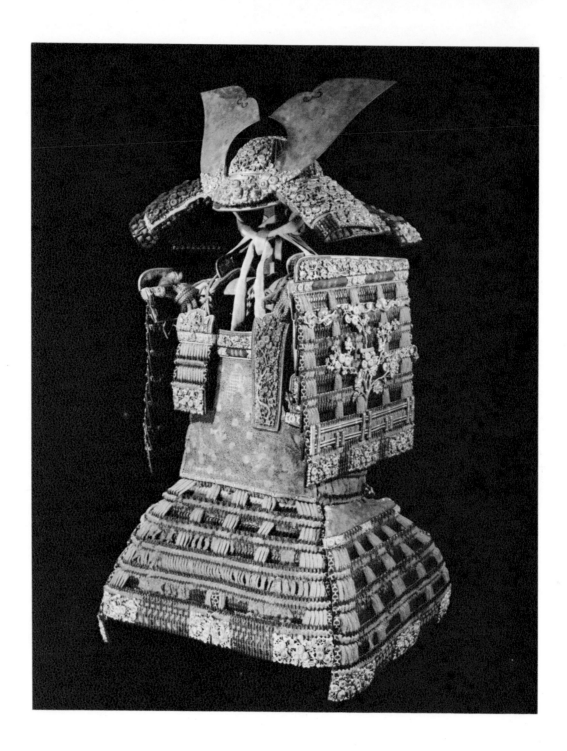

83) Suit of Armour (Ōyoroi Type)
Kamakura period, thirteenth-
fourteenth centuries.
Height of breastplate 9³/₁₆",
Height of helmet 4½".
Hachiman-gū Shrine, Aomori.
Registered National Treasure.

The *ōyoroi* was a type of armour used by
military generals in equestrian battle. This
suit is made of alternate scales of black-
lacquered hide and iron, laced with red
braid and is decorated with gilt bronze
plaques of chrysanthemum design. The

helmet is a so-called "star helmet" type
which is made of thirty-six parts. A white
decoration is on each of its four corners, which
symbolize the cosmos. A large metal orna-
ment is attached to the front of the helmet.

Each of the shoulder pieces is decorated
with gilt bronze plaques of chrysanthemum
and cloud pattern, and a family crest.

This armour was made at the end of the
Kamakura period. The luxurious effect created
by the contrast of the gilt metal and the red
lacing indicates that it was made to impress
upon others the majesty of the wearer rather
than for practical use on the battle field.

84) Suit of Armour (Dōmaru type)
Muromachi period, fifteenth century.
Height of breastplate 13⅜″,
Height of helmet 5⅛″.
Mr. Kazusue Akita, Tokyo.
Registered Important Cultural Property.

The *dōmaru* is a type of armour better
suited for walking than for riding on horse-
back. The plastron is made as one piece to
be worn around the chest and tied at the
right side, while the *yoroi* type (No. 83) has
a three-piece plastron, a front piece and two
side shields. The bottom of the *dōmaru*

type is divided into many vertical bands.

Originally the *dōmaru* lacked helmet and
shoulder pieces. Later, when the form of
battle was changed from equestrian
to pedestrian, it came to be used by generals
as well, and acquired helmet and shoulder
pieces. This example is laced with braid
coloured to resemble the feathers of a jay-
bird, while the shoulder and breast pieces
are laced with red. The helmet has large
metal ornaments in front with pierced
floral design.

Lacquer

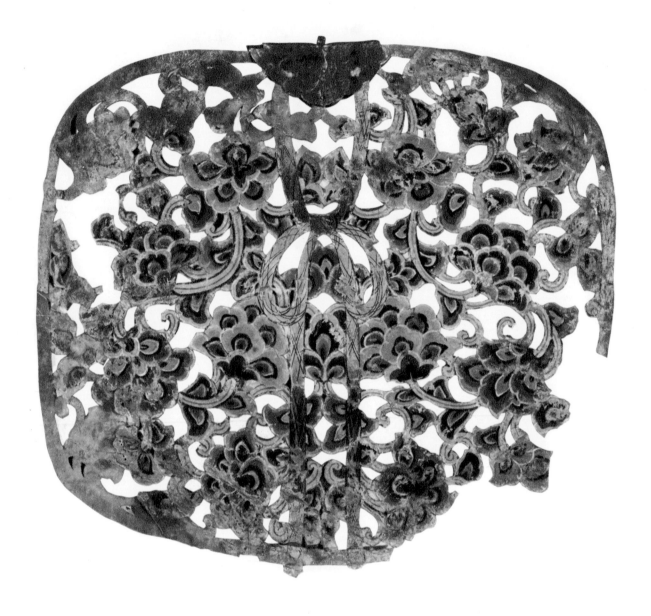

144

85) Keman (Altar Pendants)

Heian period, eleventh century.
Pair, cow-hide polychromed, gold and silver.
Height 16⅛", Width 22" and
Height 18¹¹⁄₁₆", Width 21⁷⁄₁₆".
Kyō-ō-gokoku-ji, Kyoto.
Registered National Treasures.

These *keman* of painted cow-hide are cut
in an ovoid shape, and have open-work
designs of *kalavinka* and of *hōsōge* flowers.
They are coloured in red, pale green, light
and dark blue, emerald green and other
colours. *Kirikane* is applied on some details

of the crowns and necklaces. A bronze ring
holder of repoussé work with *hōsōge* pattern
is attached in the center of the upper part
of one piece.

In the Kyō-ō-gokoku-ji there are thirteen
keman, plus fragments which are the finest
of their type.

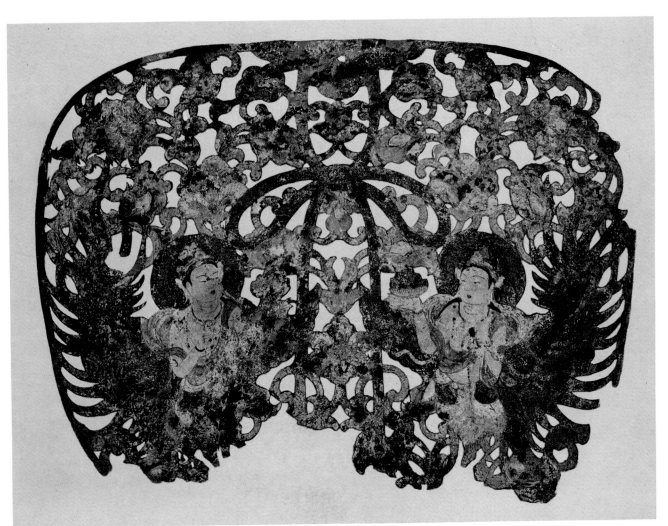

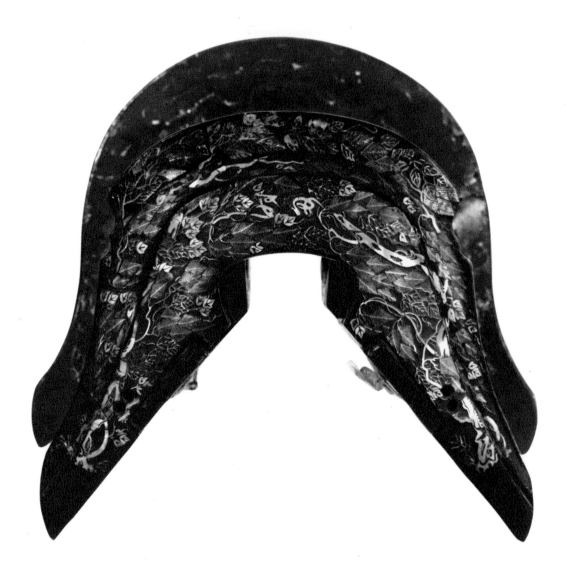

86) Saddle
Kamakura period, early thirteenth century.
Wood, lacquered, mother-of-pearl inlay.
Height 13⅛", Width 12⅞".
Eisei Bunko Foundation, Tokyo.
Registered National Treasure.

This saddle belongs to the type used in
battle, having a large seat and a strongly
curved back support. The decorative design
inlaid in mother-of-pearl, a technique called
raden, is based upon a poem composed in
the early Kamakura period. It sings of love
using as an image pine trees entwined with

ivy on a plain in a *shigure* (autumn shower).
The design takes a form called *ashide-e,*
popular in the late Heian and Kamakura
periods, in which *kana* characters signifying
love, autumn shower, field and so forth are
scattered and hidden.

The inlay is very refined and the saddle
is a masterpiece.

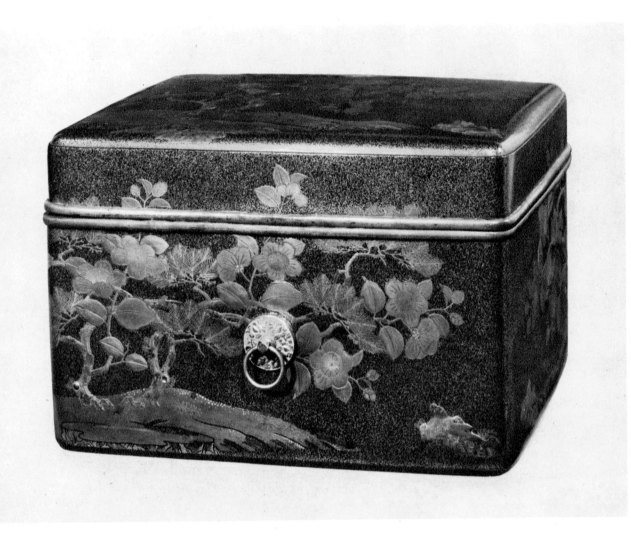

87) Tebako (Cosmetic Box)
Muromachi period, fifteenth century.
Wood, lacquered with *maki-e* design.
Height 9¼", Length 14", Width 10¾".
National Museum, Kyoto.
Registered National Treasure.

This box was one of a group of applied art
objects which were donated to the Shinto
shrines in Kumano by the Emperors,
ex-Emperors and Shoguns in the Muromachi
period.

 It contains the following articles: a
bronze mirror, two silver *haguro* (tooth-
stain) boxes, two silver face-powder boxes,
incense boxes, a pair of silver tweezers,
a pair of silver scissors, a silver ear-pick,
two silver hair scratchers, two silver
eye-brow brushes, two silver tooth-stain
brushes, a silver comb, three silver
chrysanthemum-shaped trays, a white
porcelain tray, and twenty-nine wooden
combs with *maki-e* (painting in gold
lacquer) design, and a small box to contain
the combs.

 The lacquered surface of this box is
speckled with gold powder. On the ground
the design of a hill with pine trees and
camellias is applied in *maki-e* and inlaid
gold. Two gilt bronze plaques with design
of pine trees and camellias are attached for
rings which held the binding cord.

88) Oi (Monk's Traveling Cabinet)
Muromachi period, sixteenth century.
Wood, carved and lacquered.
Height 34⅛″, Length 29⅛″, Width 16⅞″.
Jigen-ji, Fukushima.
Registered Important Cultural Property.

An *oi* is a box made to hold Buddhist
images, scriptures and personal effects. It
was carried on the back by travelling priests,
especially those of the *Shugen-dō* sect of
Buddhism which flourished from the
Kamakura period.

This example is a square box decorated
with carved designs and bronze plaques.
Divided into four horizontal sections with
three sets of doors, it is supported on three
legs. On each door panel a camellia branch
is carved and coloured in vermillion and
black on a red ground. The flowers and dew
drops are embellished with gold leaf.

89) Tray
Muromachi period, a.d. 1455.
Negoro lacquer.
Height 4⅛″, Diameter 19⅝″.
Mr. Tsūsai Sugawara, Kanagawa.

This type of lacquer work is called *negoro-nuri,* from the name of Negoro-ji in Wakayama where the technique originated. Negoro was done by applying black lacquer over the wood surface to serve as a ground and finishing the surface in red lacquer.

This large flower shaped tray has a rim of ten petals. It is thought to have been used to carry tea bowls in a Buddhist monastery. The shape suggests that it was strongly influenced by Chinese lacquers of the Yüan and Ming dynasties, which were brought to Japan mainly by Zen monks.

On the base there is an inscription which states that it was made in a.d. 1455 for the Saidai-ji.

90) **Suzuribako (Ink-stone Box)**
Muromachi period, sixteenth century.
Wood, lacquered with *maki-e* design.
Height 1¾", Length 9⅝", Width 8¹⁵⁄₁₆".
National Museum, Tokyo.

A *suzuribako* was made to contain an ink-
stone, ink-stick, water dropper and brushes.
 The surface of this box is black and upon
the ground of *nashiji,* resembling pear skin,
maki-e designs of flowering cherry-trees
are delicately done. The trunks, branches
and leaves are painted in low gold relief and
the flowers in tin lacquer. Cut gold-leaf

designs are applied to the tree trunks. Cherry
branches are scattered in polished *maki-e*
on the inside of the lid, and fallen flowers
decorate the inner tray. The technique and de-
signs are typical of the Muromachi period.

陶磁

Ceramics

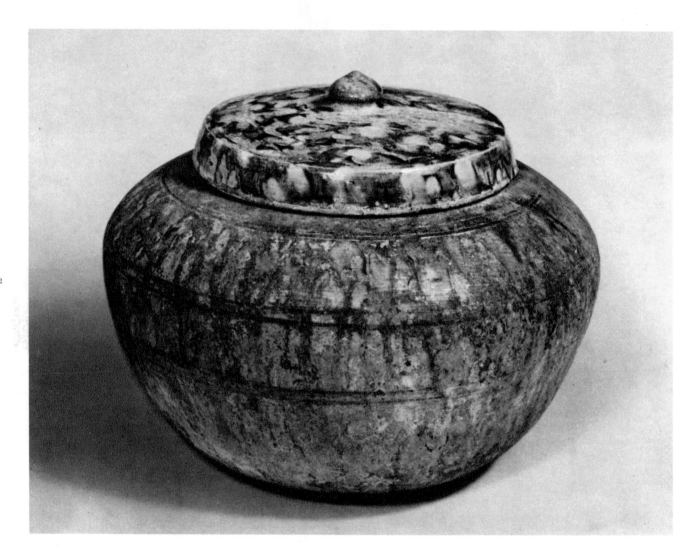

152

91) Covered Jar
Nara period, eighth century.
Pottery, three-colour ware. Height 6⅛″.
National Museum, Tokyo.
Registered Important Cultural Property.

When cremation became an established custom among the noble and the wealthy in Japan, the ashes were buried either in a metal or ceramic jar. This three-colour jar, excavated in Osaka prefecture, is a typical example.

The outside of both body and lid is glazed with three colours: brown, green and white; the inside is glazed green. While the green glaze on the interior is well-preserved, the three-colour glaze on the exterior has taken on a silvery iridescence from burial. This glazing technique was imported from T'ang China and used until the ninth century.

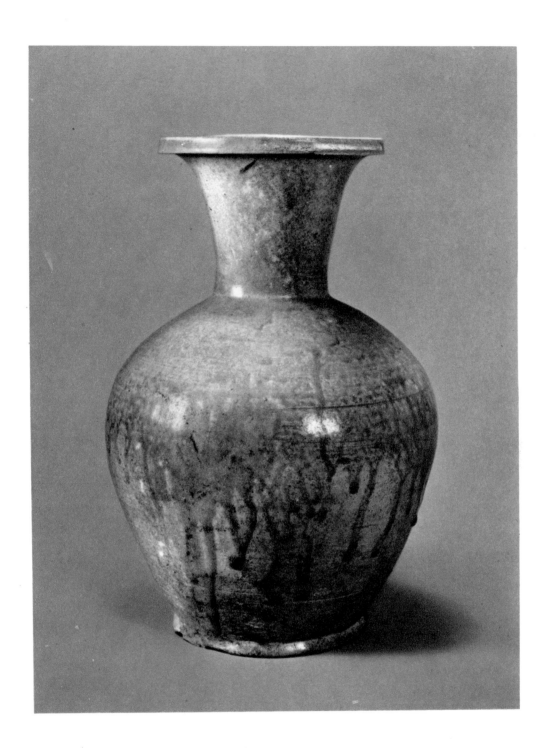

92) Jar

Heian period, eleventh century.
Pottery, *Su-e* type.
Height 11⅞", Diameter 5⅜".
Gotō Art Museum, Tokyo.

This *Su-e* type jar has a gray, high-fired
earthenware body and translucent pale
green ash glaze. The technique of making
wares of this type was introduced from
Korea at the end of the fifth century. In its
early stages this ware was unglazed, but
in the beginning of the ninth century a glaze
was introduced. As the potters became more
adept, the bodies became lighter and the
forms more sophisticated.

The rim of this jar, so cleanly shaped that
it resembles metal, is an example of this
improvement in the ceramic art. It was made
in a kiln at the foot of Mt. Sanage,
Aichi prefecture.

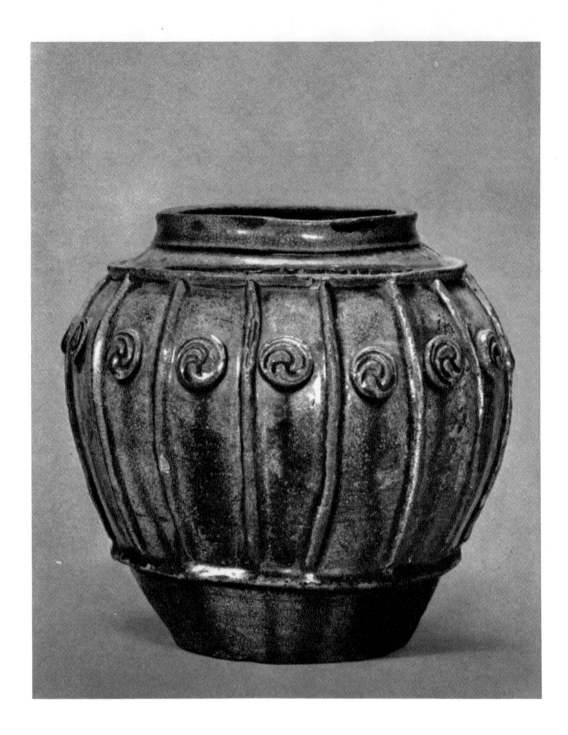

154

93)ˈ Jar
Kamakura period, fourteenth century.
Pottery, Seto ware.
Height 8¹¹/₁₆″, Diameter of mouth 5⅛″.
Mr. Hikotarō Umezawa, Tokyo.
Registered Important Cultural Property.

On this jar, a transparent grayish yellow
glaze was applied over a mottled black-
brown glaze. A raised design of comma-
shaped *tomoe* patterns, spaced at equal inter-
vals between vertical ribs, decorates the
vessel. Since the thirteenth century, this
method of applying glazes of two different

colours has been used. Decoration in relief
was another feature of the time, probably
inspired by the ceramics of the Sung dynasty.
This jar was fired in the Seto area of
Aichi prefecture.

94) Jar
Muromachi period, end of the fifteenth
century.
Stoneware, Shigaraki ware.
Height 7⅝″, Diameter of mouth 2¹⁵⁄₁₆″.
National Museum, Tokyo.

In Shigaraki, Shiga prefecture, this type of
ware was made to store grain. Since the
beginning of the sixteenth century, however,
vessels of this ware have been used in the
tea ceremony as water jars.

This jar, because of its unassuming
simplicity, was ideally suited to the tea
ceremony. It is decorated with strong,
crude incised designs and a light brown natu-
ral glaze over its shoulder.

156

95) Jar
Early Edo period, seventeenth century.
Stoneware, Bizen ware.
Height 16″, Diameter of mouth 7⅛″.
National Museum, Tokyo.

Stoneware of the Bizen type was made near
Imbe, Okayama. Instead of using glazes the
potters made the best use of the inherent
features of the baked clay, creating works of
refined taste. They developed a form of
decoration called *hidasuki* (fire marks),
marks left by straw applied to the surface be-
fore the firing. These created interesting
and varied patterns on the surface. This
jar was probably made as a water container
for the kitchen.

157

96) **Bowl**
Momoyama period, sixteenth century.
Pottery, Ki (yellow) Seto ware.
Height 2½″, Diameter of mouth 6¾″.
National Museum, Tokyo.

This bowl was made near the present city of
Tajimi in Gifu. A thick ash glaze resembling the
yellow of rapeseed oil covers the surface. A
paulownia design is drawn in rust color under
the glaze. Seto ware of this type, because of its
simplicity, was appreciated by lovers of the tea
ceremony. It is another example of the adapta-
tion of humble wares to use in the tea ceremony.

97) Covered Jar

Momoyama period, sixteenth century.
Pottery, Shino ware.
Height 6⅞", Diameter of mouth 7⅛".
Mr. Hiroaki Manno, Osaka.

Shino is a ware admired by devotees of the tea
ceremony for its rich feldspathic glaze. It was
made near Tajimi in Gifu, an area renowned for
ceramic production. The design of this piece is
painted in iron brown, faintly tinged with pink,
which beautifully complements the white glaze.
The technique of turning the lip inward was
fashionable in the Momoyama period.

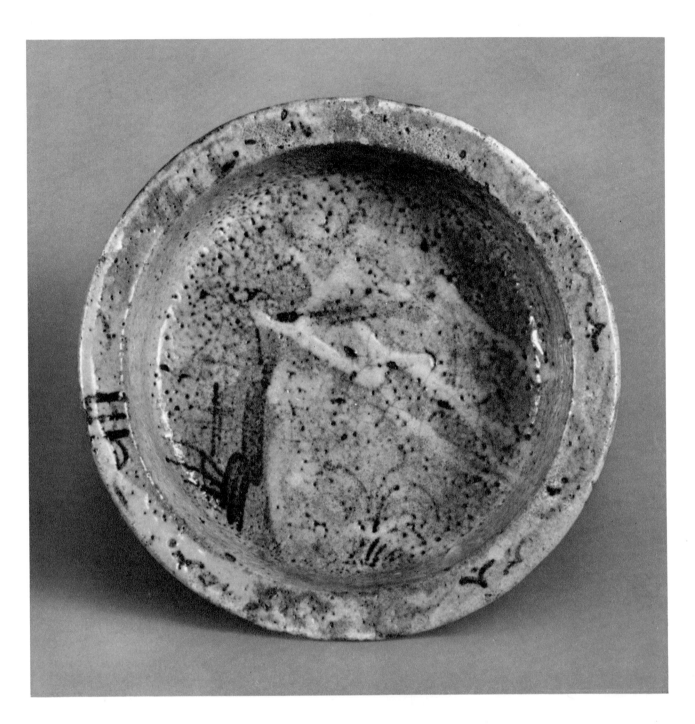

98) Bowl

Momoyama period, sixteenth century.
Pottery, Beni (pink tinted) Shino ware.
Height 2¹³⁄₁₆″, Diameter of mouth 11⁵⁄₁₆″.
National Museum, Tokyo.

Beni Shino wares were fired near Tajimi,
Gifu. Through the thick white glaze which
covers the surface, faint traces of pink appear.
This distinguishes it from white Shino.
 This bowl is decorated under the glaze
with an abstract landscape sketched in iron
and must have been used for serving at
large parties.

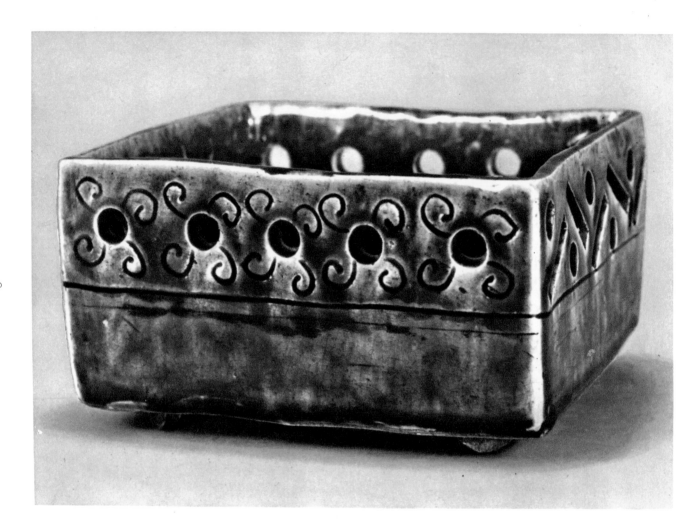

160

99) Bowl

Early Edo period, seventeenth century.
Pottery, Oribe ware.
Height 3¹¹⁄₁₆″, Width 6⁵⁄₁₆″.
Mr. Hikotarō Umezawa, Tokyo.

This square Oribe bowl was made in a kiln
near Tajimi, Gifu, where Shino wares were
also made. The development of Oribe ware
was encouraged by Furuta Oribe (a.d. 1544-
1615), a warrior and tea master, who
commissioned many ceramics.

The bold and original style of Oribe was
favored in the early Edo period and strongly
influenced other ceramic artists.

The typical Oribe ware is divided in
design into two parts: one half is covered
with green glaze, while the other half shows
abstract designs under a translucent white
glaze. The bowl with solid green glaze
exhibited is exceptional in shape and design,
and was presumably made for serving cakes
at a tea ceremony.

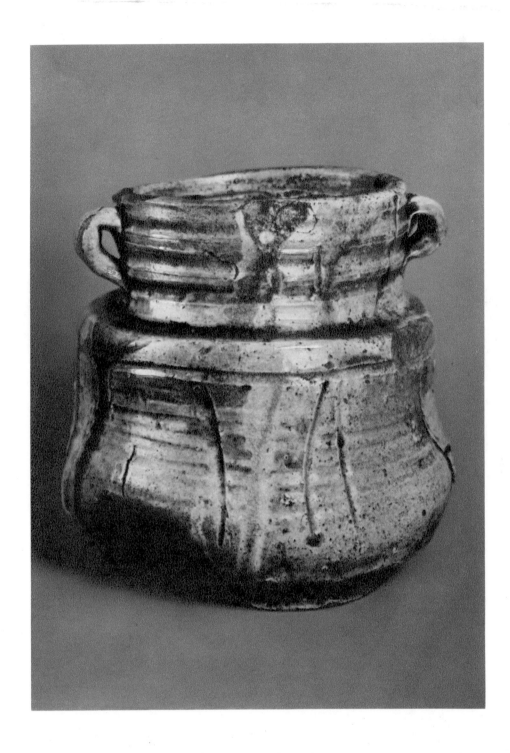

100) Jar
Early Edo period, seventeenth century.
Pottery, Iga ware.
Height 7⅞″, Diameter of mouth 5⅞″.
National Museum, Tokyo.

Iga ware was made near Ueno in Iga
Province (present Mie Prefecture). Since
the early part of the seventeenth century,
wares for the tea ceremony such as vases,
water jars, and incense containers have been
made by potters of Iga. These hand-modelled
wares seem misshapen on first sight and
look unfinished. This is due to the search

for individuality and the refined taste of
tea masters.

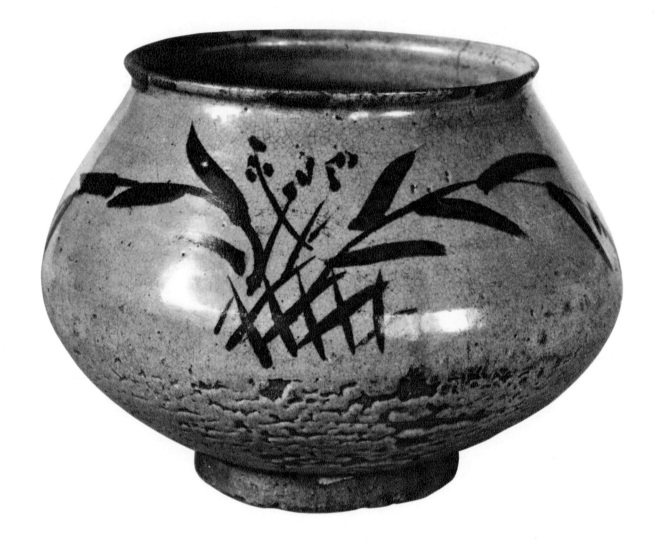

162

101) Jar
Early Edo period, seventeenth century.
Pottery, Karatsu ware.
Height 6⅜″, Diameter of mouth 6⁹⁄₁₆″.
Mr. Sazō Idemitsu, Tokyo.

Karatsu wares were made in the neighbour-
hood of the present city of Karatsu in Saga.
Their shapes and designs are often very
similar to those of Yi dynasty Korean wares.
This is only natural, since the early Karatsu
wares were actually made by Korean
immigrants. Simple designs in dark brown
are frequently painted under a grayish glaze,
a type commonly known as E-Karatsu.
Karatsu jars were originally used as
containers for salt and other things.

102) Dish
Early Edo period, seventeenth century.
Porcelain, Ko-Kutani ware.
Height 1⁹/₁₆″, Diameter 13¾″.
National Museum, Tokyo.

It is not certain where Ko-Kutani was made;
some say, in the hills east of Yamanaka,
Ishikawa prefecture while others say in the
Arita area of Saga prefecture.

One of the principal characteristics of
Ko-Kutani ware is the very bold designs in
rich, heavy enamels on the white glazed
porcelain body. Ko-Kutani is an exception

among the Japanese enameled porcelain
wares, which are sometimes criticized
as lacking boldness and strength in their
designs.

103) Wine Ewer
Edo period, seventeenth century.
Porcelain, Ko-Kutani ware. Height 6⅜″
Mr. Moritatsu Hosokawa, Tokyo.
Registered Important Cultural Property.

This wine vessel is modelled after a metal
or lacquer ewer, a form commonly used
until the early half of the seventeenth cen-
tury. It is enameled in the same style as the
dish with the peony and butterfly design
(No. 102). Containers such as jars or bottles
are rather exceptional among old Kutani
wares as most of these remaining are dishes.

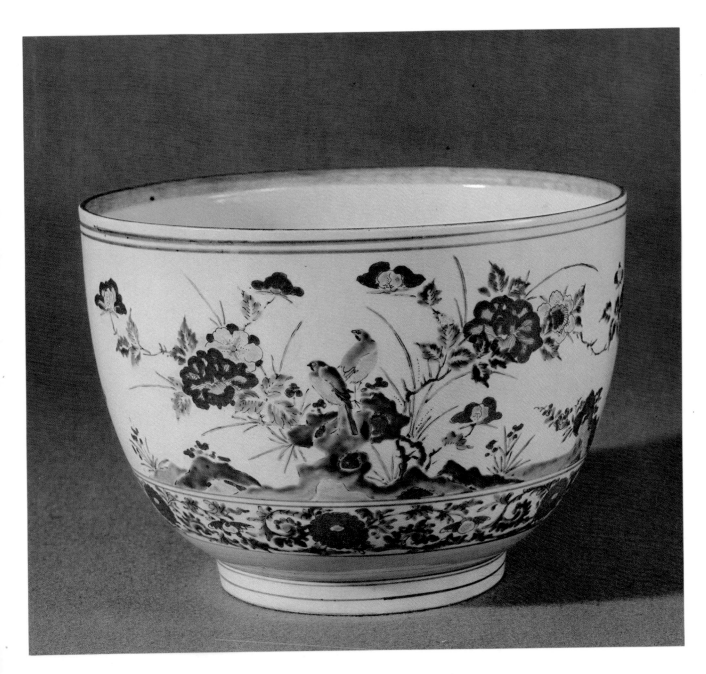

104) Bowl
By Sakaida Kakiemon.
Edo period, seventeenth century.
Porcelain, enameled, Kakiemon ware.
Height 8¼″, Diameter of Mouth 12⅛″.
National Commission for Protection of
Cultural Properties.
Registered Important Cultural Property.

In the middle of the seventeenth century
the method of decorating porcelains over
the glaze with enamels came to be used. The
first Kakiemon is generally given credit for
his major contribution in developing this
technique. The name Kakiemon was taken
by this potter as the red enamel he perfected
resembled the colour of persimmon *(kaki)*.

 There is a strong Chinese flavor in the
early Kakiemon, for it was inspired by
designs on K'ang-hsi (a.d. 1662-1722)
porcelains.

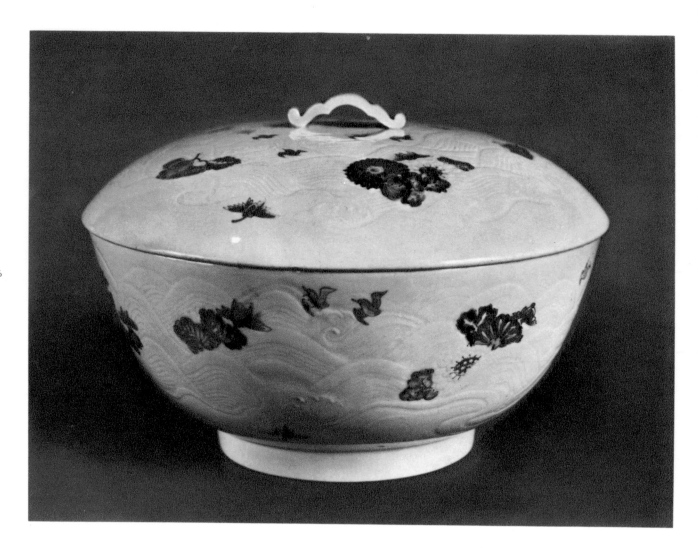

166

105) **Covered Bowl**

Edo period, eighteenth century.
Porcelain, enameled, Kakiemon ware.
Height 5½", Diameter 8¾".
National Museum, Tokyo.

Kakiemon wares are renowned for their
milk-white body and meticulous designs in
brilliant enamels. This bowl, with its lid,
is a typical specimen. The wave design on
the body is often found painted on K'ang-hsi
wares. However, the incised design of chrys-
anthemums floating on the waves and frolick-
ing plover is totally Japanese in taste.

The inscription in blue on the bottom of
the bowl suggests it was made to order.

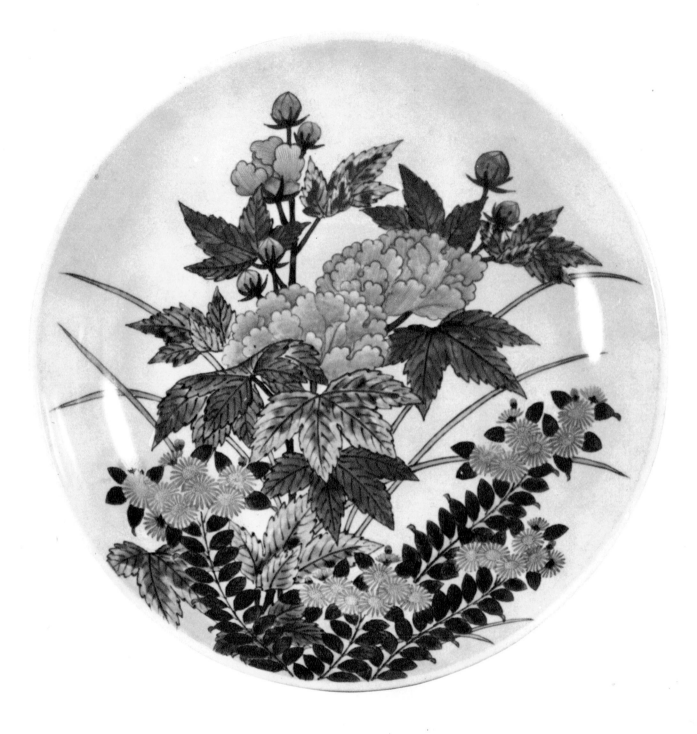

106) Dish

Edo period, eighteenth century.
Porcelain, enameled, Nabeshima ware.
Diameter 12¼″.
Mr. Hikotarō Umezawa, Tokyo.

Nabeshima wares are the most technically perfect among Japanese porcelains. They were made in kilns operated by the feudal lords of the Nabeshima family in Saga prefecture, in the Edo period. Made exclusively for the official use of this family, they were not sold for common use.

They are known for beautiful designs, and most are enameled with red, green and yellow to accentuate the rest of the design painted in underglaze blue. Unlike Kakiemon and Imari wares, underglaze blue was used instead of black for contour lines, and gold was rarely used.

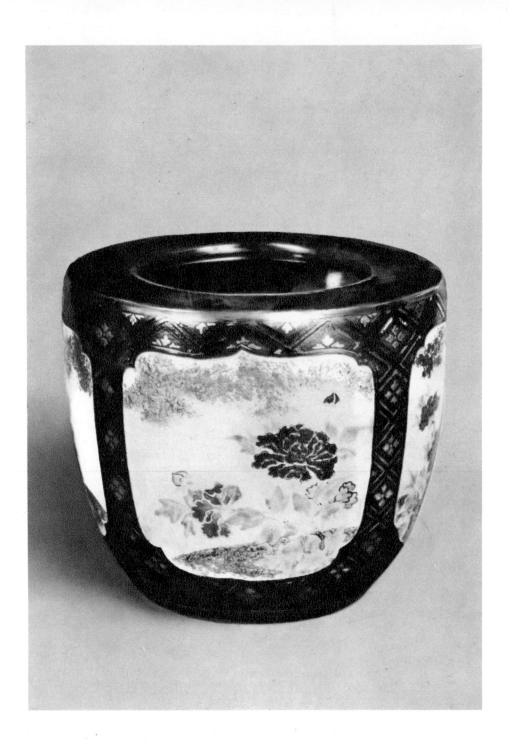

107) Jar
By Nonomura Ninsei.
Early Edo period, seventeenth century.
Porcelain, enameled.
Height 5⁵⁄₁₆″, Diameter 3¹³⁄₁₆″.
National Museum, Tokyo.

Little is known about Ninsei's life other
than that he was active as a potter in Kyoto
during the third quarter of the seventeenth
century. A master of ceramic techniques, he
made refined and delicately beautiful wares
decorated with bright enamels. His style
came to be the ideal of Kyoto potters. It was

based upon his study of lacquer techniques
and designs, as well as the patterns and
colours of textiles.

The geometrical design of gold and silver
against the red background of the borders
framing the panels of this jar is apparently
derived from lacquer designs. An oval seal
which reads "Ninsei" is stamped on the
bottom of the jar.

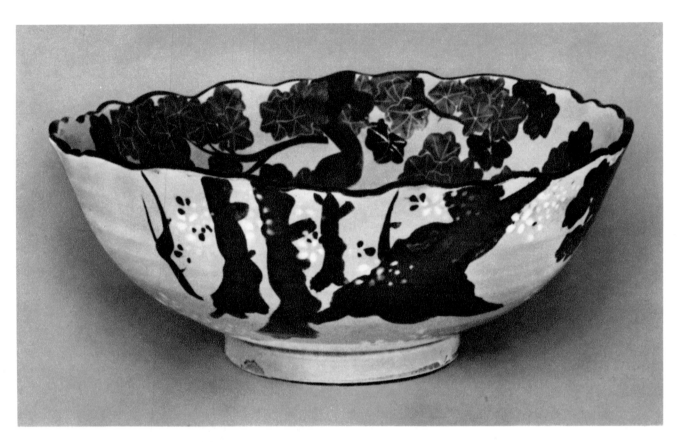

08) Bowl
y Ninami Dōhachi (a.d. 1783–1855).
do period, nineteenth century.
ottery, enameled.
Ieight 5⅞″, Diameter 11¾″.
tami Art Museum, Shizuoka
egistered Important Art Object.

Dōhachi, a famous potter in Kyoto late in
ne Edo period, entered the priesthood at the
ge of forty-two and thereafter called himself
Jina-mi. He admired the rich decorative
ryle of Ogata Kōrin and tried to
ecreate it in his pottery.

The exterior of this bowl is decorated with
cherry trees and blossoms symbolic of
spring, while the interior is decorated with
maple branches and leaves symbolic of
autumn.

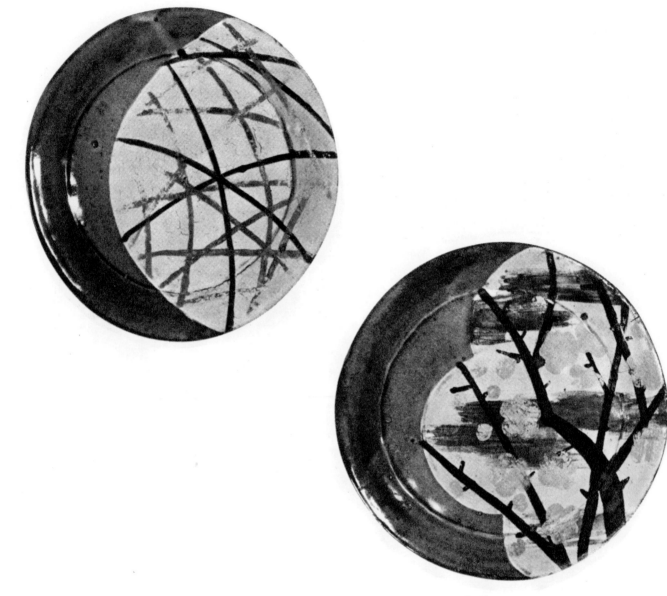

109) Five Dishes

By Ogata Kenzan (a.d. 1663-1743).
Edo period, eighteenth century.
Pottery, Diameter 4¾" (each).
Nezu Art Museum, Tokyo

Kenzan, the younger brother of the great
artist Kōrin (No. 62), worked first in Kyoto
and later in Edo. He produced pottery in a
style which combined the manner of the
literati school of painting, both in design and
shape, with the delicate beauty of Ninsei's
technique and thus created a new approach
to the art of ceramics.

On these small dishes, he painted plum
blossoms, grasses, sailboats, water plants on
waves and budding branches. The pottery
has a soft texture resembling Raku ware.
Kenzan's ability as a painter as well as a potter
is clearly demonstrated by this set.

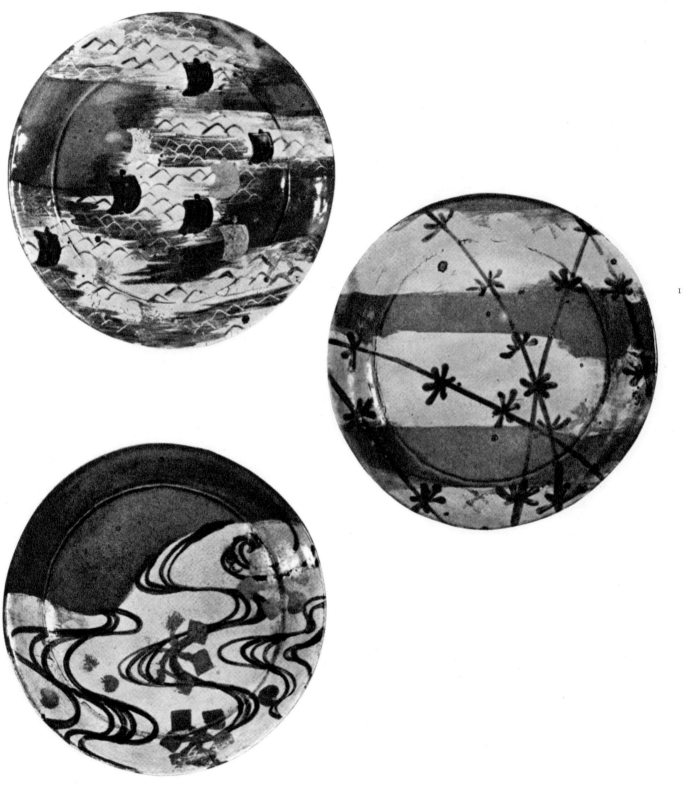

110) Tea Bowl
By Dōnyu. (a.d. 1574-1656).
Edo period, seventeenth century.
Pottery, Black Raku ware.
Height 3¾₁₆", Diameter 4¹⁵⁄₁₆".
Mr. Morio Ishijima, Tokyo.

Raku came to be made in Kyoto from the second
half of this sixteenth century as a ware designed
exclusively for use in the tea ceremony. The
potter of this tea bowl was the third generation
master in the Raku school. The outstanding char-
acteristics of his work are the bright luster of the
glaze and its thick flow over the rim of the bowl.

Textiles

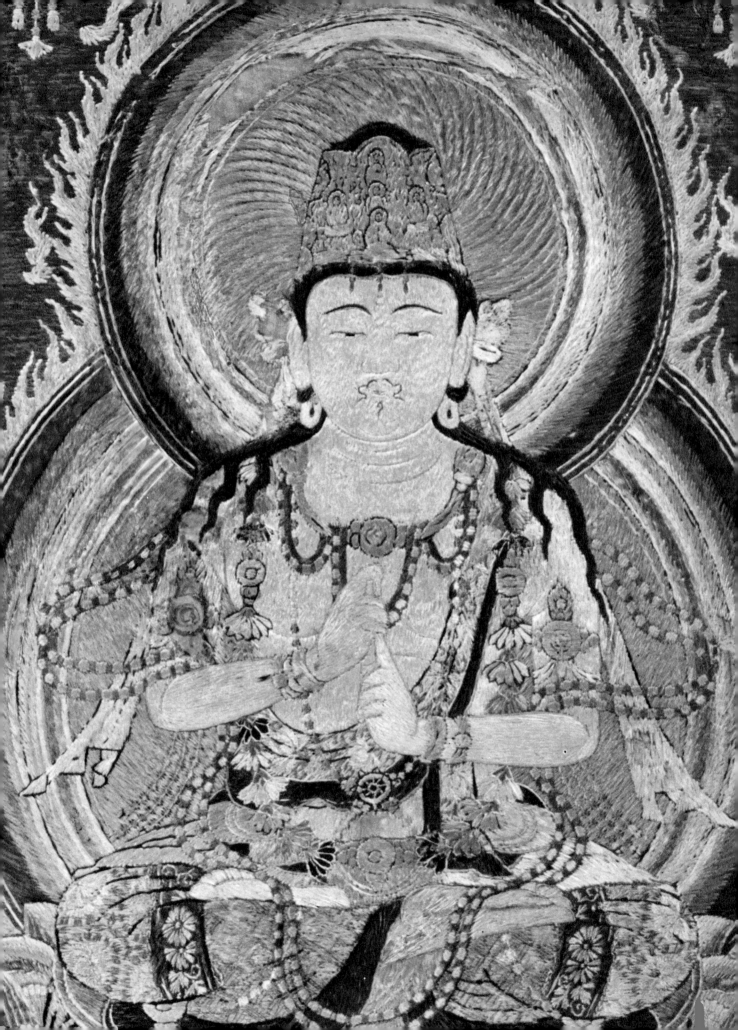

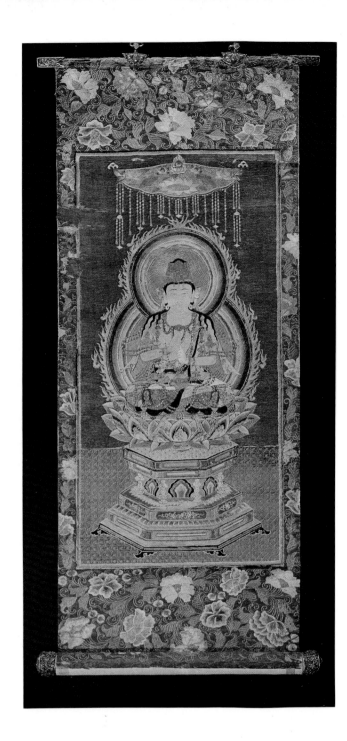

111) Dainichi Nyorai
Kamakura period, second half of the
fourteenth century.
Kakemono, embroidered silk.
Height 27¾″, Width 10¼″.
Mr. Ryōichi Hosomi, Osaka.
Registered Important Cultural Property.

This is an embroidered Buddhist icon.
Dainichi Nyorai, his hands in the *chiken
mudrā* (fist of wisdom), is seated on a lotus
pedestal. Above the Buddha, there is a
jeweled canopy decorated with lotus flowers,
and behind is an elaborate flame-edged

mandorla. The mounting is embellished with
an all-over pattern of *hōsōge* flowers, embroi-
dered in delicate colours.

The embroidery was done on plain white
silk. The Buddha's hair, eyebrows, moustache
and beard are embroidered with human hair.
For other parts, flat silk threads of various
colours in an amazing variety of complicated
embroidery stitches are skillfully combined
to produce textural effects simulating
a painting.

This kakemono was made at the end of
the Kamakura period and is well preserved.
The gilt bronze fittings with designs of

peonies in open-work and scrolls in repoussé
are from the original mounting.

Noh Costume

The noh drama had its origin in such folk entertainment as *dengaku* and *sarugaku*. The present form of noh as a stage play was developed in the early Muromachi period (late fourteenth century) by three great artists called the Three Ami, namely, Kan-ami, Ze-ami and On-ami. They refined and elaborated both the content and form of the rather vulgar proto-noh entertainments and brought them to a highly artistic dramatic level. Thereafter noh came to be regarded as a ceremonial drama and was appreciated among the upper classes, including the Shoguns. Consequently, materials of the finest quality were used for noh play costumes. The symbolic character of noh drama required the costumes to have an expressive quality in harmony with the symbolic movement of the actors. Thus, the unique beauty of noh costumes was developed.

Representative examples of the major types of noh costumes are exhibited. They are the *atsuita* type, worn in male roles, and the *karaori* type, worn in female roles, but slipped off the shoulders and held hanging about the waist by the sash.

Nuihaku Type

Nuihaku is a type of cloth decorated with designs made by both embroidery and the imprint of gold or silver leaf. This type of costume is worn by actors playing female roles. The *nuihaku* costume is more generally worn off the shoulders and hung around the waist, revealing the under-costume. Designs of the *nuihaku* type are divided into two categories: "the red colour included" and "the red colour excluded." The most gorgeous design of *nuihaku* costume is probably the type called *dohakuji* in which the entire surface of the cloth is imprinted with gold leaf and decorative designs are embroidered upon the golden ground.

176

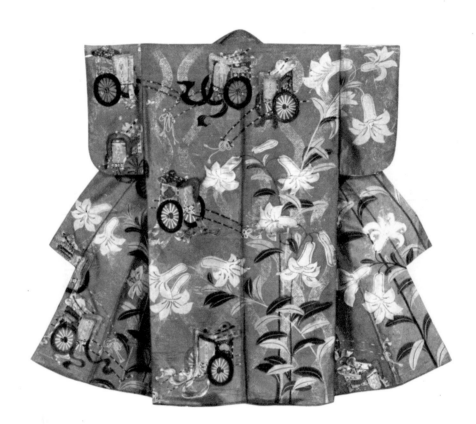

112a) Noh Costume (Nuihaku Type)
Momoyama period, sixteenth century.
Silk, embroidery and imprinted gold leaf.
Design of lilies and *gosho-guruma* on brown ground.
National Museum, Tokyo.

This is a representative *nuihaku* costume of the Momoyama period. The design of vertical zig-zag patterns is imprinted in gold leaf and the motifs of *gosho-guruma* (a court palanquin) and lily flowers are embroidered in delicate techniques. The entire design is spectacular.

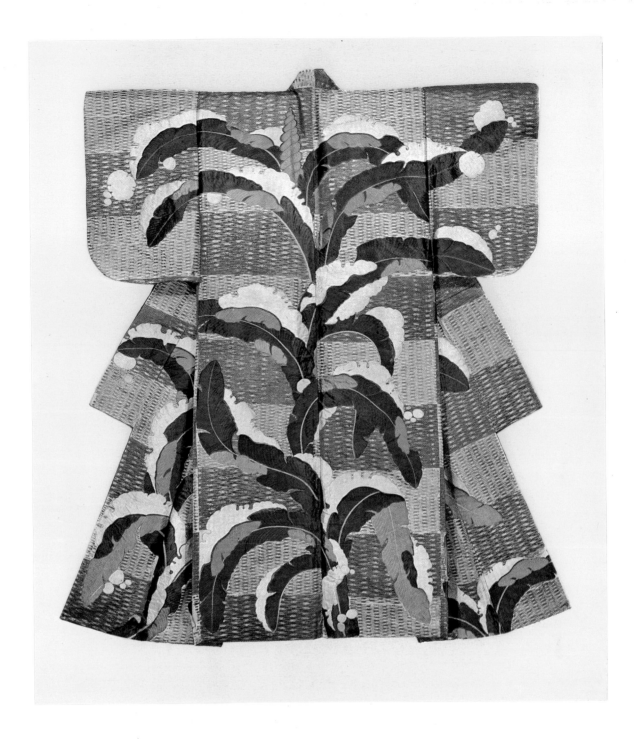

112b) Noh Costume (Nuihaku Type)
Momoyama period, sixteenth century.
Silk, embroidery and imprinted gold and
silver leaf.
Design of banana leaves in clouds.
Okayama Museum of Arts, Okayama.

The white ground is satin, woven with a
katamigawari (differing in halves) design of
red and white. It is decorated with
imprinted silver leaf and the red ground
with imprinted gold leaf. On the back the
large design of banana leaves stretched
toward both sides, surrounded by cloud

motifs, is embroidered with threads of dark
green, greenish yellow, pale brown, yellow
and white. Although the satin weave for the
ground is a later replacement, the designs
of embroidery and imprint are, for the most
part, original. This is a fine example of the
gorgeous taste of the Momoyama period.

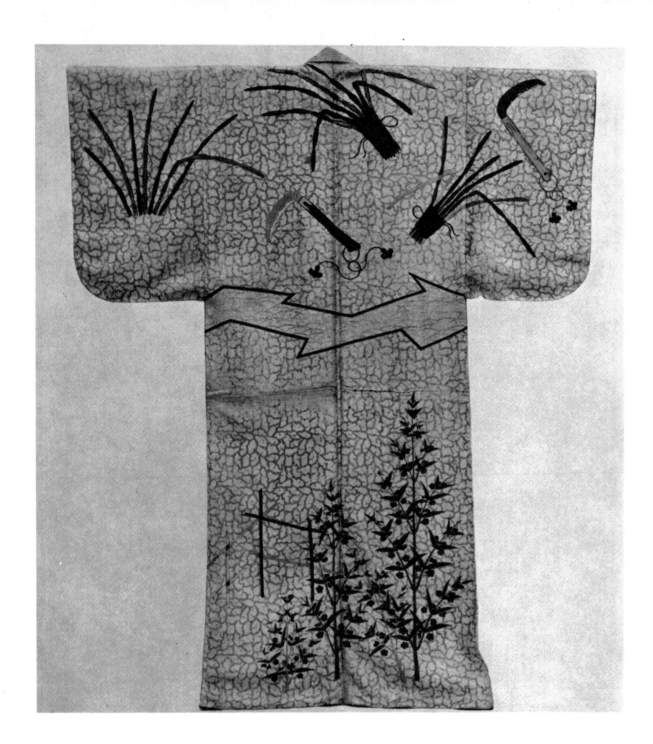

112c) Noh Costume (Nuihaku Type)
Edo period, seventeenth-eighteenth centuries.
Silk, embroidery and imprinted gold leaf.
Background design in gold, woven designs
of fence, grasses and flowers, mountain path
and others on white ground. National
Museum, Tokyo.

This costume was made in the Edo period.
In spite of the technical refinement, the
design as a whole is somewhat conven-
tional and not as free and creative as the
earlier designs. This costume was probably
made by the Nishijin artisans in Kyoto.

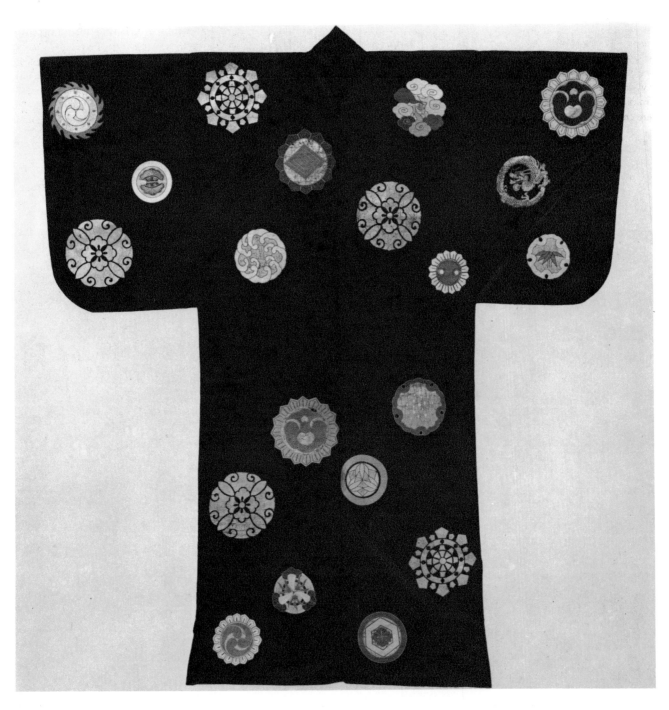

(12d) Noh Costume (Nuihaku Type)
Edo period, seventeenth-eighteenth centuries.
Silk, embroidery and imprinted gold leaf.
Design of crests on purple-gray ground.
National Museum, Tokyo.

This costume is a typical example of the
nuihaku type of the Edo period. Although
the pattern of different crests had been
used for such daily clothes as *kosode* dress in
earlier periods, the idea of utilizing such
a pattern of a comparatively reserved char-
acter as a brilliant design for a stage costume
was unique at the time. The designer
succeeeded in his attempt with a skillful
combination of embroidered patterns of
crests against the purple-gray ground.

Karaori Type

Karaori is a type of cloth with woven patterns which are produced by using threads of gold and various colours as warps upon regular wefts: the patterns are somewhat raised from the ground and look as though they were embroidered. The term *karaori* (literally: Chinese weave) probably derives from the ancient term *karaaya* (literally: Chinese twill-weave) which means twill-woven silk with "raised" woven patterns of similar technique.

Since the *karaori* costumes are especially brilliant and flowery, they are mainly worn by actors playing female roles. There are two categories of the *karaori* design, "the red colour included" and "the red colour excluded." The former is reserved for the roles of young girls and the latter for the roles of old ladies. The *karaori* type costumes are sometimes used for the roles of young aristocrats or boys.

180

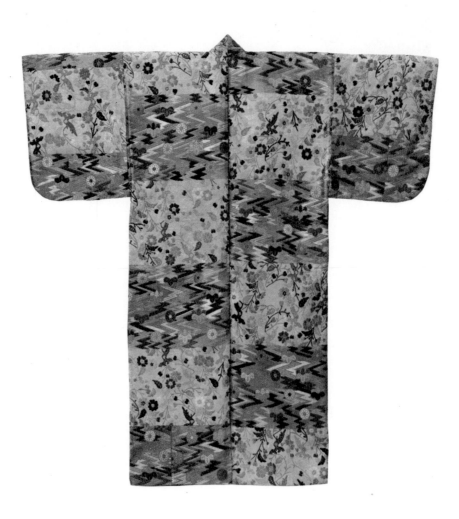

113a) Noh Costume (Karaori Type)
Momoyama period, sixteenth century.
Silk, woven patterns.
Design of lightning, chrysanthemums and paulownia on alternate red and white grounds.
National Museum, Tokyo.

Portraits of the wives of warriors and paintings of genre scenes dating from the fifteenth and sixteenth centuries show that materials similar to *karaori* were used for daily clothes. However, the term *karaori*, used in the narrow sense as a type of noh costume, means clothing specifically designed for the stage. The lightning design of this robe was a common motif used for *karaori*.

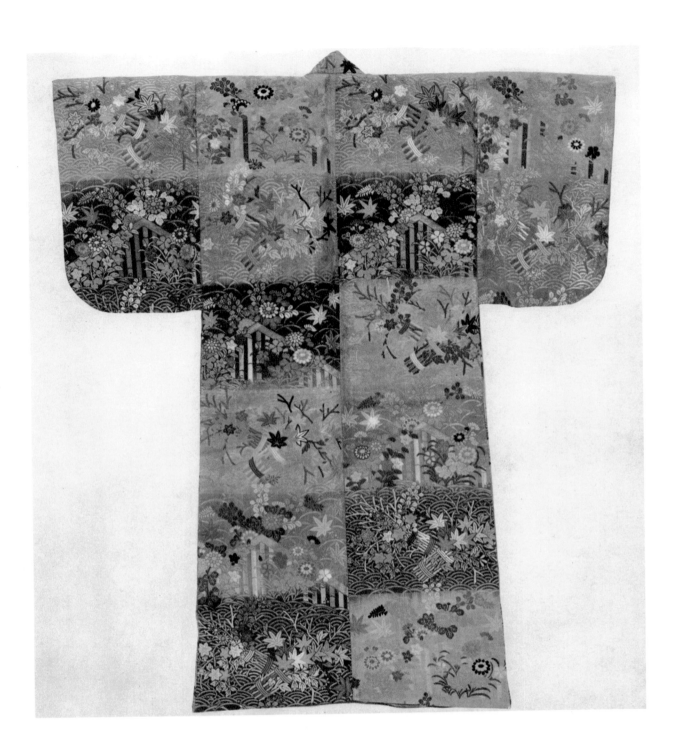

113b) Noh Costume (Karaori Type)
Edo period, seventeenth-eighteenth centuries.
Silk, woven patterns.
Design of waves in gold, fences, grasses,
autumn flowers and maple leaves on
alternate red, light blue and brown grounds.
National Museum, Tokyo.

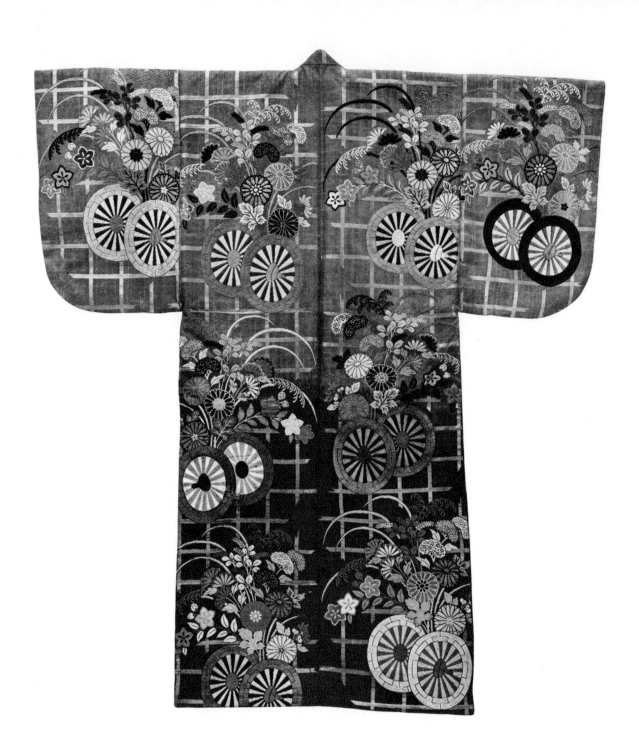

113c) Noh Costume (Karaori Type)
Edo period, seventeenth-eighteenth centuries.
Silk, woven patterns.
Design of broken lattice and floral carts on
alternate horizontal bands of red and brown.
National Museum, Tokyo.

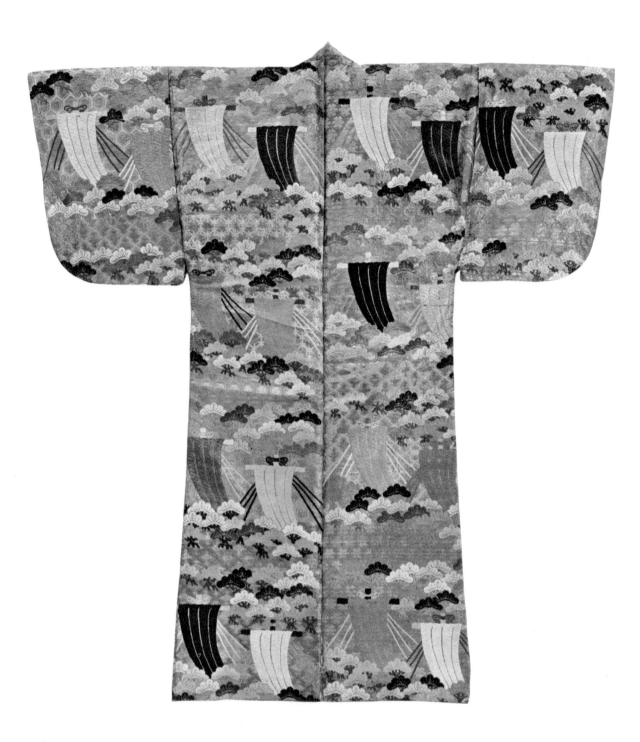

113d) Noh Costume (Karaori Type)
Edo period, seventeenth-eighteenth centuries.
Silk, woven patterns.
Design of tortoise shell, pine trees and sails.
National Museum, Tokyo.

Atsuita Type

Atsuita is a type of thick cloth which has woven patterns produced with raw silk threads for the weft and glossed silk threads for the warp. Costumes of this type are worn by male actors in roles such as warriors, *tengu* (long-nosed goblins) and demons, and are worn tied with *obi* (sashes). In many cases, *hakama* (men's skirts) are worn over the *atsuita* costumes.

184

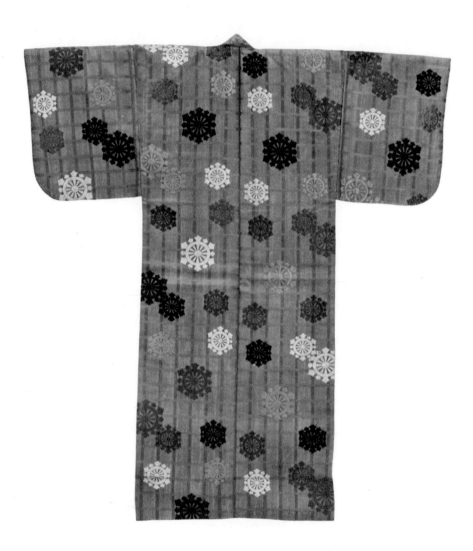

114a) **Noh Costume (Atsuita Type)**
Edo period, seventeenth-eighteenth centuries.
Silk, woven patterns.
Design of lattice and wheels on a light blue ground.
National Museum, Tokyo.

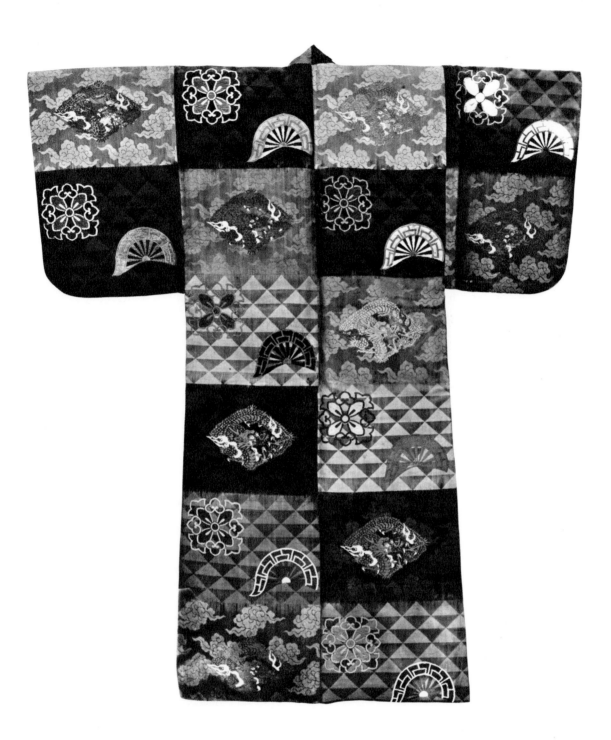

114b) Noh Costume (Atsuita Type)
Edo period, seventeenth-eighteenth centuries.
Silk, woven patterns.
Design of a cart wheel and rhomboid-shaped
flower on alternate horizontal bands of
scale-patterned ground, and dragon medal-
lions on cloud ground. National
Museum, Tokyo.

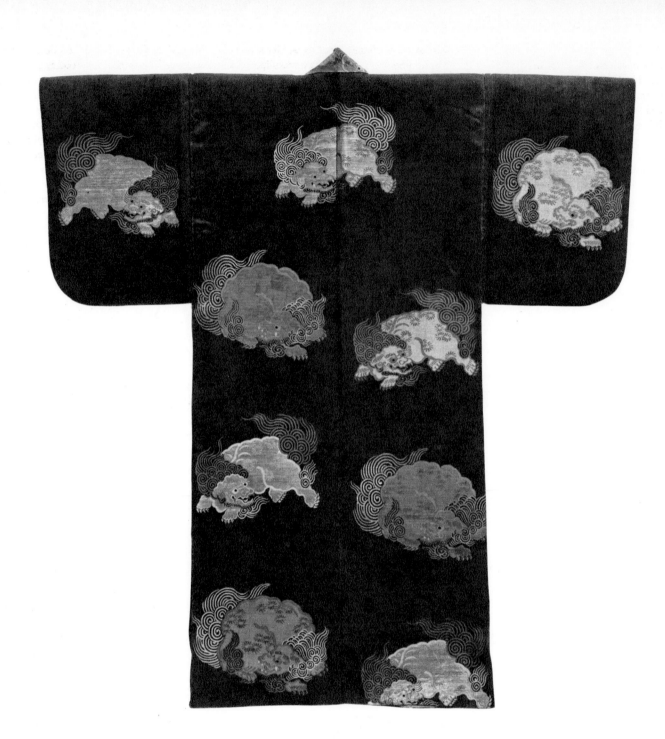

114c) Noh Costume (Atsuita Type)
Edo period, seventeenth-eighteenth centuries.
Silk, woven patterns.
Design of lion motif on purple-gray ground.
National Museum, Tokyo.

Uchikake

The *uchikake* dress was a type of formal wear used by ladies from the Muromachi period on. It was worn loosely, being fastened over *aigi* (between-season wear) which in turn was tied with an *obi*. Both *uchikake* and *aigi* are dresses of the *kosode* type, i.e., dresses with narrow-cuffed hanging sleeves, and are distinguished from dresses with wide-cuffed sleeves, worn by ladies of the upper class. The *kouchigi* dress is the aristocratic counterpart of the *uchikake* dress. In summer the *uchikake* dress was slipped off the shoulders and held around the waist by an *obi*. The summer version is called *koshimaki*.

In the Muromachi and Momoyama periods, the material used for *uchikake* was either *karaori* or *nuihaku*. In the Edo period the material used came to be more rigidly defined. The *uchikake,* when worn over the shoulders, had to be made of *rinzu* damask of white, black or red, decorated with an over-all design of embroidery and tie-dyeing. *Koshimaki* (i.e., summer *uchikake*) had to be made of black or red *nerinuki* weave (a weave using raw silk threads for warps and glossed silk threads for wefts), with fine patterns of "the treasures," "pine, plum and bamboo" and so forth, embroidered by threads of gold, silver and various colours. The *koshimaki,* in later days, was worn tied with an *obi* in such a way that it trailed.

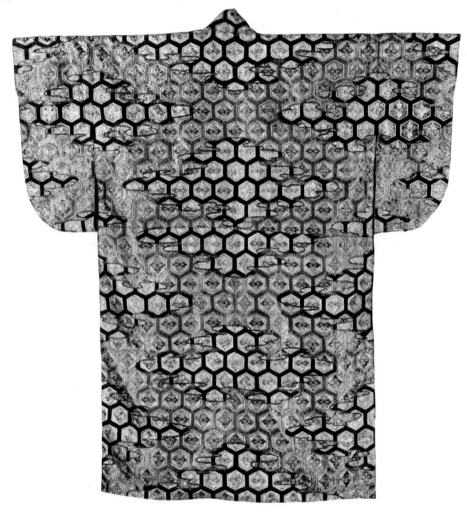

187

115a) Uchikake

Momoyama period, sixteenth century.
Silk, embroidery and imprinted silver leaf.
Design of tortoise shells and rhomboid-shaped flowers. Height 47¼".
Kōdai-ji, Kyoto.
Registered Important Cultural Property.

This *uchikake* dress is said to have been worn by Kita-no-Mandokoro, the wife of Toyotomi Hideyoshi (a.d. 1536-1598), the warrior ruler of Momoyama, Japan.

The cloth is covered with patterns of rhomboid-shaped flowers and tortoise shells embroidered upon a basic pattern of imprinted silver leaf. The simple motifs skillfully composed make this dress a masterpiece of the period.

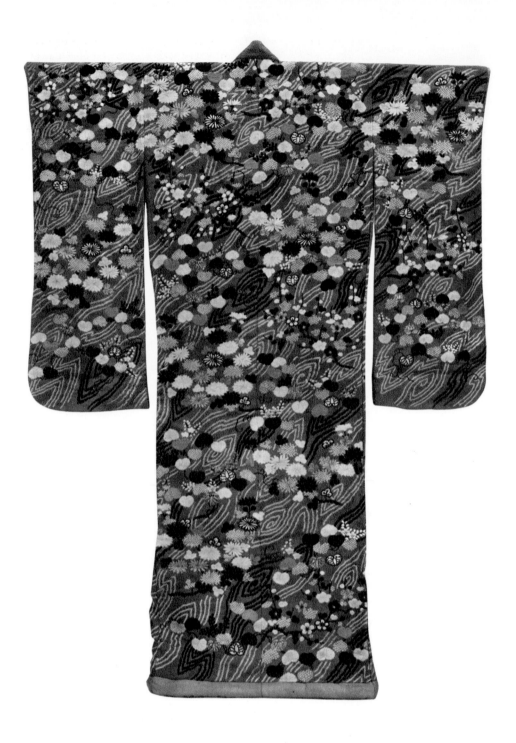

115b) **Uchikake**
Edo period, seventeenth-
eighteenth centuries.
Silk, embroidery and tie-dyeing.
Design of zig-zag patterns, chrysanthemums,
orchids, hollyhocks, plum trees and small
waves in embroidery and tie-dyeing on a red
rinzu damask ground.
National Museum, Tokyo.

Kosode

Kosode means a garment with narrow-cuffed short sleeves of round cut. Originally, it was worn by men and women as an undergarment. Later, when the warrior class developed its own culture, *kosode* gradually came to be used by it as formal outer-wear. The most formal dresses for ladies of the warrior class, such as *uchikake* and *koshimaki*, were in fact garments of *kosode* type, tied neatly with *obis*. Three different categories of designs for *kosode* are: decorative over-all patterns, decoration applied only around the shoulders and the lower part of the skirt, and decoration applied to the skirt alone.

116a) **Kosode**
Edo period, seventeenth-
eighteenth centuries.
Silk *yūzen* dyeing.
Design of hawks and screens.
Daihiko Institute of Dyework and
Embroidery, Tokyo.

The decoration of *kosode* for ladies developed rapidly from the Momoyama through the Edo period. During the Genroku-Kyōho eras (a.d. 1688-1735), new colourful and picturesque designs were made possible by the invention of the *yūzen-zome* dyeing process. *Yūzen-zome* is a technique of dyeing cloth with designs drawn by brush in a dye-resistant starch solution. It is an outgrowth of the ancient starch-resistant dyeing process using stencils. As a result of this, freely drawn designs and various effects could be produced by repeated dyeings. A whole new era of fabric decoration came into being, augmenting tie-dyeing and embroidery. It is said that the *yūzen-zome* technique was invented by a painter, Miyazaki Yūzensei, who had a little fan-painting shop in front of the gate of the Chion-in in Kyoto.

116b) **Kosode**
Edo period, seventeenth-eighteenth centuries.
Silk, embroidery and *yūzen* dyeing.
Design of clouds, screens, fans and flowers
in *yūzen* dyeing and embroidery on a
purple-gray ground.
National Museum, Tokyo.

116c) **Furisode**
Edo period, seventeenth-eighteenth centuries.
Silk.
Design of plum flowers on a scarlet ground.
National Museum, Tokyo.

The *furisode* is similar to *kosode,* but has longer
sleeves with their axillary sides unknitted and
open. From the late seventeenth century on, the
sleeves of the *kosode* gradually became longer
and at the end of the Edo period some as long as
three feet occur. The *furisode* was worn by boys
and girls before they attained adulthood and
also by young girls in the gay quarters.

192

117) Jinbaori
Edo period, seventeenth century.
Silk.
Design of Western ships.
Maeda Ikutokukai Foundation, Tokyo.

The *jinbaori* is a sleeveless coat worn over
armour. It developed in the Muromachi
period from the *dōbuku* (a coat worn over
kosode). Usually, a family insignia or favour-
ite motif is sewn, in the form of a patch,
to the back of the garment.

This example is decorated with the sails,
masts and rigging of Western ships such as

visited Japan during the sixteenth and
seventeenth centuries, reflecting a love for
the exotic. This coat was used by a feudal
lord of the Maeda clan.

Glossary

Amida Nyorai—(Sanskrit: *Amitābha*). One of the idealized "wisdom" Buddhas whose paradise in the west is called the "Pure Land." He is the principal object of worship of the Jōdo (Pure Land) sect. One of their main beliefs is that those believers who invoke his name in good faith will be admitted to his paradise. This cult was especially dominant during the Heian and following periods.

Apsaras—(Japanese: *tennin*). A "heavenly being" usually depicted in flight and often found in Buddhist iconography.

Bishamon Ten—(Sanskrit: *Vaiśravana*). An outstanding demigod who is usually depicted holding a pagoda in his left hand and a spear in his right. When grouped in the Shi Tennō, he is called Tamon Ten.

Bodhisattva—see **Bosatsu**

Bosatsu—(Sanskrit: *Bodhisattva*). A person who has attained enlightenment but forsakes entering Nirvana so that he can aid others in attaining enlightenment. Such a person is usually portrayed in an aspect similar to that of Gautama Siddhārta (the Buddha) before he became Buddha Śakyamuni. Bodhisattvas are most often shown separately or as attendants to Buddha.

Buddha—(Japanese: *Butsu*). The term signifies an enlightened person who leads others to enlightenment ("the enlightened, enlightener"). The term Buddha can apply to Śakyamuni specifically or to the other Buddhas (Yakushi, Amida and Dainichi). A Buddha represents the state achieved after the attainment of enlightenment. Thus they are found simply clothed in a priest's robe which is draped over one or both shoulders. The sutras state that each Buddha has specific physical characteristics, such as his hair in small curls resembling snail shells, and each Buddha has his own hand symbols (mudrās).

Dainichi Nyorai—(Sanskrit: *Vairocana* or *Mahāvairocana*). The supreme Buddha of Esoteric Buddhism and the Buddha "whose light shines everywhere." Worship of this deity in Japan began in the beginning of the ninth century, and the earliest statues depicting him date from that time. He is the only Buddha that can be found portrayed as a Bodhisattva.

Fudō Myōō—(Sanskrit: *Acala* or *Acanatha*). "Immovable." One who has made an immovable vow. He is said to be a manifestation of Dainichi Nyorai.

Fusuma—A sliding door or a set of sliding doors often used to partition rooms. Fusuma are made with thick wood frames and covered with heavy paper. They serve as an important part of indoor surfaces for painting.

Hosoge—"Precious-appearance-flower." An imaginary flower which originated in India. It resembles a peony and is frequently used as an ornamental motif in designs.

Ichiboku—"Single-block technique." In this method of carving, a statue is made from one large block of wood. If the projecting arms and knees are carved from a separate piece and joined, but the head and body are from a single block, the piece also may be considered *ichiboku*. This technique predominated from the seventh to the eleventh centuries.

Kakemono—A hanging scroll, mounted usually on silk, in which the length is generally greater than the width.

Kalavinka—(Japanese: *Karyōbinga*). Human-headed sacred birds which inhabit the Buddhist paradise.

Kannon Bosatsu—(Sanskrit: *Avalokiteśvara*). A Bodhisattva who is frequently depicted as attending Amida Nyorai. He has been worshipped in Japan since the advent of Buddhism.

Kirikane—"Cut gold." A technique of decorating Buddhist statues and paintings brought to Hakuhō period Japan from T'ang dynasty China. Used widely in Japan during the Heian and Kamakura periods, it consists of pasting thread-like thin strips or tiny triangular and square bits of gold and/or silver leaf on a surface, in a manner similar to a brushwork drawing.

Makimono—Horizontal scroll or hand scroll. It is intended to be viewed a little at a time, as each section is shown consecutively.

Miroku Bosatsu—(Sanskrit: *Maitreya*). The future Buddha or Messiah who is to inherit the position of Shaka, the Lord Saviour, in the next world. In Buddhist scriptures he is said to live in the Tosotsu Ten (Tusita Heaven) and in the future will descend to attain enlightenment and become the Saviour in place of Shaka. Thus he is represented as a Buddha or Bodhisattva.

Mudrā—(Japanese: *Shu-in, inzō* or *kei-in*). "Hand-symbol." Various positions of the hands and fingers which symbolize the virtues or actions of Buddhist deities such as meditation, salvation or wisdom.

Negoro—A type of Japanese lacquer dating from the Kamakura period characterized by its finish of red lacquer over an undercoating of black lacquer. The red lacquer finish becomes worn with use, revealing the black underneath. This accidental effect greatly enhances the beauty of these pieces.

Nehan—(Sanskrit: *Parinirvāna*). Absolute extinction of individual existence, i.e., glorified death. These are commonly found scenes in Japanese art depicting the death of Buddha.

Nyorai—(Sanskrit: *Tathāgata*). "One who chose the absolute way of cause and effect, and attained to perfect wisdom." In Japanese art the term is used identically with Butsu or Buddha.

Padmāsana—(Japanese: *renge-za*). Lotus posture (and throne). In Northern Buddhism almost all deities are presented standing or sitting on a lotus flower. As an attitude descriptive of the posture each leg is crossed and its foot is placed, sole upward, on the opposite thigh. The pose is most closely associated with representations of a Buddha, but is also used with other deities, monks and worthy men.

Raigō-Zu—"Greeting Scene." In this type of picture Buddha (Amida) descends from the Western Paradise, his Pure Land, and greets the believer. Followers of the Jōdo faith believe that at their death they will be admitted to the Western Jōdo, the paradise of Amida. Such scenes representing the coming down of Amida surrounded by attendants were usually found during the Heian and Kamakura periods.

Rakan—(Sanskrit: *Arhat*). A person who has attained enlightenment and is of saintly character. Such a person is usually depicted as an ascetic.

Rinzu—Satin damask weave.

Seishi—(Sanskrit: *Mahāsthāmprāpta*). A Bodhisattva and attendant of Amida, usually found with Kannon, another Bodhisattva.

Shaka Nyorai—(Sanskrit: *Śakyamuni*). The founder of Buddhism. As a prince he was known as Gautama. He decided to give up his luxurious life after seeing three miseries of mortals—old age, disease and death. He went to a mountain to meditate upon the eternal truth. The ascetic period which followed is often used as subject matter for suiboku paintings. Immediately upon the introduction of Buddhism in Japan, Shaka was worshipped, and early examples of Shaka still survive.

Suiboku—"Water and sumi." Ink paintings in which slight colour was sometimes added. It flourished in Japan during the Muromachi period, having been imported from Sung dynasty China. Notable features are the ample spacing, gradations of the sumi, sharp brushwork and simple composition.

Sutras—The holy scriptures of Buddhism.

Yakushi Nyorai—(Sanskrit: *Bhaiṣajyaguru*). "Medicine-master." The Buddha who is healer of all diseases, including spiritual ones which might hinder Buddhist faith and enlightenment.

Yamato-E—A style of painting developed during the Heian period which shows pure Japanese taste in its subject matter, style and technique. This type of painting is found on screens and scrolls and often employs classical Japanese literature as a source of subject matter.

196

Credits

Design: Louis Danziger, Los Angeles

Typography: Advertisers Composition, Los Angeles

Typographic Consultant: Norman Jacobson

Publisher: Kodansha International, Ltd., Tokyo

Printer: Mitsumura Printing Co., Tokyo

Printed in Japan